Essential KLIMT

This is a Parragon Book This edition published in 2003

Parragon Queen Street House 4 Queen Street Bath BA1 1HE, UK

Copyright © Parragon 2000

ISBN: 0-75253-487-4

All rights reserved. No part of this publication may be reproduced, stored in a retrieval system, or transmitted in any form or by any means, without the prior written permission of the copyright holder.

A copy of the CIP data for this book is available from the British Library, upon request.

The right of Laura Payne to be identified as the author of this work has been asserted in accordance with Section 77 of the Copyright, Designs and Patents Act of 1988.

The right of Dr Julia Kelly to be identified as the author of the introduction to this book has been asserted in accordance with Section 77 of the Copyright, Designs and Patents Act of 1988.

Printed and bound in China

Essential KLIMT

LAURA PAYNE

Introduction by Dr Julia Kelly

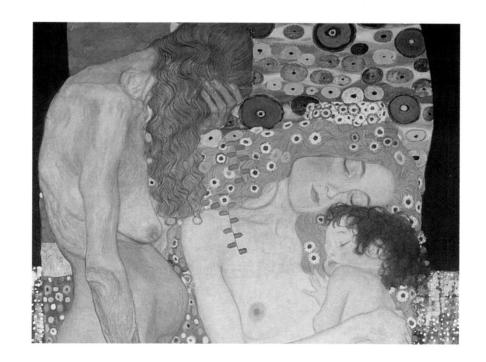

CONTENTS

Introduction		
Male Nude in Walking Pose		
Youth		
Fable		
The Idyll		
The Organ Player		
The Globe Theatre in London		
The Antique Theatre in Taormina		
	ater	
0		
	seum	
Frescoes in the Kunsthistorisches Museum		
Frescoes in the Kunsthistorisches Museum Portrait of the Pianist and Piano Teacher, Josef Pembaur		
	44	
	Portrait of a Lady	
09	Love	
	Burgtheater Actor Josef Lewinsky as Carlos	
	Music I	
	Design for Allegory 'Junius'54	
	Woman in Green	
CANTED STATE	Portrait of a Young Woman	
	Sculpture Allegory	
0.0000	Tragedy	
	Woman by the Fireside	
A second	Helene Klimt	
9	Allegory of Sculpture	
	Sonja Knips	
1/2	Ver Sacrum poster	
	Ver Sacrum poster	
	Water in Motion	
	Water in Motion	
	Water in Motion 76 Nuda Veritas 78 Jealousy 80	
SOR.	Water in Motion 76 Nuda Veritas 78 Jealousy 80 Pallas Athene 82	
	Water in Motion 76 Nuda Veritas 78 Jealousy 80 Pallas Athene 82 Portrait 84	
Serena Lederer	Water in Motion 76 Nuda Veritas 78 Jealousy 80 Pallas Athene 82 Portrait 84 86	
Serena Lederer	Water in Motion 76 Nuda Veritas 78 Jealousy 80 Pallas Athene 82 Portrait 84 86 88	
Serena Lederer Nuda Veritas (Naked Truth) Schubert at the Piano	Water in Motion 76 Nuda Veritas 78 Jealousy 80 Pallas Athene 82 Portrait 86 88 90	
Serena Lederer Nuda Veritas (Naked Truth) Schubert at the Piano After the Rain	Water in Motion 76 Nuda Veritas 78 Jealousy 86 Pallas Athene 82 Portrait 84 86 88 90 92 92 92	
Serena Lederer Nuda Veritas (Naked Truth) Schubert at the Piano After the Rain Philosophy	Water in Motion 76 Nuda Veritas 78 Jealousy 86 Pallas Athene 82 Portrait 86 86 88 96 92 92 94	
Serena Lederer Nuda Veritas (Naked Truth) Schubert at the Piano After the Rain Philosophy Medicine	Water in Motion 76 Nuda Veritas 78 Jealousy 86 Pallas Athene 82 Portrait 86 See 96 92 94 96 96	
Serena Lederer Nuda Veritas (Naked Truth) Schubert at the Piano After the Rain Philosophy Medicine Medicine	Water in Motion 76 Nuda Veritas 78 Jealousy 86 Pallas Athene 82 Portrait 86 Se 96 92 96 98 96 98 96 98 96 98 98	
Serena Lederer Nuda Veritas (Naked Truth) Schubert at the Piano After the Rain Philosophy Medicine Medicine Hygeia	Water in Motion 76 Nuda Veritas 78 Jealousy 80 Pallas Athene 82 Portrait 86 86 88 90 92 94 96 98 98 100 100	
Serena Lederer Nuda Veritas (Naked Truth) Schubert at the Piano After the Rain Philosophy Medicine Medicine Hygeia Jurisprudence	Water in Motion 76 Nuda Veritas 78 Jealousy 80 Pallas Athene 82 Portrait 86 86 88 90 92 94 96 98 98 100 102	
Serena Lederer Nuda Veritas (Naked Truth) Schubert at the Piano After the Rain Philosophy Medicine Medicine Hygeia Jurisprudence	Water in Motion 76 Nuda Veritas 78 Jealousy 80 Pallas Athene 82 Portrait 86 86 88 90 92 94 96 98 98 100 100	
Serena Lederer Nuda Veritas (Naked Truth) Schubert at the Piano After the Rain Philosophy Medicine Medicine Hygeia Jurisprudence The Blood of Fish	Water in Motion 76 Nuda Veritas 78 Jealousy 80 Pallas Athene 82 Portrait 86 86 88 90 92 94 96 98 98 100 102	
Serena Lederer Nuda Veritas (Naked Truth) Schubert at the Piano After the Rain Philosophy Medicine Medicine Hygeia Jurisprudence The Blood of Fish Farmhouse with Birches	Water in Motion 76 Nuda Veritas 78 Jealousy 80 Pallas Athene 82 Portrait 86 88 90 92 92 96 96 96 100 102 102 104 104	
Serena Lederer Nuda Veritas (Naked Truth) Schubert at the Piano After the Rain Philosophy Medicine Medicine Hygeia Jurisprudence The Blood of Fish Farmhouse with Birches Goldfish	Water in Motion 76 Nuda Veritas 78 Jealousy 86 Pallas Athene 82 Portrait 84 88 90 92 92 96 98 100 100 104 106 106 106 107 108 108 108	
Serena Lederer Nuda Veritas (Naked Truth) Schubert at the Piano After the Rain Philosophy Medicine Medicine Hygeia Jurisprudence The Blood of Fish Farmhouse with Birches Goldfish Music	Water in Motion 76 Nuda Veritas 78 Jealousy 86 Pallas Athene 82 Portrait 86 90 92 92 94 96 96 100 102 104 106 105 106 106 108 118 108	
Serena Lederer Nuda Veritas (Naked Truth) Schubert at the Piano After the Rain Philosophy Medicine Medicine Hygeia Jurisprudence The Blood of Fish Farmhouse with Birches Goldfish Music Judith with the Head of the Holofer	Water in Motion 76 Nuda Veritas 78 Jealousy 86 Pallas Athene 82 Portrait 86 86 96 92 92 96 96 97 96 100 102 104 104 105 106 110 110 111 110 112 111 113 112	
Serena Lederer Nuda Veritas (Naked Truth) Schubert at the Piano After the Rain Philosophy Medicine Medicine Hygeia Jurisprudence The Blood of Fish Farmhouse with Birches Goldfish Music Judith with the Head of the Holofer	Water in Motion 76 Nuda Veritas 78 Jealousy 86 Pallas Athene 82 Portrait 86 90 92 92 94 96 96 100 102 104 106 105 106 106 107 116 116 117 116 118 112 119 114 110 114 111 114 112 114 113 114 114 115 115 116 116 117 117 118 118 119 119 110 110 111 111 111 112 111 113 111 114 111 115 111 116 111 117 111 118 111	
Serena Lederer Nuda Veritas (Naked Truth) Schubert at the Piano After the Rain Philosophy Medicine Medicine Hygeia Jurisprudence The Blood of Fish Farmhouse with Birches Goldfish Music Judith with the Head of the Holofer	Water in Motion 76 Nuda Veritas 78 Jealousy 86 Pallas Athene 82 Portrait 86 90 92 92 94 96 96 100 100 104 106 105 108 106 108 116 116 117 116 118 116	
Serena Lederer Nuda Veritas (Naked Truth) Schubert at the Piano After the Rain Philosophy Medicine Medicine Hygeia Jurisprudence The Blood of Fish Farmhouse with Birches Goldfish Music Judith with the Head of the Holofer	Water in Motion 76 Nuda Veritas 78 Jealousy 86 Pallas Athene 86 Portrait 86 90 92 92 94 96 96 102 104 104 106 105 108 106 116 118 116 118 116 118 118	
Serena Lederer Nuda Veritas (Naked Truth) Schubert at the Piano After the Rain Philosophy Medicine Medicine Hygeia Jurisprudence The Blood of Fish Farmhouse with Birches Goldfish Music Judith with the Head of the Holofern Judith with the Head of the Holofern Marie Henneberg Emilie Flöge Women's Heads	Water in Motion 76 Nuda Veritas 78 Jealousy 86 Pallas Athene 82 Portrait 86 90 96 94 96 95 100 102 104 103 106 104 106 105 116 116 116 117 116 118 116 119 120	
Serena Lederer Nuda Veritas (Naked Truth) Schubert at the Piano After the Rain Philosophy Medicine Medicine Hygeia Jurisprudence The Blood of Fish Farmhouse with Birches Goldfish Music Judith with the Head of the Holofern Judith with the Head of the Holofern Marie Henneberg Emilie Flöge Women's Heads The Beethoven Frieze 'Yearning for	Water in Motion 76 Nuda Veritas 78 Jealousy 80 Pallas Athene 82 Portrait 86 88 96 96 100 102 106 116 116 116 116 116 116 116 120 120 120 120 120 120 120 120 120 120 120 120 120	
Serena Lederer Nuda Veritas (Naked Truth) Schubert at the Piano After the Rain Philosophy Medicine Medicine Hygeia Jurisprudence The Blood of Fish Farmhouse with Birches Goldfish Music Judith with the Head of the Holoferi Judith with the Head of the Holoferi Marie Henneberg Emilie Flöge Women's Heads The Beethoven Frieze 'Yearning for	Water in Motion 76 Nuda Veritas 78 Jealousy 86 Pallas Athene 82 Portrait 84	
Serena Lederer Nuda Veritas (Naked Truth) Schubert at the Piano After the Rain Philosophy Medicine Medicine Hygeia Jurisprudence The Blood of Fish Farmhouse with Birches Goldfish Music Judith with the Head of the Holofert Judith with the Head of the Holofert Marie Henneberg Emilie Flöge Women's Heads The Beethoven Frieze 'Yearning for The Beethoven Frieze 'Longing for The Beethoven Frieze 'The Forces of	Water in Motion 76 Nuda Veritas 78 Jealousy 86 Pallas Athene 82 Portrait 84	
Serena Lederer Nuda Veritas (Naked Truth) Schubert at the Piano After the Rain Philosophy Medicine Hygeia Jurisprudence The Blood of Fish Farmhouse with Birches Goldfish Music Judith with the Head of the Holofert Judith with the Head of the Holofert Marie Henneberg Emilie Flöge Women's Heads The Beethoven Frieze 'Yearning for The Beethoven Frieze 'Longing for The Beethoven Frieze 'The Forces of	Water in Motion 76 Nuda Veritas 78 Jealousy 86 Pallas Athene 82 Portrait 84	
Serena Lederer Nuda Veritas (Naked Truth) Schubert at the Piano After the Rain Philosophy Medicine Medicine Hygeia Jurisprudence The Blood of Fish Farmhouse with Birches Goldfish Music Judith with the Head of the Holofert Judith with the Head of the Holofert Marie Henneberg Emilie Flöge Women's Heads The Beethoven Frieze 'Yearning for The Beethoven Frieze 'Longing for The Beethoven Frieze 'The Forces of The Beethoven Frieze 'Ode to Joy'	Water in Motion 76 Nuda Veritas 78 Jealousy 88 Pallas Athene 82 Portrait 86 86 96 96 92 96 96 97 96 98 100 102 102 103 106 104 106 105 116 106 116 116 116 117 116 118 120 Happiness find Fulfilment in Art' 122 Happiness' 124 of Evil' 126 f Evil' 126 f Evil' 128 130 130	
Serena Lederer Nuda Veritas (Naked Truth) Schubert at the Piano After the Rain Philosophy Medicine Medicine Hygeia Jurisprudence The Blood of Fish Farmhouse with Birches Goldfish Music Judith with the Head of the Holofert Judith with the Head of the Holofert Marie Henneberg Emilie Flöge Women's Heads The Beethoven Frieze 'Yearning for The Beethoven Frieze 'Longing for The Beethoven Frieze 'The Forces of The Beethoven Frieze 'The Forces of The Beethoven Frieze 'Ode to Joy'	Water in Motion 76 Nuda Veritas 78 Jealousy 88 Pallas Athene 82 Portrait 86 86 86 96 92 97 94 98 100 102 104 104 106 105 116 106 116 116 116 117 116 118 120 Happiness find Fulfilment in Art' 122 Happiness' 124 of Evil' 126 Fevil' 128 130 132	
Serena Lederer Nuda Veritas (Naked Truth) Schubert at the Piano After the Rain Philosophy Medicine Medicine Hygeia Jurisprudence The Blood of Fish Farmhouse with Birches Goldfish Music Judith with the Head of the Holofert Judith with the Head of the Holofert Marie Henneberg Emilie Flöge Women's Heads The Beethoven Frieze 'Yearning for The Beethoven Frieze 'The Forces of The Beethoven Frieze 'The Forces of The Beethoven Frieze 'Ode to Joy' The Beethoven Frieze 'Ode to Joy' Half-Length Portrait of Man	Water in Motion 76 Nuda Veritas 78 Jealousy 88 Pallas Athene 82 Portrait 86	
Serena Lederer Nuda Veritas (Naked Truth) Schubert at the Piano After the Rain Philosophy Medicine Medicine Hygeia Jurisprudence The Blood of Fish Farmhouse with Birches Goldfish Music Judith with the Head of the Holofert Judith with the Head of the Holofert Marie Henneberg Emilie Flöge Women's Heads The Beethoven Frieze 'Yearning for The Beethoven Frieze 'The Forces of The Beethoven Frieze 'The Forces of The Beethoven Frieze 'Ode to Joy' The Beethoven Frieze 'Ode to Joy' Half-Length Portrait of Man	Water in Motion 76 Nuda Veritas 78 Jealousy 88 Pallas Athene 82 Portrait 86 86 86 96 92 97 94 98 100 102 104 104 106 105 116 106 116 116 116 117 116 118 120 Happiness find Fulfilment in Art' 122 Happiness' 124 of Evil' 126 Fevil' 128 130 132	

≋ CONTENTS **№**

Pine Forest (Forest of Firs I)	140
Life: A Battle (The Golden Knight)	142
The Procession of the Dead	144
Pregnant Woman with Man (Study for Hope I)	146
Beech Forest	148
The Tall Poplar II	
Birch Trees	
Drawing	
Portrait of Hermine Gallia	
Water Snakes I (Female Friends)	
Three Ages of Woman	160
Margarethe Stonborough-Wittgenstein	
Country Garden with Sunflowers	166
Working Cartoons for The Stoclet Frieze 'Tree of	Life' 160
Working Cartoons for The Stoclet Frieze 'Tree of	Life'
Working Cartoons for The Stoclet Frieze 'Narrow	Wall'
Working Cartoons for The Stoclet Frieze 'Expectator'	tion'
Working Cartoons for The Stoclet Frieze 'Fulfilme	nt'
Roses Among the Trees	
The Sunflower	
Fritza Riedler	
Adele Bloch-Bauer I	
Danaë	
Field of Poppies	
The Kiss	
Salome (Judith II)	
Woman with Hat and Feather Boa	
Schloss Kammer on Attersee II	100
Schloss Kammer on Attersee III	200
Woman in a Black Feather Hat	202
Death and Life	204
Upper Austrian Farmhouse	
Country Garden with Crucifix	208
Avenue of Trees in the Park at Schloss Kammer	
Adele Bloch-Bauer II	
The Girls (The Virgin)	
Girl (Drawing for Mäda Primavesi)	
Malcesine on Lake Garda	
Villa on Attersee	
Reclining Female Nude	
Schloss Untersch on Attamas	
Unterach on Attersee	
Friederike Maria Beer	
	Appletree II
	Houses at Unterach on Attersee 234
S NOT TO SO SO	Girlfriends
	The Italian Garden (Garden of Flowers) 238
	Portrait of Johanna Staude
	Woman in White
	Portrait of a Lady
	Head of a Woman
	Amalie Zuckerkandl
	The Bride
	Head of a Man
(1) (1) (1) (1) (1) (1) (1) (1) (1) (1)	Adam and Eve
	Acknowledgements

INTRODUCTION

HE name of Gustav Klimt (1862–1918) is intimately associated in the art-lover's mind with sensuous lines, erotic and beautiful women, and decorative golden detail. His paintings are instantly recognisable and have been exhibited in major art galleries worldwide, ensuring Klimt an international reputation as one of the foremost artist of his era. At the start of this century, the critic Hermann Bahr wrote in his 'Speech on Klimt' of 1901, 'Just as only a lover can reveal to a man what life means to him and develop its innermost significance, I feel the same about these paintings'. This statement, by comparing the rapport of Klimt's works with the viewer to the relationship between lovers, stood as a striking metaphorical expression of the emotional intensity that they inspired.

It is surprising, given Klimt's fame today, that before the midtwentieth century his work was little known outside the European art elite. It was not until he became the subject of extensive art-historical and critical interest that he was claimed by the general public.

Klimt's rise to prominence has been more complex than that of many other artists who are now regarded as great modern masters. He is often perceived as an isolated and misunderstood artist, working in opposition to the prevailing moral climate of his time: Hermann Bahr's statement, quoted above, was part of a sustained defence of Klimt's work in the face of the establishment's disapproval of his evocative depictions of sexual themes. Yet, Klimt actually worked as a successful painter within

his own lifetime, particularly as a portraitist and as the creator of several significant large-scale projects.

Today, Klimt is regarded as one of the progenitors of Viennese Modernism: he was a leader of the Secessionists and a motivating example for younger artists in the revolt against the values of their parents' generation. A crucial player within the artistic dynamics of *fin-de-siècle* Vienna, his career was closely related to some of the most important developments of the second half of the 1800s in both the institutions and practice of art. However, Klimt also produced significant work during the early years of the twentieth century. His essential 'modernity' thus

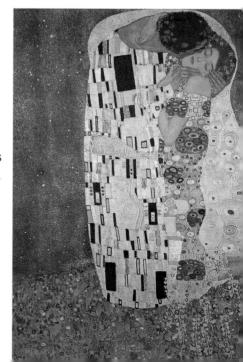

bridges both centuries, and has become a crucial and fascinating aspect of his historical importance.

The complexity of Klimt's career has been heightened by the sense of mystery surrounding his private life and the inner workings of his mind. Notoriously reticent about his life and art, he stated, 'I am not very good at the spoken or the written word, particularly not if I am supposed to say something about myself or my work.' This reticence led to the painter often being described by his contemporaries as taciturn and reserved. Records reveal that he was a thickset and brooding man, usually photographed wearing his painter's smock, who never married and led an openly bohemian lifestyle. If Klimt preferred to allow his paintings to speak for him, then the message that they gave

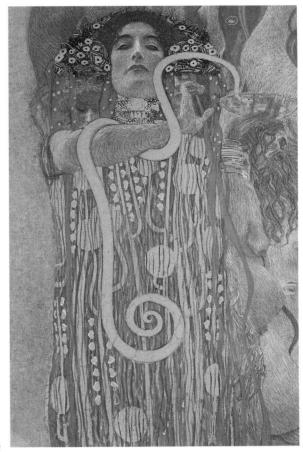

was extremely evocative – hinting, through their elaborate surfaces, at the workings of an enigmatic subconscious. It is no coincidence that Klimt's work is often linked to that of his Viennese compatriot, and near-contemporary, Sigmund Freud (1856–1939). When Klimt died in 1918, at the premature age of 55, several unfinished works of a strikingly sexual nature were found in his studio, as if revealing the erotic undercurrent latent beneath much of his earlier work.

Gustav Klimt was born on the 14th July 1862 in Baumgarten, near Vienna, the second of seven children. His father, originally from Bohemia, was an engraver of gold and silver, and his profession undoubtably rubbed off on his offspring. Klimt's brother Georg went on to become a goldsmith, while another brother, Ernst, joined Gustav as a painter and became his earliest collaborator. Their early home apprenticeship showed a traditional bias towards craftsmanship, rather than a pursuit of 'high' art ideals.

In 1876, at the age of 14, Klimt enrolled in the School of Arts and Crafts at the Royal and Imperial Austrian Museum for Art and

Industry in Vienna, along with his brother. It is significant that Klimt did not have an Academy training: the School of Arts and Crafts provided a broader training in applied art techniques, including fresco painting and mosaic, and in the history of art and design. He was soon able to earn a living, working with Ernst and fellow student Franz Matsch, executing architectural decorations to commission, after being

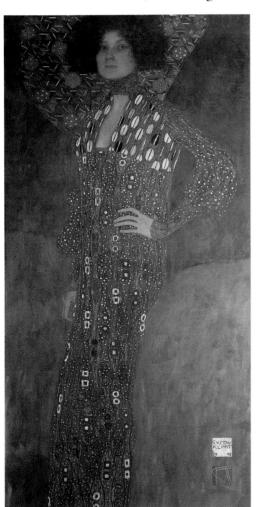

recommended by their professor, Ferdinand Laufberger. The commissions, including a series of villas and theatres, were supplemented by their making portraits, which were copied from photographs.

Their major break came when they were asked to create ceiling and wall paintings for two of the newly erected buildings of Vienna's celebrated Ringstrasse. For the Burgtheater (1886–88), the three young artists executed a series of panels depicting different stages in the history of drama; these included scenes from the ancient theatres of Dionysus and Apollo, and from the Shakespeare's Globe Theatre in London. Klimt looked to a wide variety of sources for the motifs and details of these paintings, in particular antique vases, which would later become a staple of his artistic repertoire. In 1890, he was awarded the Emperor's Prize for another painting on a theatrical theme, of the Old Burgtheater, which focused not on the stage and its actors, but on the audience, the Viennese elite, who were faithfully and individually recorded as they moved within

the auditorium. Klimt was beginning to find fame within his homeland.

For his second Ringstrasse commission in 1891, Klimt decorated the staircase of the new Kunsthistorisches Museum (Museum of Art History) with panels representing the progression of art from Egypt to the Renaissance. He chose the female form as his main vehicle, again drawing upon stylistic details taken from art books and artefacts in museums, to create striking figures such as the *Girl from Tanagra*

(1890–91), a prototype 'femme fatale'. Within the limitations of an important public commission, Klimt was already beginning to inject a new spirit into his art. This would manifest itself in Klimt's gradual shift away from photographic naturalism and towards effects of mood within allegorical compositions and portraits. The painting *Love* (1895), part of the second of the artist's portfolios, through which he displayed his abilities to potential clients, is a good example of a work which creates a brooding, almost melancholy atmosphere while tackling a grand theme, and whose prominent golden frame reinforces its power of mystery and its precious, almost sacred nature.

The changes in Klimt's work, such as his rejection of the naturalistic principles of the academic tradition, were reflected in broader shifts in the surrounding Viennese artistic milieu. From about 1890 onwards, *Jung-Wien* ('Young Vienna'), a literary movement made up of writers such as Arthur Schnitzler and Hugo von Hofmannsthal, began to react against what it perceived as the moralistic tone of nineteenth-century literature. The group began to produce work which explored disturbing psychological states of mind, dreams and a liberated sexuality. Their reaction against those who believed in rationality and progress, was reflected in the work of their peers in the visual arts, influenced by other European movements, such as Impressionism

in France, or the earlier Pre-Raphaelites in England.

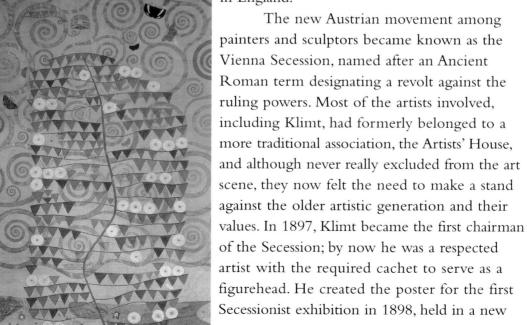

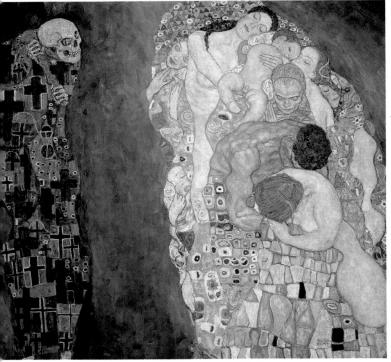

building designed for the purpose by architect Joseph Maria Olbrich. A drawing he made for the first issue of the Secessionist journal *Ver Sacrum*, in a linear and simplified style, showed a naked female figure holding up an empty mirror to the onlooker, as if to invite new inspiration, a new beginning. Inscribed above the entrance to Olbrich's exhibition hall were the words 'To the Age its Art, To Art its Freedom'.

Klimt's Secessionist association marked a new freedom in his style and subjectmatter. He was drawn to myths

and symbols taken from primitive Greece, which represented the life of the instincts and pre-rational desires as yet untrammelled by classical restraint. These were fused with figures from his own time, the women of late nineteenth-century Vienna, whom he continued to depict in portrait commissions as part of his artistic career. From this fusion arose primeval goddesses, such as *Pallas Athena* (1898) and *Nuda Veritas* (1899), with their forceful eroticism and primitive powers of seduction. In *Nuda Veritas*, the figure's dense, red hair and pale, curvaceous body gives her the appearance of a real flesh-and-blood woman as well as a bearer of myth.

In 1899, Sigmund Freud published *The Interpretation of Dreams* in Vienna. Although it is unlikely that Klimt read Freud himself, he would have been aware of Freudian ideas through his interaction with other artists and thinkers, in particular through the work of Nietzsche (1844–1900), especially the *Birth of Tragedy*. The irrational face of humanity had already begun to show itself in Klimt's paintings, and Freud's theories would add further impetus to his use of sexual forms and motifs, as ciphers for fundamental hidden passions.

At the end of the century, Klimt carried out a commission for the decoration of the new University in Vienna marked a turning point in his reputation. After the success of the other Ringstrasse buildings,

Klimt, along with Franz Matsch (his brother had died in 1892), was invited to paint the ceiling in the University's ceremonial hall, depicting its different faculties. This commission was given in 1894, but not begun by Klimt until 1898, by which time he had become involved with the Secession and its new aesthetic ethos. The three paintings which Klimt executed between 1898 and 1907, Philosophy, Medicine and Jurisprudence, were scarcely in keeping with the intentions of his clients, who had intended representation of the rational progress of education. Instead Klimt gave them swirling masses of clothed and naked figures, provocative foreshortening and distortions of human form, and areas of heavily patterned decoration contrasting with mysterious hazy depths. The original drafts of the first two of these paintings in 1900 and 1901 were badly received by critics and the establishment, who objected to the artist's indefinite forms and ambiguous evocation of human relationships, suggestive of permissive sexual liberation. Some 87 members of the faculty began a protest against Klimt's proposed decoration, which even became a cause in the Austrian parliament. The artist decided eventually to annul his contract and pay his advance commission back to the State. The bleak mood of the final painting, Jurisprudence, is often seen as

Despite the fiasco of the University faculty paintings, Klimt had begun to become known internationally. He had been made a member of the International Society of Painters, Sculptors and Engravers in London in 1898, and an associate member of both the Berlin and Munich Secessions. His painting Philosophy (1899-1907), which aroused so much indignation in Vienna, was awarded a gold medal at the 1900 World's Fair in Paris. In subsequent years, Klimt would continue to exhibit throughout Europe, and to win awards. His works would also go on to be bought by the major Austrian museums. Yet his own attitude, as expressed in published interviews and letters, was one of antagonism towards the

Klimt's personal reaction to this rejection.

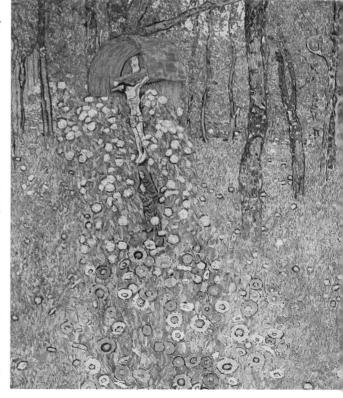

State. 'I've had enough of censorship', he once proclaimed, taking refuge in the support of his fellow Secessionists and his high-society clients.

In 1902, the Secession was at the height of its powers, and mounted a spectacular 14th exhibition on the theme of Beethoven, conceived as a *Gesamtkunstwerk* ('total work of art'): a combination of architecture, interior design, painting and a sculptural centrepiece by Max Klinger. The exhibition was a huge success, welcoming 58,000 visitors. Klimt's brief was to produce a mural, and he gave full vent to his creative impulses. In a synthesis of fluid lines and abundant decoration,

Klimt's own private life, as far as it is known, gives away few clues about the personality of the man who could depict women such as these and the striking murderess *Judith with the Head of Holofernes* (1901). He was known to be a shy and silent man, not wont to express his feelings publicly. In 1891, his late brother Ernst had married Helene Flöge, who ran a fashion house with her sister Emilie from 1904 onwards. Klimt and Emilie became long-term lovers but never married; Klimt had three children with Maria Ucicky and Marie Zimmermann. In a series of photographs of Emilie in a garden setting, published in the journal *German Art and Decoration* in 1906–07, Klimt combined his two muses: his life partner, and the complex natural forms that surrounded her.

In 1904, the Vienna Secession experienced a crisis as its members split into two camps; the 'Realists' and the 'Stylists'. Klimt, with his increasingly decorative technique, belonged to the latter. The dissolution of the Secession led to new groupings, the most important of which was the Viennese Workshops (*Wiener Werkstätte*), founded originally in 1903 by designers Josef Hoffmann and Koloman Moser, and growing to prominence in subsequent years. Klimt played a central role in the association, exhibiting 16 works in its important Kunstschau exhibition

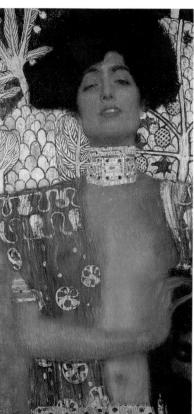

of 1908 within an inner sanctum among works by artists whom we now designate the 'Klimt group'. Between 1905 and 1909, the Viennese Workshop worked on one of their most famous group projects, the decoration of the villa of Adolphe Stoclet in Brussels, to which Klimt contributed a striking dining-room frieze.

This project, which became known as The Stoclet Frieze (1905–11), gave Klimt the opportunity to create a decorative scheme free from the kind of philosophical content that had informed his University paintings and the Beethoven frieze. His designs, based on the interweaving of the stylised forms of tree branches with figures, birds and flowers, served as a celebration of the senses, appropriate to their function as a backdrop for elegant society diners. In 1903, Klimt had travelled twice to Ravenna, where he saw the mosaics of San Vitale, whose Byzantine influence was apparent in the paintings of what would become known as his 'Golden Period', such as those of the Stoclet villa. The use of gold harked back to Klimt's own past, to the metal work of his father and younger brother Ernst, who had both died a decade earlier. Klimt's interest in the Byzantine period also symbolised a move towards greater stability, through static, inorganic forms; suggesting a search for refuge after the artist's exploration of the instinctual powers of archaic Greece.

One painting in particular stood out during the years of *The Stoclet Frieze* and the Kunstschau exhibition, and in fact became the most popular work at that exhibition: the celebrated *The Kiss* of 1907–08. Here, Klimt's loosening of naturalism, in favour of a personal symbolic

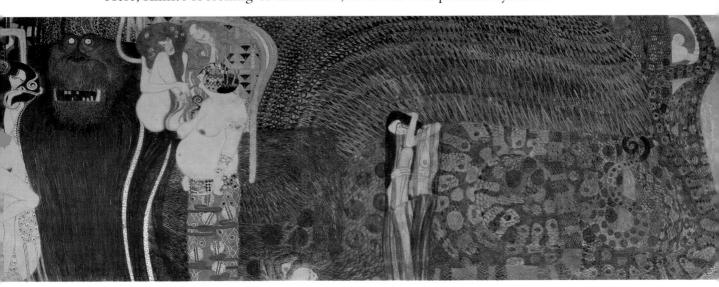

language suggesting the workings of the unconscious mind, in particular its erotic urges, reached a climax. Through two figures, depicted not naked, but draped in densely patterned cloths, Klimt succeeded in evoking a moment of intense sensual pleasure, within a sharply stylised and flattened composition.

Landscapes and portraiture accounted for a significant proportion of Klimt's output throughout his career. As a constant feature of his production, they provide a means of charting the developments of the

painter's style as it moved towards a greater use of ornamentation and of mysterious evocation. For most of his adult life, Klimt painted landscapes mainly during the summer months, while holidaying with Emilie and her family in various small villages around the Attersee in Austria. His early views of the lake, such as Island in Lake Attersee (c. 1901), and paintings of woods, Beech Forest I (c. 1902) and Birch Wood (1903), showed a manner of composition that would dominate all of his landscapes: a use of 'close perspective', a narrow focus upon the natural details captured within the picture frame. In later years, this technique became more marked, and the leaves and flowers of parks, orchards and gardens grew to form screens of decorative and two-dimensional patterning, as in The Park (1910), or Garden Path with Chickens (1916). Klimt's portraits also manifested an increasing domination of the female sitter by her environment. Fritza Riedler and Adele Bloch-Bauer, whom Klimt painted in 1906 and 1907 respectively, were depicted as frozen icons, their personalities concealed behind the elaborate trappings of their fashionable costumes and settings, finding sublimated expression only in the swelling curves and suggestive archetypal forms around them.

Ornament and evocation were crucial to some of Klimt's last works, pursuing the

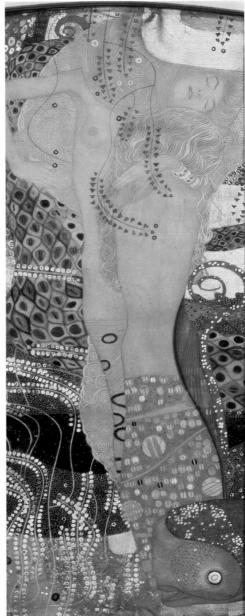

allegorical subject-matter to which he had previously been drawn, in stark and powerful paintings of the theme of the 'cycle of life' such as The Three Ages of Woman (1905) and Death and Life, for which he was awarded the first prize at the International Art Exhibition in Rome in 1911. When Klimt died of a stroke in February 1918, the paintings that he left behind in his studio were of an extremely enigmatic nature. The Bride (1917–18) in particular transformed a meditation on a significant stage in life into an ambiguous erotic encounter, where a mass of interlocking bodies counterbalanced a young woman with bared breasts and a naked body just visible beneath a layer of

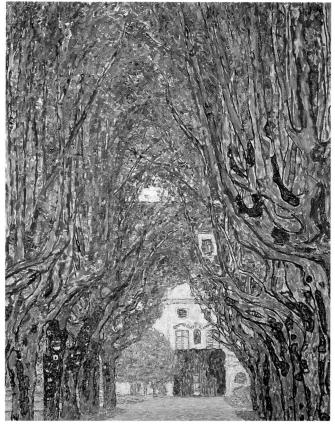

patterned fabric. Klimt's allegory was now decidedly private, its meaning uncertain and its atmosphere dream-like.

In these last unfinished works, he seemed to have been pursuing an ideal of erotic happiness, far removed from the grand statements of historical and social progress that had marked the paintings of the older generation in late nineteenth-century Vienna, but also significantly removed from his own earlier engagement with a world of dark passion and ominous 'femmes fatales'. If Klimt had made a major breakthrough in his earlier work, which explored the new experience of psychological depths and the power of the subconscious, these later works showed the way forward to the emerging younger generation in Austria, influencing painters such as Egon Schiele (1890–1918) and Oskar Kokoschka (1886–1980), as well as future generations of artists.

DR JULIA KELLY

MALE NUDE IN WALKING POSE (1877–79)

Courtesy of Historical Museum, Vienna

ERALDED as a master of ornamentation, Gustav Klimt's remarkable talent for drawing is often ignored. Here, his skills emerge beautifully early in a remarkable, pencilled life study from his student portfolio, capturing dramatic physical tension and detailed muscle power. Although revealing excellent draughtsmanship, there is a static quality which will be rapidly refined in ensuing years. Klimt won a place at the celebrated Viennese School of Arts and Crafts, *Kunstgewerbeschule*, which demanded intensive training in classical studies and faithful copying of ornament, form, design and classical sculpture plaster casts. His entrance at the age of 14 became his large, impoverished family's passport to fame and fortune within the cultured circles of turn-of-the-century Vienna.

The city was a dazzling world of refinement, wealth and excitement associated with capitals of power in late nineteenth-century Europe. It was the epicentre of the Habsburg's dying Austro-Hungarian Empire, briefly bolstered by industrialisation and commerce. Yet, like other burgeoning cities, huge civic programmes glossed over poverty, slums, and socio-political degeneracy. Within this urban ferment the buds of the Art Nouveau and Symbolist movements germinated: a new spiritual quest to capture something better and purer through art — with Klimt in Vienna at the forefront.

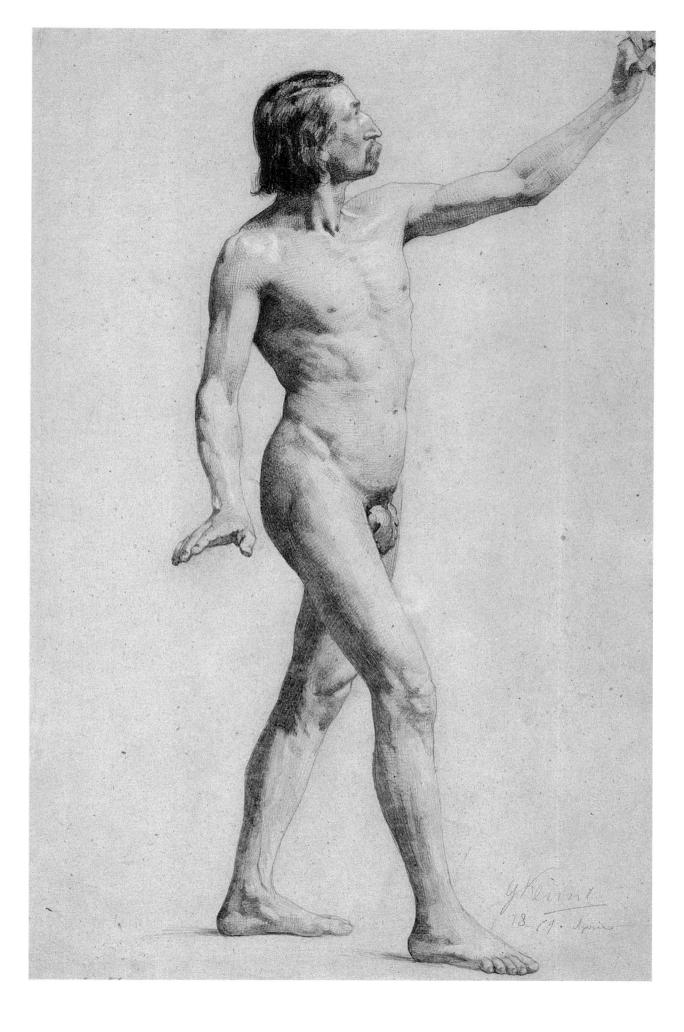

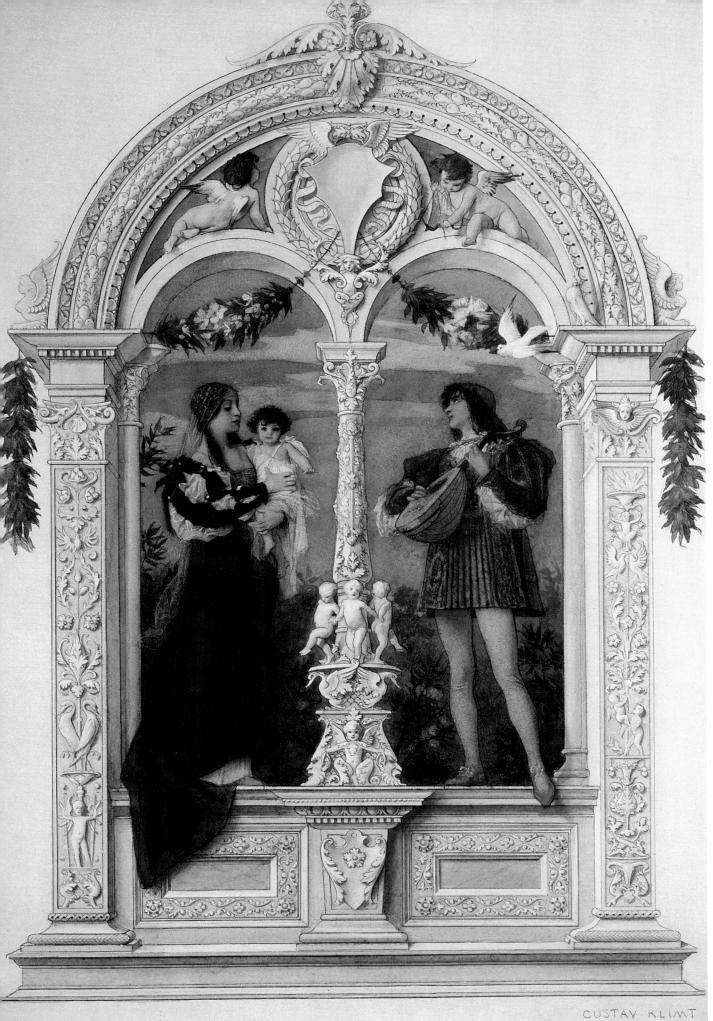

YOUTH (1882)

Courtesy of Historical Museum, Vienna

LIMT'S intense classical training provided the foundation for his rapid, commercial development. The Golden Age of Vienna saw unparalleled patronage and investment in the arts, and valuable influential contacts made during his apprenticeship at the Arts and Crafts School, combined with great talent, soon opened doors for ambitious commissions, such as: a contribution to the three-volume publishing series, *Allegories and Emblems*.

The contract, procured by his art master, demonstrates how Klimt was not merely a creative dreamer. He proved to be an enterprising businessman, forming the *Künstlercompagnie*, the Artists' Company, with fellow student Franz Matsch, and budding artist, his younger brother, Ernst.

Sadly, little is known of Klimt's character, or his beliefs about art or life; he loathed all forms of self-expression other than his work, rarely writing letters, tracts or diaries. Yet his swift acceptance into Vienna's powerful artistic milieu reveals a determined, resourceful force, capable of capitalising on his undoubted skill. Already enduring hallmarks of his work are present in this Neo-Classical contribution, Youth, with its exquisitely captured ornamentation blended with naturalistic imagery; these were still at work 16 years later in Allegory of Sculpture. Classical concepts of structural balance and perspective are well defined with a keen comprehension of spatial depth.

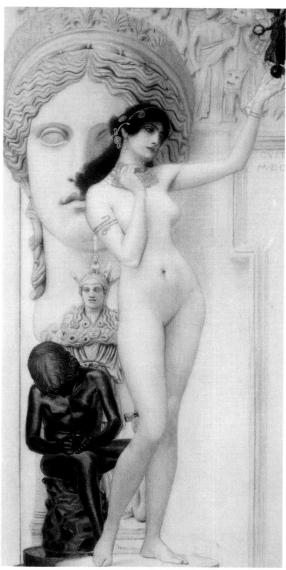

Allegory of Sculpture (1898) Courtesy of Galerie Welz, Salzburg. (See p. 69)

FABLE (1883)

Historical Museum, Vienna. Courtesy of AKG London

OST artists contributing to the lavish Allegories and Emblems publishing series were already renowned, so this meant that the Künstlercompagnie's involvement was a remarkable start and a valuable source of income for the two Klimts and Matsch. Their initial success was due to their speedy work and unity of style as they had all been instructed by the same teacher. In the early years, they often swapped work: Gustav painting from a Matsch design, for instance.

This immense compendium, which eventually stretched to three volumes, aimed to rejuvenate 'old' concepts of allegory, often the foundation stone of Renaissance, Baroque and Rococco art, by modern artists. It wanted to explore the 'real and ideal', and so introduced Klimt to a philosophical debate which absorbed his life's work. Months, seasons, and emotions, such as love and sorrow, were interpreted allegorically along with contemporary expressions of government, trade and technology.

Here, Klimt's work, Fable, faithful to the period's typical demands of academic Neo-Classicism and historicism, reveals superb handling of light, draughtsmanship and brushwork. His treatment of the theme selects some beautiful and popular fable imagery, such as the lion and the mouse, yet apart from the animated mice, the subject-matter remains wooden and lifeless.

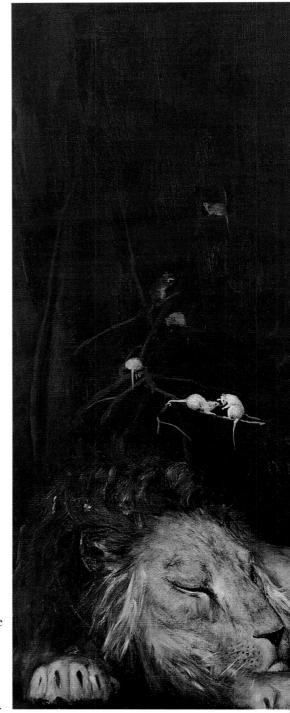

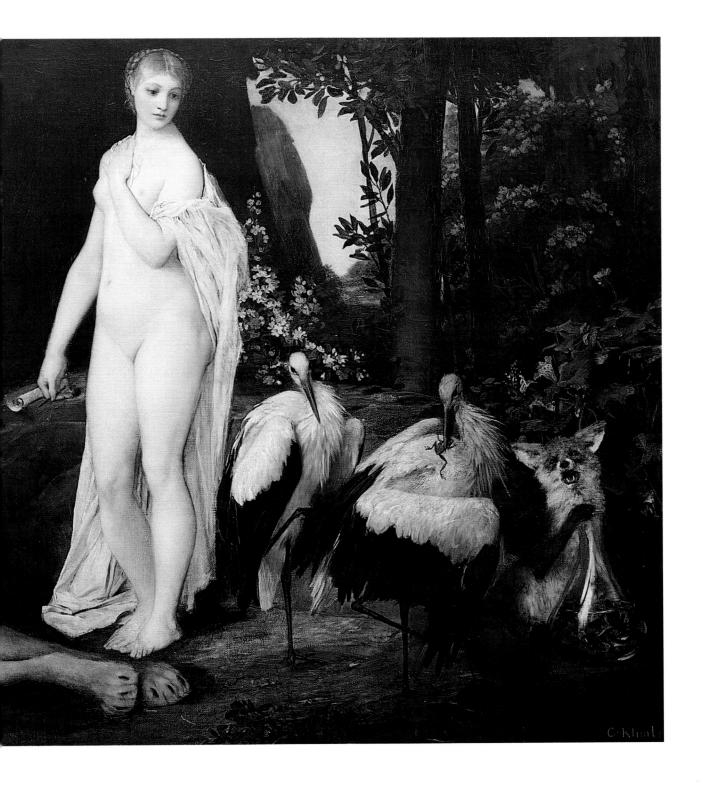

THE IDYLL (1884)

Historical Museum, Vienna. Courtesy of AKG London/Erich Lessing

LSO part of the publishing series Allegories and Emblems, Idyll, which was painted the year after Fable, shows a distinct improvement in Klimt's ability to infuse life and drama into his figure work. Ironically these supposed stone sculptures flanking the

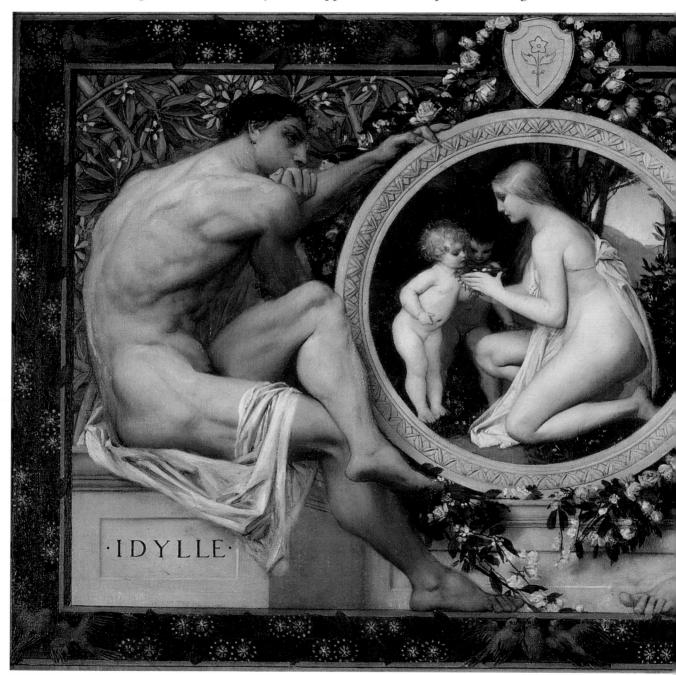

decorated stucco of the central 'tondo' have a beautiful sense of dynamic movement. Their detailed physicality is reminiscent of Michelangelo's Sistine Chapel work, though the heads and faces are contradictorily life-like, recalling the work of the English Pre-Raphaelite artist, Edward Burne-Jones, with their haunting, inward-looking and meditative expressions.

Klimt is known to have had contacts with contemporaries of the Pre-Raphaelites. Their work, and that of William Morris (1834–96), was widely published on the Continent. In fact, behind this oil painting's traditional Classical overtones, elements of the new European language of Symbolism can be discerned – in features such as the tangled, but intricately patterned, Morris-like jasmine web. Klimt also explores the artistic impact of symbolic decoration, as in the star-like flower entwined around the mock frame surround, a pattern to be repeated and reworked during the rest of his career. Consequently, this is cited as an important transitional work in which Klimt discovers a new artistic language. Over the years this is boldly synthesised to create a personal aesthetic, the enduring hallmark of his success.

THE ORGAN PLAYER (1885)

Courtesy of Osterreichische Galerie Belvedere, Vienna

GAIN Klimt plays within the confines of the 'tondo' shape, using its inherent boundaries to locate form and content. This work is an oil study for a ceiling panel entitled the *Allegory of Music* for the Bucharest National Theatre in Romania, the *Künstlercompagnie*'s first major independent fresco commission. The project came after Klimt's college teacher recommended the three artists to an architect's firm, which was renowned for designing a programme of theatres throughout the Habsburg Empire and central Europe. The highly regarded young artists were suddenly inundated with interesting commissions to capture The Golden Age of the Empire, in a society obsessed with theatre, a focal meeting point for the elite.

In this sketch, the brushwork, although crude due to it being a study, is still distinct and vibrant. The handling of colour and the medium, particularly the white of the angel's robes, is authoritative, becoming increasingly stylised in later portrait work. In fact, several elements of this study surface in the following theatre project, *The Globe Theatre in London* (1886–88). The upward curve of the player's head is much like that of the dead Juliet and the angel's flowing white expanse is reworked into her death robes.

The Globe Theatre in London (1886–88) Burgtheater, Vienna. Courtesy of AKG London/Erich Lessing. (See p. 26)

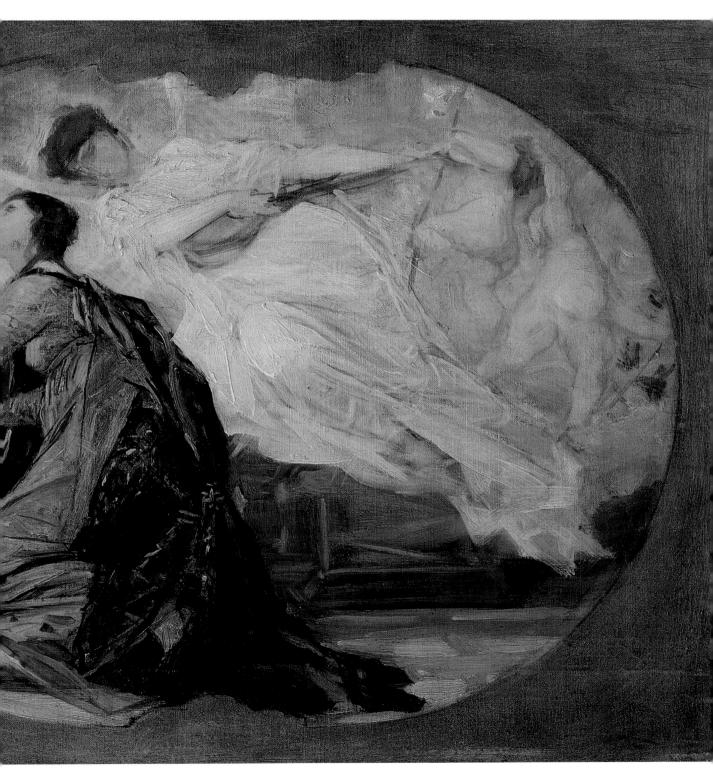

THE GLOBE THEATRE IN LONDON (1886–88)

Burgtheater, Vienna. Courtesy of AKG London/Erich Lessing

HE Künstlercompagnie's reputation gained momentum and the three young artists become wunderkinder of Viennese high society. Their acute business acumen enabled them to rent a sizeable studio to produce their speciality: vast historical murals, in great demand with the lucrative civic building programme centred round the Ringstrasse since 1860. Construction projects on this massive European boulevard included the state opera, courthouses, town hall, university, sumptuous apartments and theatres.

This commission, to decorate the ceilings above the two main stairways of the magnificent new Burgtheater, was part of this scheme. Financed privately by the Emperor, the fabulous two-year project represented extraordinary patronage for the Klimt brothers, whose large family still lived in the slums. The artists used their family, dressed in period costume, in addition to photography, to achieve the realism required for the theme: a history of world theatre. This beautifully balanced work develops a flat perspective, which resurfaces in Klimt's later works, making the viewer part of the audience.

More significantly, it is the only self-portrait Klimt produced: he is richly attired on the right in the large white ruff, Ernst and Matsch beside him; a sardonic recording of their social acceptance, both literally and artistically. It won a Gold Order of Merit, the Emperor's highest order.

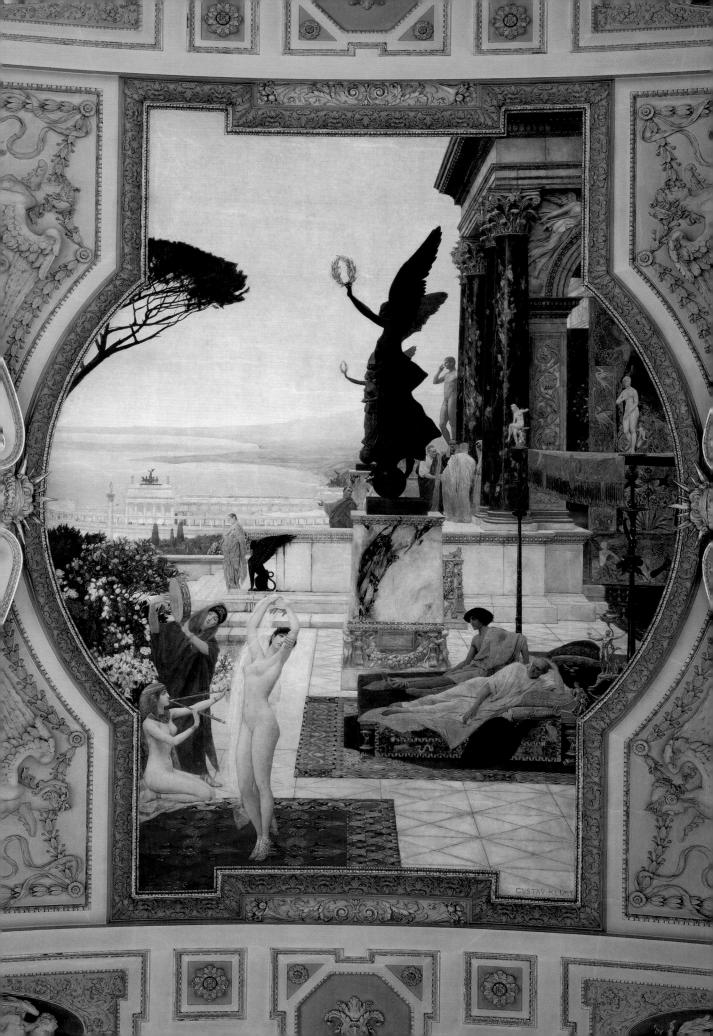

THE ANTIQUE THEATRE IN TAORMINA (1886–88)

Burgtheater, Vienna. Courtesy of AKG London/Erich Lessing

LIMT'S other major contribution to the Burgtheater commission, this stunning Classical work is on the ceiling of the left staircase, while *The Globe Theatre in London* (1886–88) sits over the right hand stairway. In contrast with the latter work, this bright, intense scene appears like an opening into another world, lost in time; an idyllic world where calm, serene beauty and the love of arts reign supreme. The commissions for this northern stairwell were themed around music, dance and impromptu stage pieces, rather than Classical drama, but contributed to the overall historical depiction

of world theatre. Klimt's open-air, impromptu splendour of the Classical Roman Empire in Taormina, Sicily, was faithful to then-contemporary Viennese expectations of historicism.

Unlike the tight, flat *Globe* work, an expansive panorama stretches far out across the sea from this lofty palatial retreat. The dancer in the foreground and her pan-player satisfy Classical nude conventions, confines that Klimt was to challenge controversially in subsequent commissions. A pervasive mood of harmony and structure is brilliantly at work in this highly technical composition.

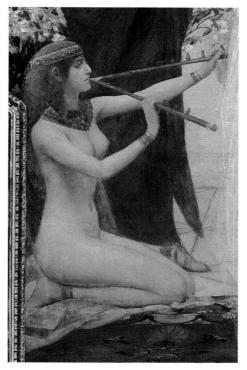

The Roman architecture is carefully detailed so that it flows out of the surrounds of the theatre's ceiling, blending the world of Vienna imperceptibly with this ancient time.

Auditorium of the Old Burgtheater (1887–88)

Historical Museum, Vienna. Courtesy of Artothek

OW adored by the commissioning authorities, Klimt, just 25, was approached by Vienna City Council to immortalise the Old Burgtheater before its demolition. The result, seen here, is a wonderful twist on the theatre theme, laden with irony; Klimt chooses to portray the audience, who, as the crème of Viennese society, represent the real heart and power of the theatre, the stage where real dramas unfolded. It is significant that the viewer, like the artist and actors, is also figuratively separated from the auditorium.

This social microcosm is neatly captured in a distorted fisheye perspective, created in gouache on paper, as bodies and faces clamour to steal the scene. In fact, prominent figureheads were desperate to appear in Klimt's work, realising its historical significance as the scene brokered the closing of the old theatre and opening of the new. The Prime Minister, the mayor, the composer Brahms and the Emperor's mistress joined 150 delicate and painstaking miniature portraits, winning Klimt even further celebrity. His powerful and skillful use of light within the almost colourless work is remarkable as the viewer can pick out facial detail even at a distance, consolidating a sense of black-and-white photographic realism. Klimt won the distinguished Emperor's Prize for the work.

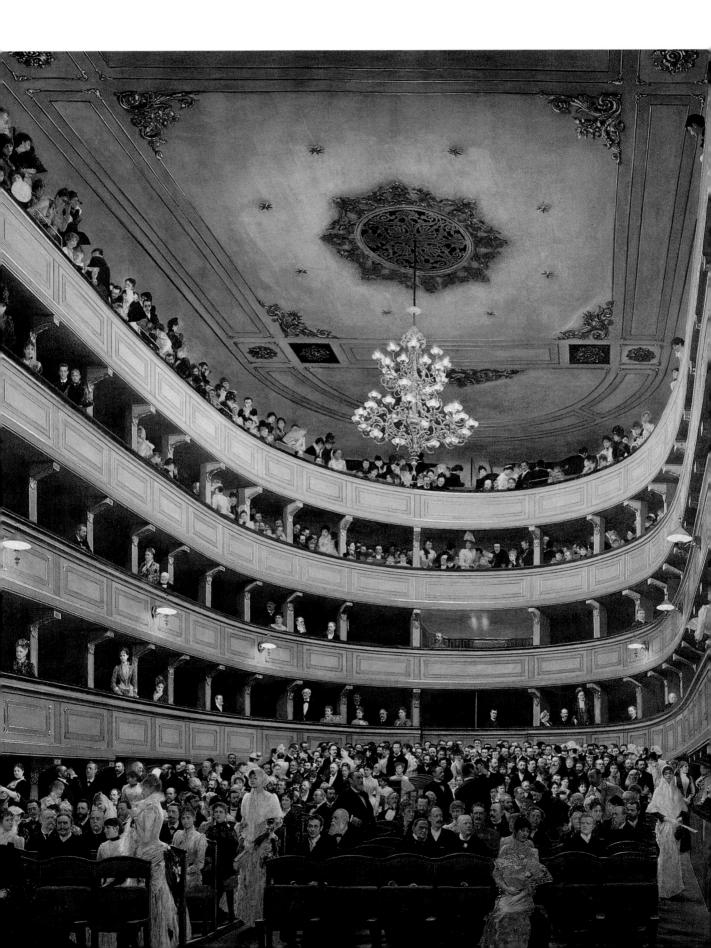

HERMINE KLIMT (1887–88)

Courtesy of Historical Museum, Vienna

HIS sketched portrait of Hermine, Klimt's youngest sister, is possibly his earliest known portrait, but despite adept draughtsmanship, it has little of the animation of later work, such as the Helene portrait (1898). Here, the black-and-white medium and static pose connect the work to the emerging use of photography. Klimt, like many artists, enjoyed playing with photographs to construct a portrait although the technique was frowned on by purists, who considered the camera an inferior artistic medium.

Klimt was devoted to his family; becoming financially responsible for them after his father's death in 1892. The family, with six children,

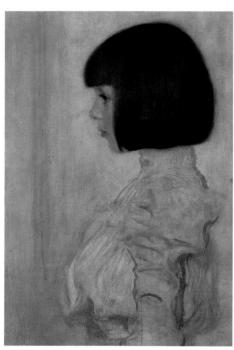

Helene Klimt (1898) Courtesy of Osterreichische Galerie Belvedere, Vienna. (See p. 66)

had struggled to make ends meet; Klimt senior, an immigrant Bohemian and gold engraver married to a Viennese musician, was often out of work. Hermine, who recorded much that is known about Klimt's life, recalled that 'at Christmas there wasn't any bread in the house, let alone presents'. The brothers' remarkable early success was a lifeline.

Hermine was the mainstay female in the household. Klimt's beloved mother, Anna, suffered from depression after the death of her second youngest daughter, also called Anna, at five years old, followed by the progressive insanity of Klara, her eldest child.

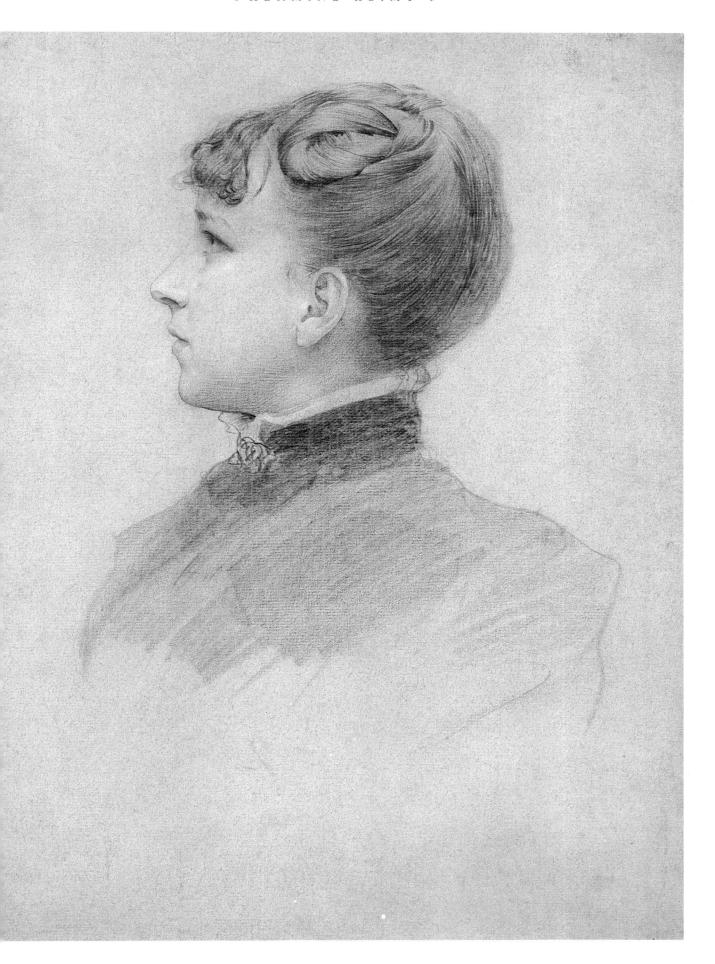

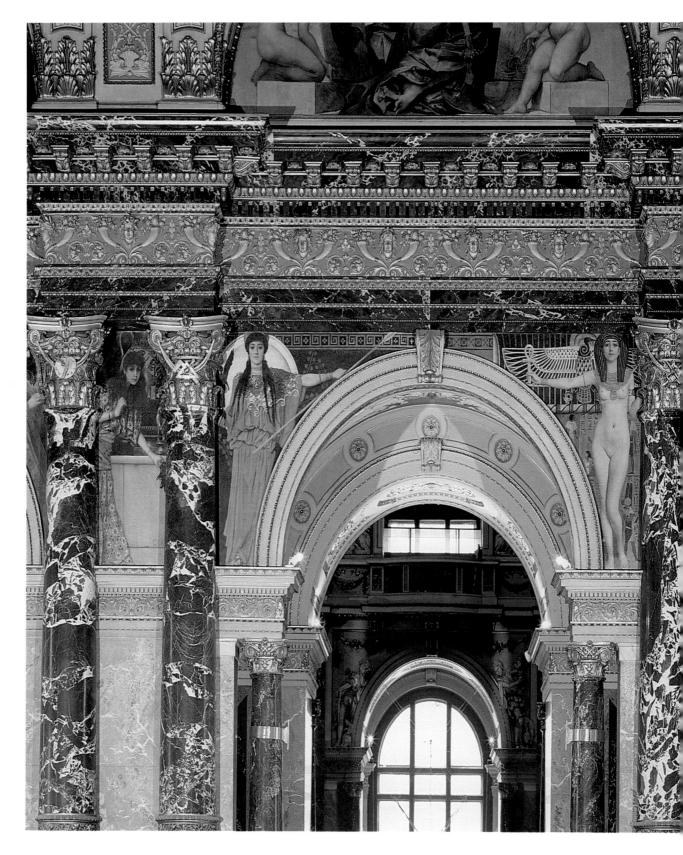

Frescoes in the Kunsthistorisches Museum (1890–91) 'Egyptian Art I and II' and 'Greek Antiquity I and II'

Courtesy of AKG London/Erich Lessing

HE young artists' resounding fame meant that they were next approached to tackle the immense entrance hall of the Kunsthistorisches Museum, built on the Ringstrasse to house the fabulous Imperial art collection. The work had been initially assigned to Hans Makart (1840–84), Austria's most revered artist and pioneer of this period of historicism, but only 12 lunettes were completed before his sudden death in 1884. The Klimts and Matsch were employed to decorate more than 40 wall spaces between the columns and at the side of the arches (spandrels), illustrating the theme of art's development from ancient to modern times.

Here, we see Klimt's introduction to heavy gold ornamentation, a hallmark of his later work. His choice of gold is representational of Egyptian art. Subsequent use is attributed to working on architectural decorative projects in these early years and to the influence of his father's work. He completed 11 Museum paintings, employing the accuracy of research and presentation that won the team renown during the Burgtheater project.

Detail from Egyptian Art I and II (1890–91)Courtesy of AKG London/Erich Lessing. (See p. 36)

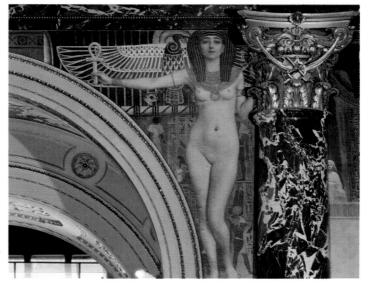

Frescoes in the Kunsthistorisches Museum (1890–91) 'Egyptian Art I and II'

Courtesy of AKG London/Erich Lessing

LOSE study of Egyptian Art I and II reveals Klimt's gradual change of aesthetic approach in his painting of nudes, which was later to cause severe ructions in the Vienna University commission. Unlike Klimt's distinct Neo-Classical nude, Fable (1883), the full-frontal aspect of this Egyptian model has a strong contemporary feel in body stance and facial characteristics. The influence of Pre-Raphaelitism and the more progressive work of the late nineteenth-century European Symbolists, which fascinated Klimt for the rest of his career, start to percolate through at the time this fresco was painted.

The Symbolists were fascinated by ancient archetypal images as references to signify a new language of idealism. Here, the nude stands in front of a traditional Egyptian emblem, the hawk, either connoting Horus, god of sky and light, or Ra, god of creation. The bird's swirling neck motif is to recur regularly as a favourite Klimt patterning device. The nude holds the 'ankh', symbol of life and reincarnation, to contrast

with her mummified body and its golden death mask on the other side of the column. Around the mummy are other images of Egyptian artefacts. Here, Klimt's fascination with the paradoxical concept of life in death takes shape to become a recurrent theme of future work.

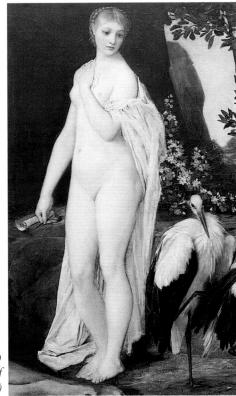

Fable (1883) Historical Museum, Vienna. Courtesy of AKG London. (See p. 20)

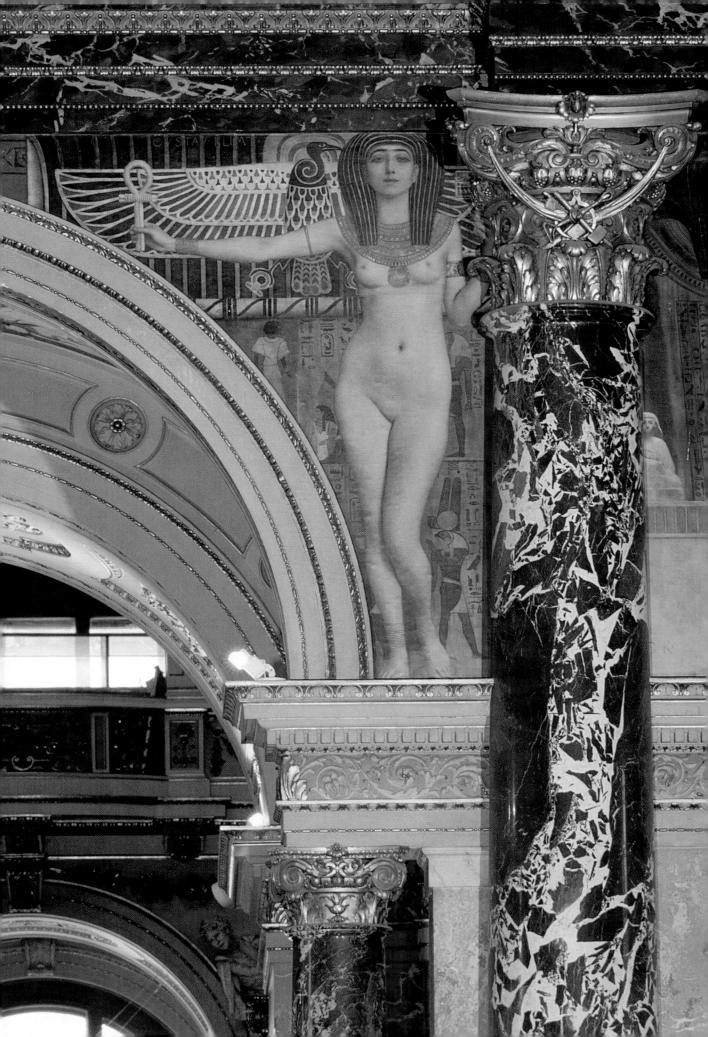

Frescoes in the Kunsthistorisches Museum (1890–91) 'Italian Renaissance'

Courtesy of the Bridgeman Art Library

HE height of the Kunsthistorisches Museum's spandrel work makes it difficult to appreciate this extraordinary project, particularly when the detail is overshadowed by the ostentatious surrounding architecture, with its heavy gilding, elaborate paint work and richly veined marble. The female figure in this fresco, depicting Renaissance, may be the Madonna, considering the ornate golden halo behind her head which matches that of the bold red cherub. If the Madonna is depicted, then this is an astounding, highly unconventional representation for the period. As in Egyptian Art I and II, the face is contemporary, recalling a Dante-Gabriel-Rossetti -style Pre-Raphaelite woman rather than a typical Renaissance countenance; the unusual dress is not the traditional costume of the Madonna.

As with the hawk patterning in *Egyptian* Art I and II (1890–91), Klimt plays here with another exquisite embellishment on the figure's dress, which will be reformatted and patterned into future work. This emblem, reminiscent of the medieval Tarot card 'pentacle', an ancient coin representing material wealth and power, appears in the celebrated work, *Judith with the Head of Holofernes* (1901), embossed on the figure's robe. Not much is known about Klimt's private symbolic language, but many enduring motifs were undoubtedly born out of this period.

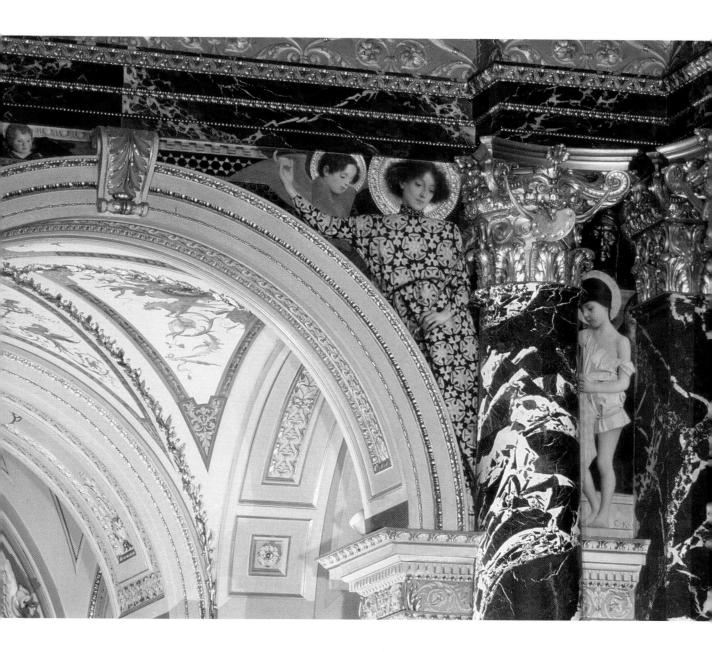

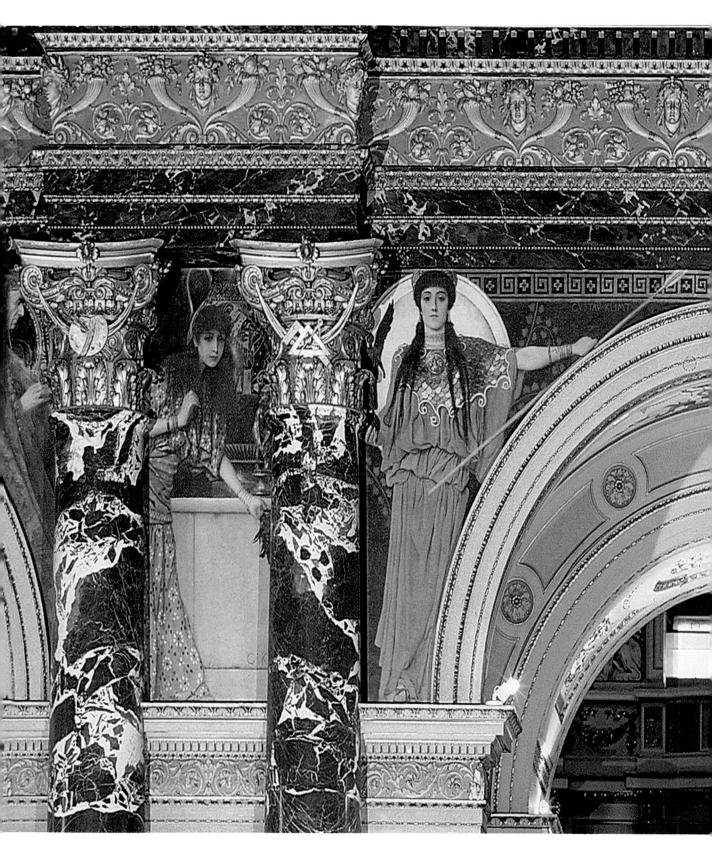

FRESCOES IN THE KUNSTHISTORISCHES MUSEUM (1890–91) 'EGYPTIAN ART I AND II' and 'GREEK ANTIQUITY I AND II'

Courtesy of AKG London/Erich Lessing

depicting Greek antiquity, sited on the opposite side of the arch to Egyptian Art I and II. The flower motif on the dress of the crouched figure, painted within the intercolumnar section, becomes another a favourite device. This girl, representing a Pygmalion figurine, brought to life from the antique Greek Tanagra vase behind her, is also reminiscent of Pre-Raphaelite images. The mythical sculptor, Pygmalion, fell in love with a statue he created. The goddess Venus brought his figure of ideal beauty to life, taking pity on him. Accordingly, Klimt musters a greater sense of depth in this spandrel's perspective, to denote a sense of life; it appears lifted out from its decorative surroundings, unlike the flatter dimensions of other frescoes in the series. The figure's emergence from behind the pillar is also hesitant, as though wary of the real world.

This uncertainty contrasts strongly with the spandrel's strident Classical image of Athena, goddess of war, wisdom and patroness of arts and crafts. She stands forcefully against a large, burnished gold shield, which sets behind her like an enlarged sun, and her outstretched spear cleverly defines the arch's span. Complete with the Medusa head on

her breastplate, she later becomes an emblem of artistic power for Klimt's breakaway arts movement, Secessionism.

Pallas Athene (1898) Courtesy of AKG London/Erich Lessing. (See p. 82)

PORTRAIT OF THE PIANIST AND PIANO TEACHER, JOSEF PEMBAUR (1890)

Courtesy of Tiroler Landesmuseum, Innsbruck

HIS distinctive portrait, within an exquisitely gold-painted wooden frame is a powerful demonstration of Klimt's developing style. The work merges the sharp realism of a photographic-quality portrait, with its stunningly life-like face, against a dramatic, beautifully decorated background. Like a collage, this startling combination of idealism and realism is a technique that was to surface later in Klimt's portraits of beautiful Viennese women.

Much is written about the indecipherability of Klimt's highly personal symbolism, yet these formative years reveal illuminating esoteric influences. Several European secret orders surfaced in this period to celebrate mysterious rituals and advance ancient spiritual beliefs. These included the Pembaur society, which met in Vienna's Löwenbräu tavern every Thursday; it was a group of up-and-coming artists and actors, including Gustav and Ernst Klimt and their friend, Franz Matsch. It was named after the influential pianist, teacher and composer whose portrait Klimt painted for the meeting room. The society's ideals are unknown but the frame, with its interesting blend of symbolic Classical images, such as the ionic column, ancient golden lyre, and tripod, are representative of Neo-Platonic Apollo-Dionysian influences: nineteenth-century German philosopher Friedrich Nietzsche, a major influence on Klimt, saw art as a struggle between Dionysus, the creative, passionate 'superman', versus the critical rationality of Apollo.

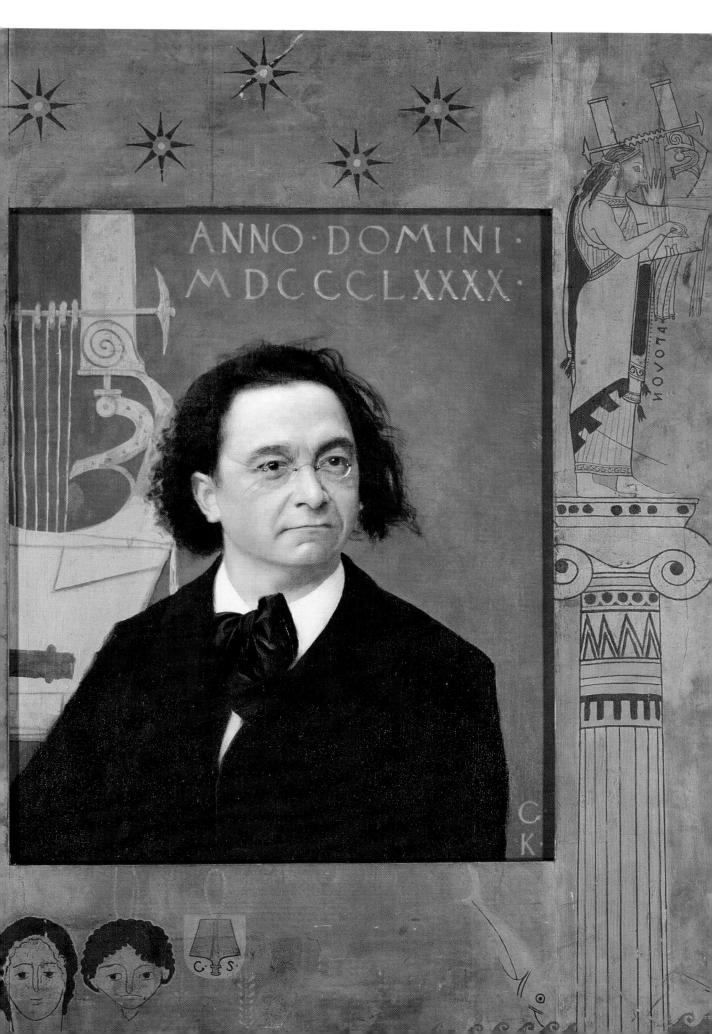

WATER SPRITES (1894)

Central Savings Bank. Courtesy of AKG London/Erich Lessing

HIS haunting picture is an important early precursor of Klimt's future controversial development with its Symbolist style and patterning; a style that recurred in the dress depicted in the 1902 portrait of his life-long companion, *Emilie Flöge*. These mysterious disembodied creatures float out of the creative ether, like dangerous sirens. The powerful upward sensation is produced by the

tapering tails of these sperm-like heads, and the mottled iridescent watery green background, possibly influenced by Aubrey Beardsley's (1872–98) subtly phallic illustrations, *Bon Mots*, exhibited in Paris in 1892 and published in 1893 to controversial acclaim.

European Symbolism at this time was engrossed in portraying the siren or Salomé temptress as artists explored profound philosophical concepts of flesh versus the spirit, and the dream world between body and mind. Fascination with exotic creatures encapsulated notions of the temptress becoming the priestess, with subsequent links to higher spiritual dimensions of essential truths. Over flowing hair imagery became a sexual symbol of fertility and rebirth.

This snapshot of future work at the height of the *Künstlercompagnie*'s success represents Klimt's dissatisfaction with Vienna's artworld, furthered by the death of his father in 1892 and the sudden death of beloved brother Ernst from

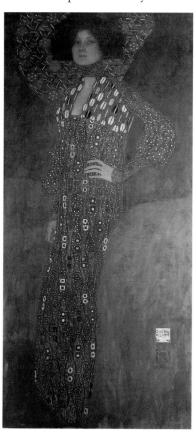

Emilie Flöge (1902) Historical Museum, Vienna. Courtesy of AKG London/Erich Lessing. (See p. 118)

pericarditis six months later. By the time of *Water Sprites*, Gustav was financially responsible for two families, as his brother had married Emilie Flöge's sister.

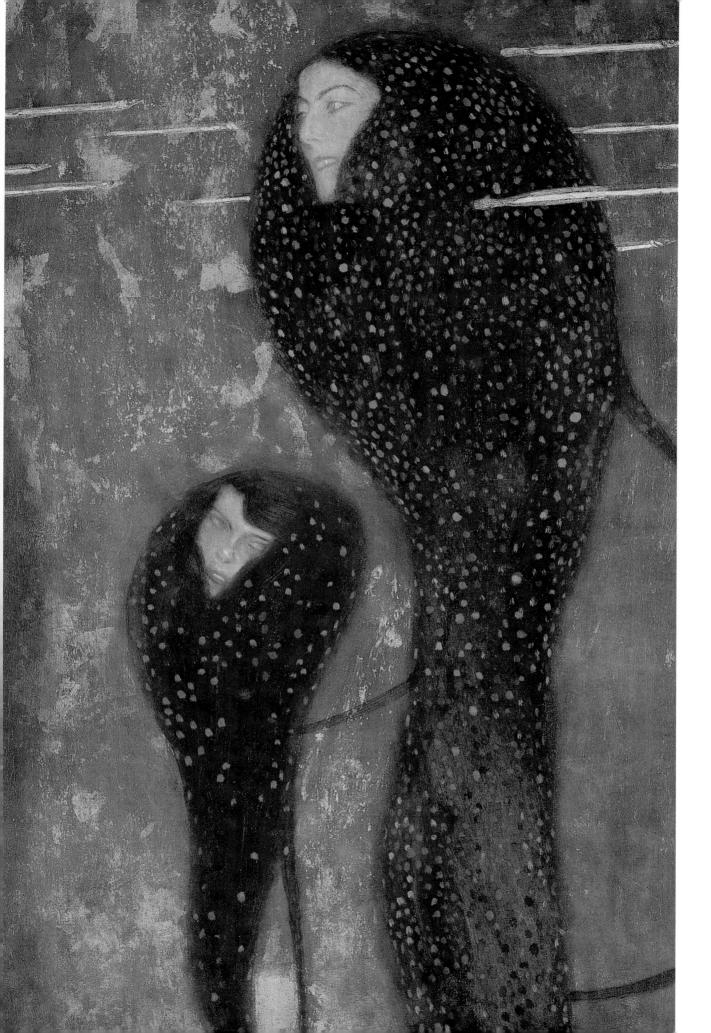

PORTRAIT OF A LADY (1894)

Historical Museum, Vienna. Courtesy of AKG London/Erich Lessing

HE fusion of photographic realism and decoration continues apace with this work, one of Klimt's earliest known female portraits. Such commissions inevitably provided useful income and, after the University debacle in the early 1900's, portraiture of loyal clients undoubtedly helped to bolster Klimt's loss of earnings from official contracts.

After his brother's death in 1892, Klimt's output was said to be affected, and work was notably sparse during this period. However, the celebrated *Künstlercompagnie* had an accumulated backlog of historical commissions which he was probably working through. Little is known about this sitter; she was possibly a family friend, though it is believed that Klimt often liked to work from photographs to capture a convincing likeness. Some critics believe it is of a Mrs Heymann; though fascinating facial similarities with Klimt's 1898 portrait of Sonja Knips have been discerned – suggesting this could possibly be of her mother, the wife of an Imperial Army brigadier.

Although painted four years after the Pembaur work the comparisons are obvious, such as the use of the red background, though more muted here, and Klimt's distinctive decorative gold

flowering. The work, oil on wood, is not very large at 39 cm x 23 cm (15.5 in x 9 in), but was encased in a large wooden frame, decorated with a series of heavy, parallel lines.

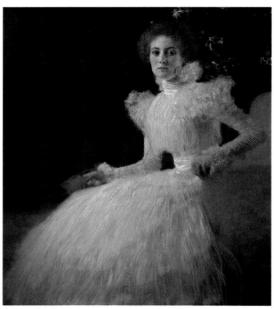

Sonja Knips (1898) Osterreichische Galerie Belvedere, Vienna. Courtesy of AKG London/Erich Lessing. (See p. 70)

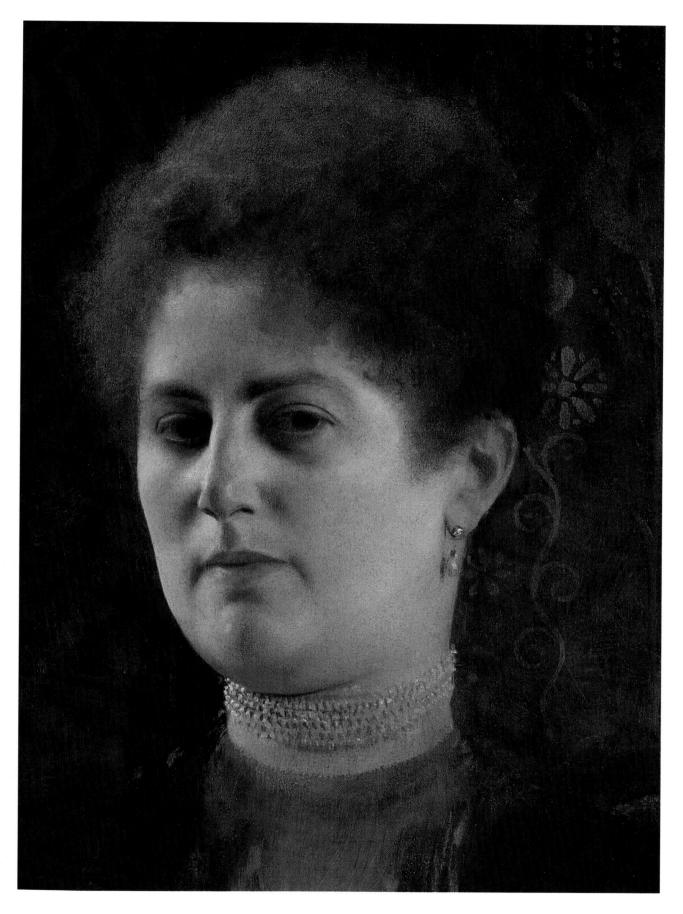

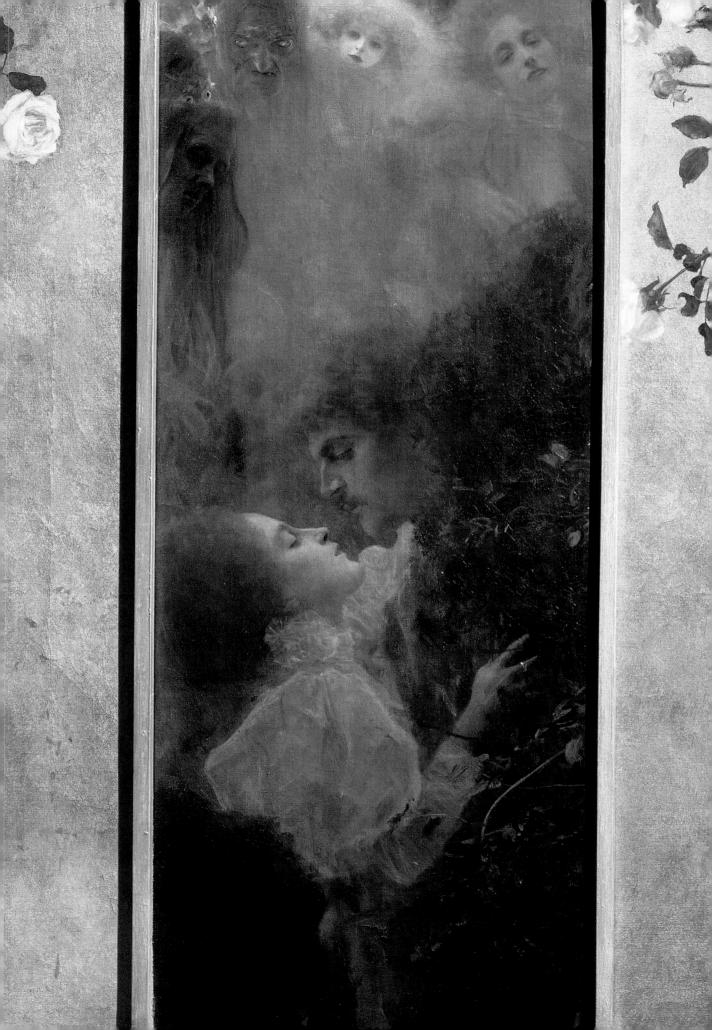

LOVE (1895)

Historical Museum, Vienna. Courtesy of AKG London/Erich Lessing

HE amazing success of the first Allegories and Emblems series led to a second series in which Klimt produced Sculpture, Tragedy and, shown here, Love. Painted in oil on canvas, the work is another milestone in Klimt's developing fascination with Jugendstil, the burgeoning German equivalent of the Art Nouveau movement. This sugary romanticised work is an interestingly kitsch forerunner to Klimt's most famous piece, The Kiss (1907), though here the couple are entwined at the moment before embrace.

The dark pervasive moodiness of *Love* is reminiscent of the style employed by German romanticist, Caspar David Friedrich (1774–1840), whose early nineteenth-century work is viewed as a symbolic dedication to light. In *Love*, the light, emanating from the highly significant hazy

virgin whiteness of the young girl, moves spiritually upwards to a celestial mixed tableaux of angelic and disturbingly ghoulish harridan faces. This is love mixed with gothic-like horror. The bold white columns framing the inner pictorial panel enhance this upward movement of light, whereas the burnished-gold surround, continues to evolve as Klimt's favourite symbol for transcendent love - a concept of ultimate spiritual union beyond carnality and flesh. Here, it is coupled with the traditional medieval image for love - a rose - though its briar thorns ensnare the man within the central panel.

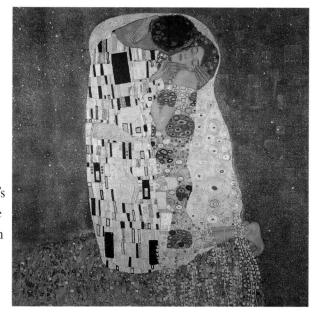

The Kiss (1907) Osterreichische Galerie Belvedere, Vienna. Courtesy of AKG London. (See p. 191)

BURGTHEATER ACTOR JOSEF LEWINSKY AS CARLOS (1895)

Courtesy of Osterreichische Galerie Belvedere, Vienna

LIMT'S continued association with the theatre – through interior decorative work and his regular links with the arts community, as a result of the Pembaur society – is at work in this picture. Painted in oil on canvas, *Burgtheater Actor Josef Lewinsky as Carlos* is undoubtedly indebted to *Love* (1895), his previous *Allegories and Emblem* commission, with its ornate silver decorative surround and continued use of organic motifs, this time embossed in gold. The Greek tripod, possibly the Pembaur society insignia, as it can be seen in the 1890 Pembaur portrait, is inscribed on the bottom right of the decorative surround.

Again, Klimt plays with his recurrent image of upward-floating, vaporised light, this time representing a symbolic creative life-force, out of which masked concepts of comedy and tragedy are born. This represents theatre's ancient Dionysian ancestry, as Greek classical theatre developed from the rituals of Dionysus' followers, and their autumnal and spring celebrations of death and resurrection. The vine-of-life

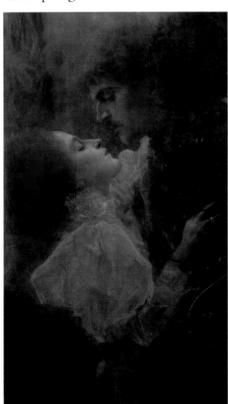

imagery, strongly associated with Dionysus, is emblematic of these resurrection beliefs and is possibly represented here by the frame's golden tendrils.

The painting, commissioned by the Society of Reprographic Art, features Lewinksy, an actor from the Burgtheater and possible Pembaur society member, dressed for a performance as 'Carlos' from Johane Wolfgang Goethe's (1746–1832) *Clavigo*.

Love (1895) Historical Museum, Vienna. Courtesy of AKG London/Erich Lessing. (See p. 49)

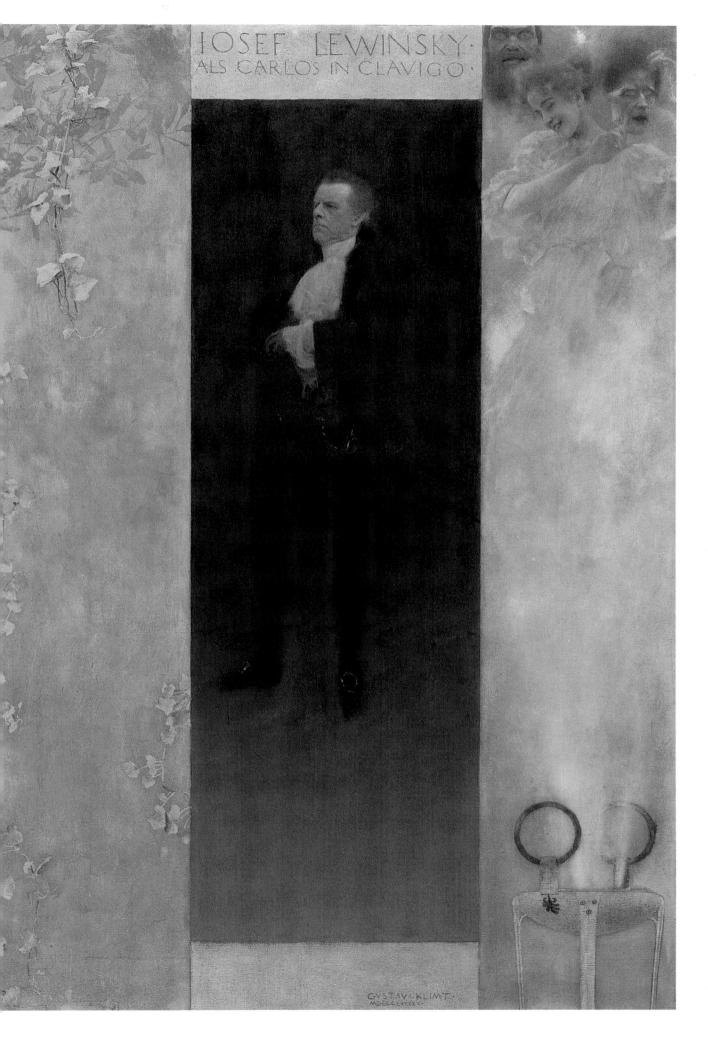

Music I (1895)

Neue Pinakothek, Munich. Courtesy of AKG London/Erich Lessing.

HIS vibrant work is a feast of ancient imagery as Klimt refines his personal artistic vocabulary. A deep sense of rich sound and harmony emanates from this luxurious painting with its electrifying turquoise background and gold leaf embossing. The work is believed to be one of two oil studies Klimt submitted to help secure a contract with Franz Matsch for the spectacular decoration of the Palais Dumba, a wealthy industrialist's residence on the distinguished Ringstrasse. The two artists decorated the music room and dining room, but Schubert at the Piano (1899) is the only other remaining example of their Palais enterprise. Although only a study, the detail in Music I and the use of costly materials demonstrates Klimt's deep sense of commitment to business prospects; this was an artist who grounded artistic idealism with sound commercial judgement.

Again, we see his now-favourite esoteric device, the Classical Apollo-Dionysian lyre, as the central image of music. The music is given physicality as it flows forth, like a life-force, in bulbous golden swirls from the strings. Two stone images guard either side of the picture; the right-hand image is identifiable as a stone sphinx, an example of Klimt's increasing adaptation of popular Symbolist imagery.

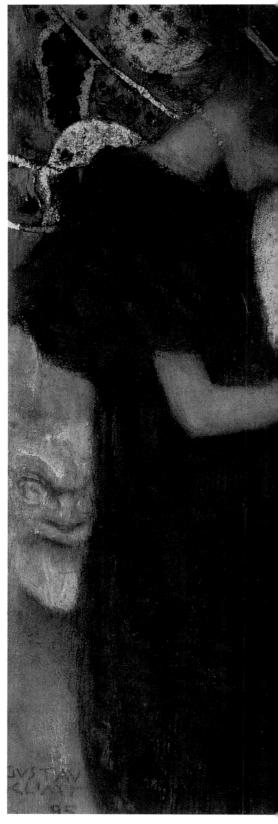

Design for Allegory 'Junius' (1896)

Historical Museum, Vienna. Courtesy of Artothek

LIMT'S WORK continued to gain momentum after the period of shock and probable lack of creativity following the deaths of both his father and brother Ernst in 1892. The third volume of *Allegories and Emblems*, which commenced his career back in 1883 with *Fable*, demanded more time, and after completing *Love* (1895) he submitted this design as the allegory of *Junius* for the month of June. The close-up of this beautiful face is an interesting echo of his previous work, *Music I* (1895), with the distinctive nose profile, chin and cheekbone structure. Interestingly, it relates to a later sketch of the same year entitled, *Portrait of a Young Woman*, which also has remarkable facial similarities to the 1898 portrait of Ernst's young daughter, Helene Klimt, who was now Klimt's ward and seemingly an important influence on his work.

Once again, delicate gold leaf is used to enhance the closely cropped image and highlight the recurring floral motif in the background. Tightly set in the central square, the work conveys innocence balanced by elegance. The unfinished surrounding frame completes the dense organic theme, with its rich clusters of fruit and heavy blooms, reminiscent of the *Idyll* submission to the series 12 years earlier in 1884. The illustration is typical of many contemporary bookplates of

the period and reveals the changes in Klimt's style along with his unfolding involvement with the *Jugendstil* movement.

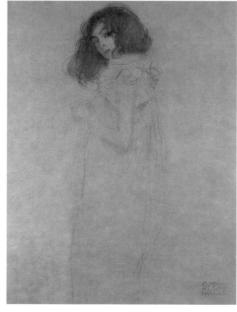

Portrait of a Young Woman (1896–97) Courtesy of The Bridgeman Art Library. (See p. 58)

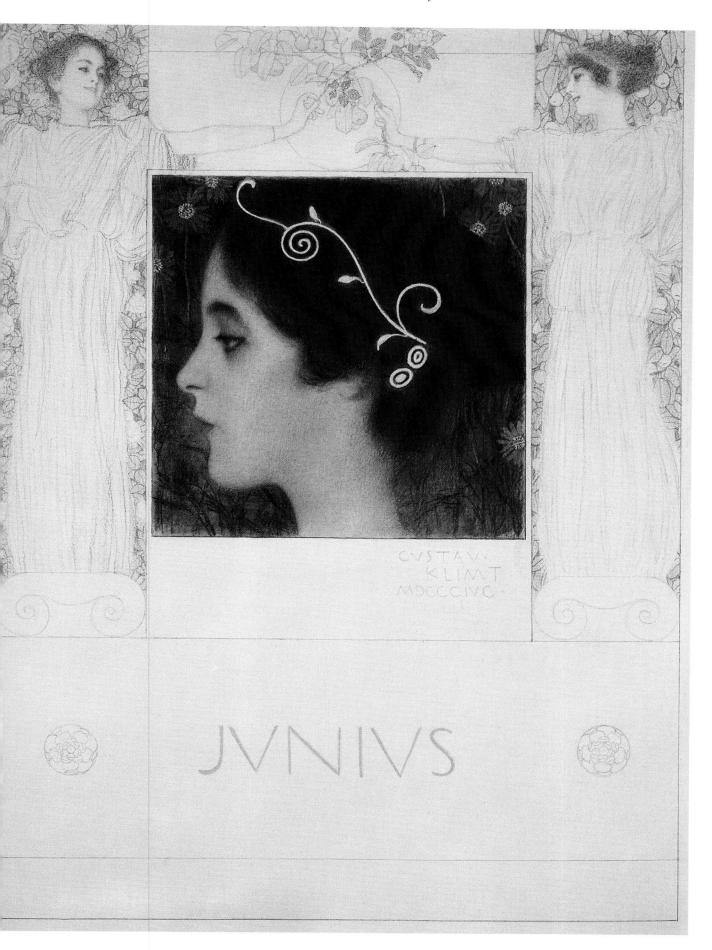

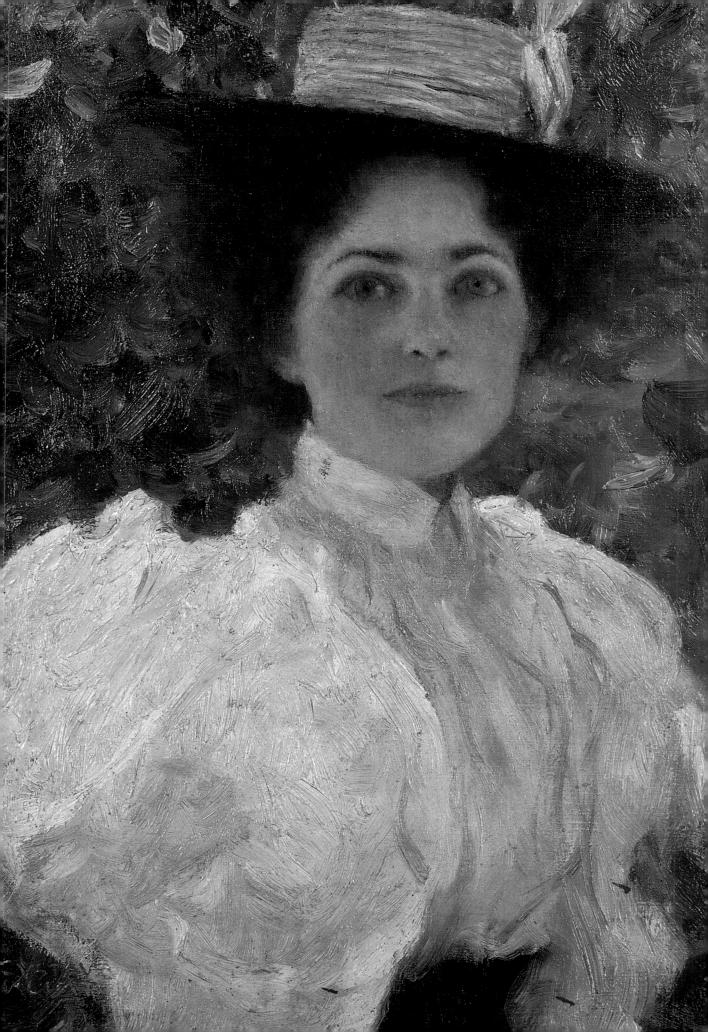

Woman in Green (1896)

Courtesy of Galerie Welz, Salzburg

NLIKE Klimt's contemporary style and his approaching artistic development, this painting is an interesting flirtation with Impressionism. It recalls the heavy brushwork of Paul Cézanne (1839–1906) but could also be influenced by the softer approach of Auguste Renoir (1841–1919). Klimt probably encountered their work through exhibitions and journals, though he ultimately rejected Impressionism's bonds with Realism in favour of the idealist temperament of Symbolism.

Here, Klimt plays with Impressionist methods of depicting light and the exchange of coloured reflections, attempting to create a sensation of unity. Using the movement's characteristic choppy paint strokes, Klimt strives to instill effects of shimmering light, particularly on the blouse and in the lighter green by the side of the face. Impressionism's blurring of outline to capture a sensation of form was often achieved at the expense of solidity and structure, and Klimt's result certainly appears unsatisfactory and clumsy. For instance, the illusion of foliage across the girl's blouse at the shoulder is awkward and ineffective.

This lesson in Impressionism is informative as it underscores Klimt's ultimate preference for gold and jewels to create sensations of shimmering light over the methods favoured by the Impressionists. However, he later assimilated the brighter prismatic colours of

Impressionism within the magnificent mid-1900's 'Golden Period' or in personal landscape works such as *Upper Austrian* Farmhouse (1911–12).

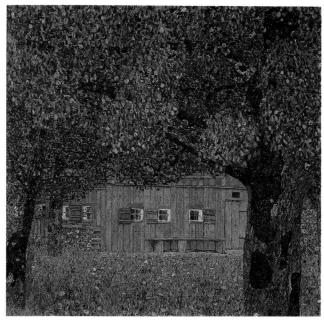

Upper Austrian Farmhouse (1911-12) Courtesy of AKG London/Erich Lessing. (See p. 206)

PORTRAIT OF A YOUNG WOMAN (1896–97)

Private Collection. Courtesy of The Bridgeman Art Library

HIS sketch's similarities to the facial characteristics of Helene Klimt's portrait of 1898) and the illustration *Junius* (1896), are fascinating. At the time of the 1898 portrait Helene was six and so would have been aged four here. As a result, the provocative gaze in this drawing, with its model's rumpled hair, probably precludes it being a composition of the child. So perhaps the face here, and in the *Junius* illustration, is of her mother, who was widowed at just 21 when Gustav's brother, Ernst, died in 1892, leaving her with baby Helene, not yet a year old. Gustav became her guardian and doted on her.

His association with both his widowed sister-in-law and her beautiful sister, Emilie, continued for the rest of their lives; Emilie became Klimt's companion and lover, though they were never married. The face in this sketch could, of course, be Emilie's; she would have

been 22 in 1896. For comparison's sake, Klimt's only known work of her is a 1902 portrait where the face is more sophisticated. However, the 1902 ornamentation impedes effective comparison. Although loosely sketched, this drawing's light pencil strokes and shading capture a sensation of movement and inquisitive surprise.

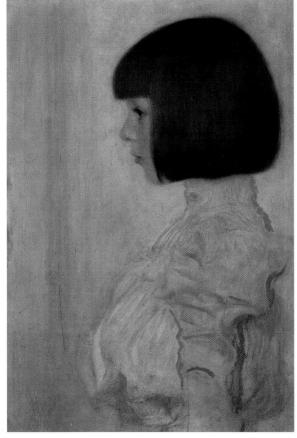

Helene Klimt (1898) Courtesy of Osterreichische Galerie Belvedere, Vienna. (See p. 66)

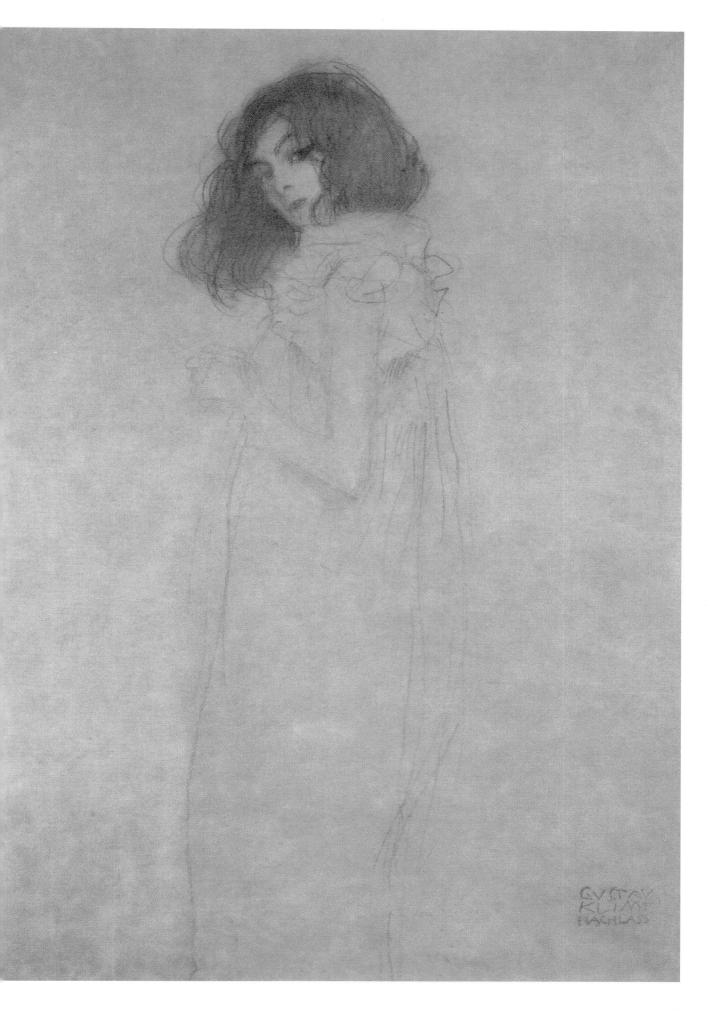

SCULPTURE ALLEGORY (1896)

Courtesy of Galerie Welz, Salzburg

HIS drawing, with *Tragedy* (1897), are final contributions to the highly successful *Allegories and Emblems* series, a commission that lasted an incredible 16 years. Again Klimt uses this study to explore a 'life in death', 'modern borne out of old' theme as the lyrical nude poses against an antique sculptured head and wall. The contemporary facial features, fertile flowing hair, and modern body stance are juxtaposed against the Classical backdrop, suggesting she has emerged alive from the stonework. This invokes the Pygmalion 'mythology, as in the 1890–91 *Greek Antiquity* Kunsthistorisches Museum frescoes; yet, the apple also suggests biblical imagery of the first woman, Eve.

This reanimation of the nude with a modern image deliberately signifies the modernisation of allegory and art, one of the publishing series' original themes. In the final 1898 plate, the contemporary aspects of the nude are moderated as the body stance readopts Classical attributes.

Yet here, despite the flattened dimensions, the female figure is more voluptuous and real compared to the final work's pale skin colouring and loss of animation. Instead, Klimt employs a greater sense of spatial depth in the final work to express these dimensions of reality, and notions of artistic freedom and creativity.

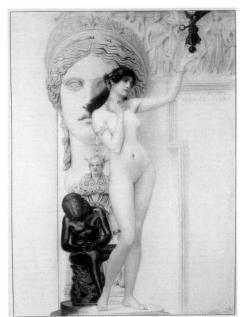

Detail from Allegory of Sculpture (1898) Courtesy of Galerie Welz, Salzburg. (See p. 69)

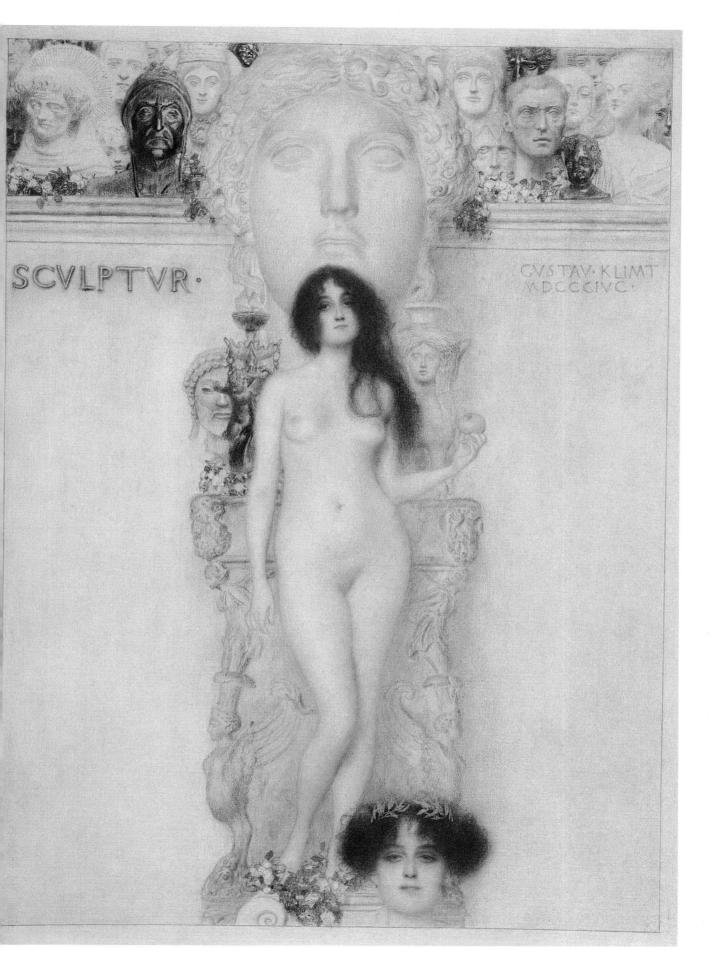

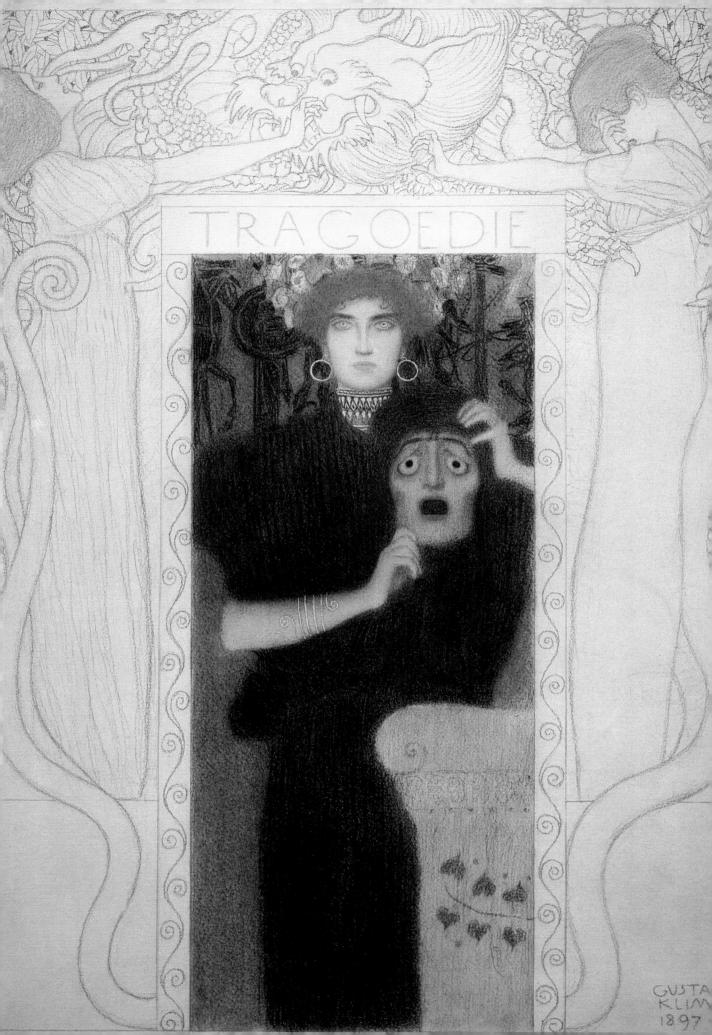

TRAGEDY (1897)

Historical Museum, Vienna. Courtesy of AKG London/Erich Lessing

HE development of the femme fatale paradox continues in *Tragedy* – the last of the *Allegories and Emblems* series – as does an interest in mythological imagery from earlier theatre commissions. Like *Junius* (1896), this final study is in black crayon, pencil and wash, intensified with gold and white paint, and features the continued spiralling organism, strongly associated with the Germanic Art Nouveau movement, which became known as *Jugendstil*.

The classical imagery of *Tragedy*, with its mask of horror, is superbly personified by the Pre-Raphaelite feminizing influence of *Jugendstil* to explore the paradox of beauty in ugliness. It is a thematic development of the more romanticised depiction of tragedy in *Burgtheater Actor Josef Lewinsky as Carlos* (1895). It is also an indication of Klimt's greater commitment to Symbolist aesthetics and the quest to transcend beyond materialism in the mind to the realm of the sublime. Here, we see an organic decoration of this 'truth to nature' movement entwine itself around the border as the rapacious tendrils sprout from the flat central panel to become ensnaring female figures who then fight an oriental dragon, centred significantly at the top of the frame. This is the first depiction of Klimt's lifelong interest in Japanese art.

Burgtheater Actor Josef Lewinsky as Carlos (1895) Courtesy of Osterreichische Galerie Belvedere, Vienna. (See p. 50)

Woman by the Fireside (1897–98)

Courtesy of Osterreichische Galerie Belvedere, Vienna

S in Woman in Green (1896), Klimt plays here with Impressionism, despite his ultimate preference for Symbolism and the Art Nouveau-inspired Jugendstil movement. However, in this work, Klimt is interested in the Impressionists' advances concerning the play of light and the discovery that shadows are not brown or black but coloured by surroundings. He appears to be playing with this analysis by studying the dramatic light effects of a fire but also attempting to maintain a black-and-brown palette in some respect. The resulting heavy blocks of darkened colour, centralised in the composition, make this a sombre, difficult work, which, like Woman in Green, lacks solidity of form. The spontaneity associated with Impressionist work does not seem to suit Klimt's more deliberate and detailed methodology.

However, the scientific techniques of Georges Seurat's (1859–91) Divisionism or Pointillism fascinated Klimt, and the blending of its effects with his decorative style opened up a new aesthetic world in his landscape work, as in *Beech Forest* (1903) where he

created the necessary clearer tonal structure, missing from this picture.

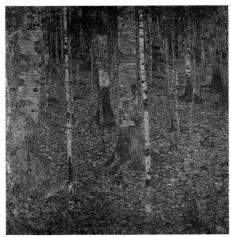

Beech Forest (1903)
Osterreichische Galerie
Belvedere, Vienna. Courtesy of
AKG London/Erich Lessing.
(See p. 148)

HELENE KLIMT (1898)

Courtesy of Osterreichische Galerie Belvedere, Vienna

HIS is Klimt's first Impressionist-style portrait in which the balance of light works effectively. Reminiscent of John Singer Sargent's (1856–1925) work, Klimt loads whites upon creams to create greater tonal depth, thereby lifting the sitter's presence, as seen in the play of shadows on the blouse against the paler background. This

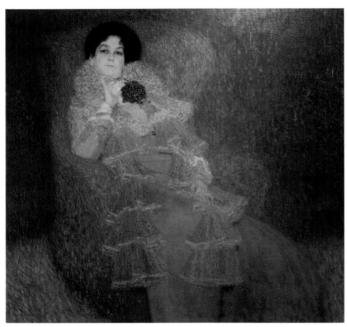

Marie Henneburg (1901–02) Courtesy of AKG London/Erich Lessing. (See p. 117)

working of a white palette is further developed in later portrait work, such as *Marie Henneburg* (1901–02), wherein a combination of Pointillism and Impressionist tonal framework, in the colours of the chair and the white of the dress, generates impressions of depth, structure and shape.

A superb tension is generated by the contrasting use of white against the vibrant density of the dark hair. Each strand is almost visible due to precise brushwork and control of light, which enhances the portrait's overall intensity. This

simple, yet highly effective, contrasting and layering of colour creates a beautiful impression of innocent poise balanced by the inherent vitality of childhood, a refinement of artistic tensions first intimated in Klimt's early student-life studies. Klimt was made Helene's guardian after her father Ernst died when she was a baby. He adored the beautiful child, and helped with her upbringing.

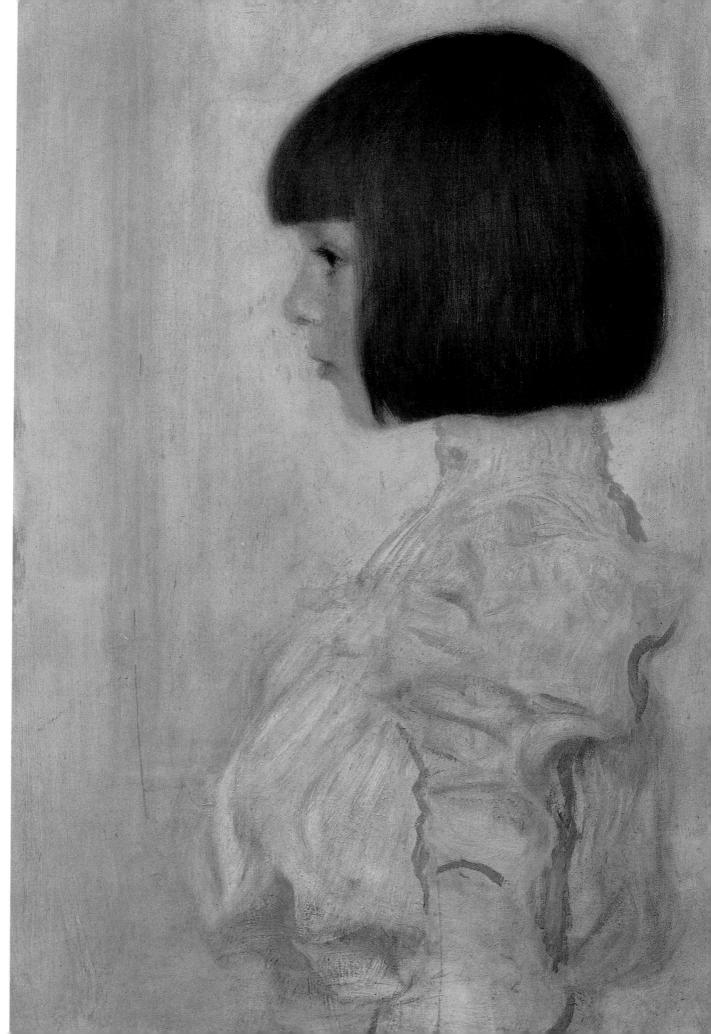

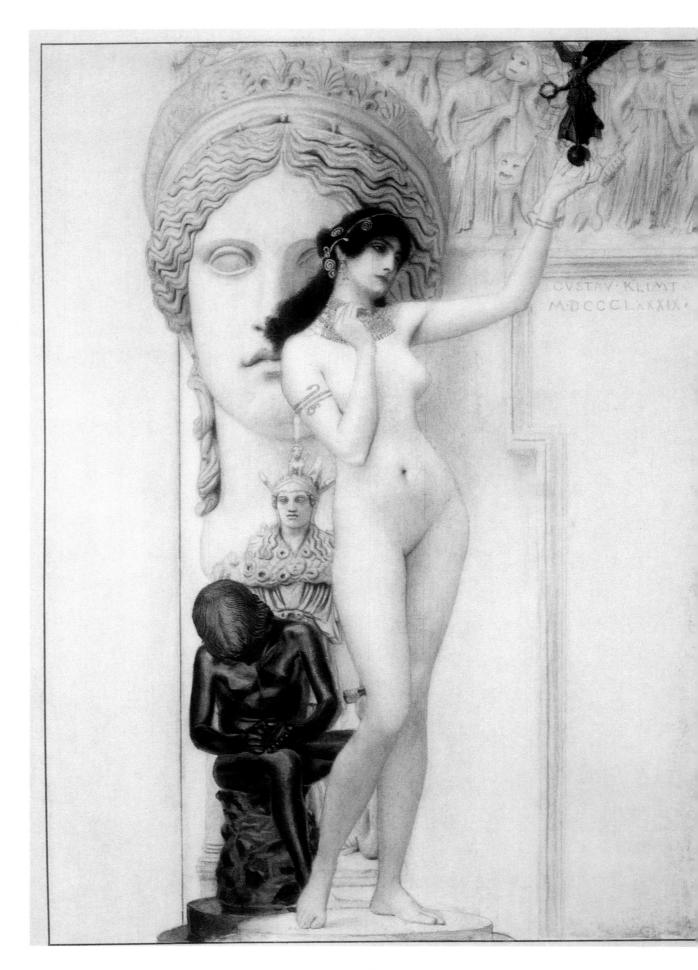

Allegory of Sculpture (1898)

Courtesy of Galerie Welz, Salzburg

T is incredible that Klimt could still muster key components of his highly successful historicism style 16 years after starting this commission, but he was well able to do so, as can be seen in the finalised submission, *Allegory of Sculpture* for the *Allegories and Emblems* series. Continuity is achieved by his repetition of characteristics, such as gold embellishment and the face from *Junius* 1896.

This work symbolises superbly the division between Klimt's old and controversial new styles, soon to pitch him against the orthodox commissioning authorities. Like the antique stone head depicted, the Viennese establishment looked backwards while the delicate nude, just breaking into life, faces the future holding a bronze of Winged Victory.

Unlike the flat perspective of *Julius*, Klimt employs better spatial depth to express notions of reality and artistic freedom in *Sculpture*. Using watercolours, the nude here is less animated but is beautifully lifted into perspective from the greyness of the stone backdrop by the infusion of a slightly pinker skin tone. This is a wonderful evocation of the Pygmalion myth, as the plate's sculpture is brought to life through colour contrast. The subtle tonal graduation is also highlighted by three bronze features: the seated figure, the nude's darkened hair and the Winged Victory statue, which establish a strong diagonal visual line across the composition.

Detail from Design for Allegory 'Junius' (1896) Historical Museum, Vienna. Courtesy of Artothek. (See p. 54)

SONJA KNIPS (1898)

Osterreichische Galerie Belvedere, Vienna. Courtesy of AKG London/Erich Lessing

LIMT'S solid reputation with the elite and his charismatic, sensuous personality had a potent effect on Vienna's beautiful young women, who were willing to pay handsomely to commission him as their portraitist. Possibly influenced by Sargent's large, rich, glossy portraits, and definitely by James Abbott McNeill Whistler's (1834–1903) strong tonal and geometric structures, this work reveals characteristics of both. The depth of the textured black background is reminiscent of Whistler's *Noctumes*, and of Japanese decorative techniques, which inspired Whistler, and Klimt later explored in depth. The canvas squaring technique, at 145 cm x 145 cm, (57 in x 57 in) is another Whistler and Japanese influence; Klimt applies its effects more powerfully in his later landscape work, probably to intimate notions of aesthetic balance and harmony.

In *Sonja Knips*, the sharp relief of the translucent creamy whiteness of the dress, juxtaposed against the darkness, gives the sitter an aura of graceful fragility, but with an underlying strength of character. This static balance creates an odd sense of composed authority, enhanced by the sitter leaning forward and looking down on the viewer. The daughter of an Imperial Army brigadier and the wife of a leading industrialist, Sonja Knips was a Secession patron and long-term customer of Emilie Flöge's fashion house.

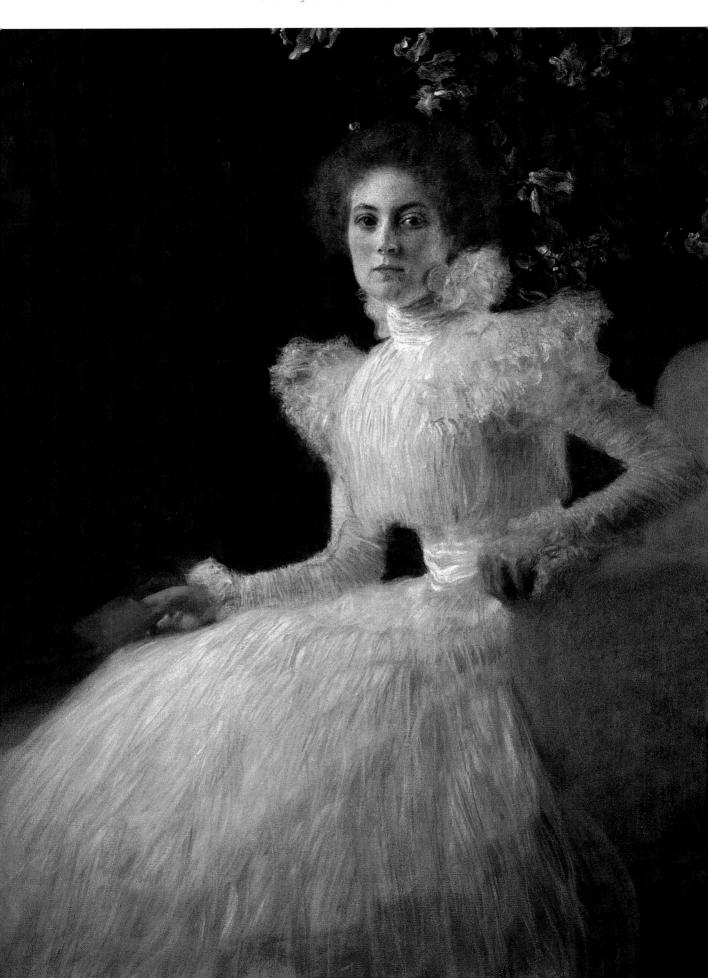

VER SACRUM POSTER (1898) (BEFORE CENSORSHIP)

Historical Museum, Vienna. Courtesy of AKG London/Erich Lessing

CLIMT'S disenchantment with the art establishment crescendoed with his spearheading a dissident breakaway movement, the 'Secession', from the autocratic but parochial exhibiting body, Künstlerhaus. Membership to the latter had previously been essential as the conservative Künstlerhaus owned Vienna's only exhibition building, and so controlled members' sales, access to the public and access to foreign art. Klimt made a hopeless attempt at reform in 1897, which

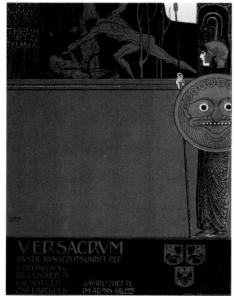

Ver Sacrum poster (1898)
(after censorship)
Historical Museum, Vienna. Courtesy of The
Bridgeman Art Library. (See p. 75)

ended with his censure and subsequent walkingout, with eight other members, in silent protest. Inspired by *Jugendstil*, the Secessionists, with Klimt as first president, then rocked Vienna with their own daring retort exhibition, advertised in a Klimt-designed poster, seen here in two forms; before and after censorship.

As little is known about Klimt, the whole episode is crucially illustrative of his self-belief, determination and respected charismatic leadership. This intrinsic strength of conviction is forcefully expressed in the stunning poster, undoubtedly influenced by Aubrey Beardsley illustrations, with its fluid upward movements, dynamically checked by the horizontal classical frieze. Theseus's wrestle with the Minotaur was an obvious representation of the Secessionists' battle with the Künstlerhaus committee, though the authorities were still enough in control to censor the nude's genitalia.

Klimt then cleverly incorporated Beardsleyesque sexual inferences across the offending parts.

The exhibition was a huge success: 57,000 visitors, including the Emperor, came to see Europe's finest *avant-garde* works such as pieces by Auguste Rodin (1840–1917), Belgian symbolist, Fernand Khnopff (1858–1926), Whistler and Singer Sargent.

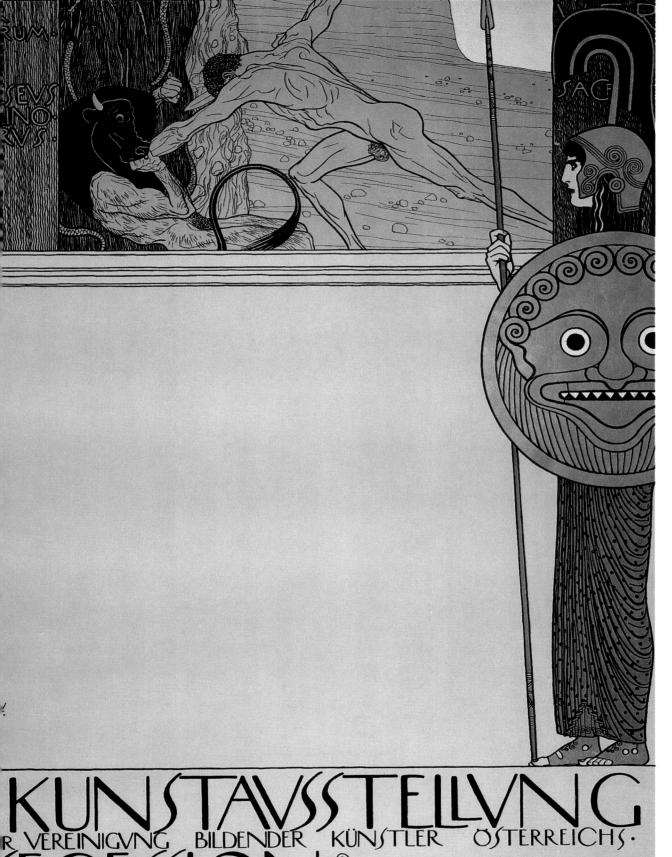

R VEREINIGUNG BILDENDER KÜNSTLER ÖSTERREICHS.

ECESSON BERÖFFNUNG: ENDE MÄRZ
SCHILVSS: MITTE JUNIPARCRING: 12: CARTENBAUGESEILSCHAFT.
EBÄUDE DER K.K. GARTENBAUGESEILSCHAFT.

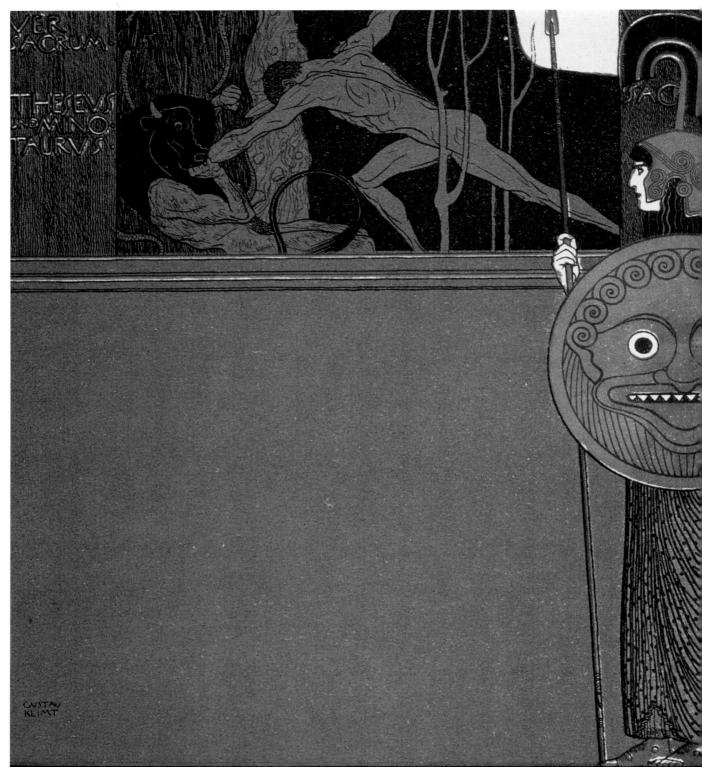

VERSACRVM NEVSTR. KVNSTZEITSCHRIFT DER VEREINIGVNG BILDENDERG KVENSTLER JÄHRLIZHEFTE OSTERREICHS IM ARONN 66-10-05

VERLAG V. GERLAGI V. SUITE

VER SACRUM POSTER (1898) (AFTER CENSORSHIP)

Historical Museum, Vienna. Courtesy of The Bridgeman Art Library

HE weight of Klimt's Classical training was still a major inspiration for him in the early days of Secessionism. However, even in this exhibition poster, revised to satisfy the authorities, who were desperate to find fault, Classicism is superbly merged with elements of Art Nouveau to sound a definitive break from his earlier historicism. Here, Klimt strengthens aspects of the first design, underscoring the Theseus frieze with a gold rim, but darkening

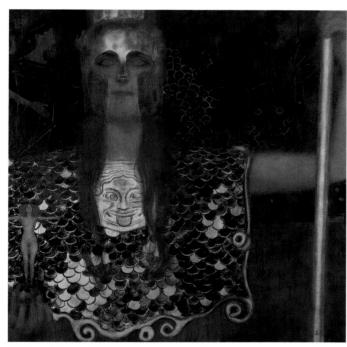

Pallas Athene (1898) Historical Museum, Vienna. Courtesy of AKG London/Erich Lessing. (See p. 82)

the background to emphasise the newly incorporated, sexually implicit upward spears of the bush. Pallas Athene. goddess of war and wisdom and the patroness of arts and crafts, was designated as being the Secessionists' iconic protector. Here the Medusa's face on the shield confronts the viewer boldly. In a later 1898 work, Pallas Athene, the Medusa face is more rudely animated. The Latin script, Ver Sacrum, means 'Sacred Spring', chosen to represent the group's new artistic lifeforce, and recalls the Pembaur society's supposed mystic tripod insignia, with its

ascending Apollo-Dionysian water-vapour imagery. *Ver Sacrum* became the title of the movement's accompanying publication, but the group had no clearly defined manifesto other than to provide young, *avant-garde* artists with an opportunity to exhibit – they achieved this by building their own exhibition hall – and to introduce exciting new foreign artistic work to Vienna.

Water in Motion (1898)

Osterreichische Galerie Belvedere, Vienna. Courtesy of AKG London/Erich Lessing

LIMT'S new-found freedom from traditional aesthetic boundaries is beautifully shown in this fabulous visual outpouring of creativity. These stunning figures flow as personified forms of moving water. Their erotically charged, explicit bodies shape and course through the force of the stream, their flowing hair, a symbol of fertility and rebirth, becoming one with the current. This work is an amalgamation of some of Klimt's highly personal symbolism, becoming another critical milestone in pinpointing his future development.

From this eternal moving flux the female personification of creative energy is born. The work explores the nature of desire and sexual creativity as pre-cursors of this fundamental life-force, and again reinterprets the Symbolist fascination for the siren motif as temptress as well as priestess, the female initiator to the transcendent realms of idealism and essential truth.

A lyrical musical quality about the work recalls the bizarre *Water Sprites* (1894), and *Love* (1895), in which Klimt plays with a ghostly vapour light rising from the female figure. Here the watery light is cast on the female forms, lifting them eerily out of the dark fast-flowing water. A monster-like creature gazes up from the depths at the beautiful shapes, conceptualising notions of ugliness in beauty previously established in *Love*.

NUDA VERITAS (NAKED TRUTH) (1898)

Courtesy of Historical Museum, Vienna

IKE many artistic movements in Europe during this period the Secessionists produced their own monthly publication, *Ver Sacrum*, meaning 'Sacred Spring'. This beautiful, colour-plated periodical quickly became a collector's item, resulting in lavish fortnightly publications, featuring radical layouts, design and typography. Content included reproductions or photos of works from Austria and abroad, and illustrations of new poetry.

This illustration for the third edition of the journal translates as 'Truth is fire and telling the truth means shining and burning'. This,

combined with the personification of naked truth in the form of the nude holding a mirror, reveals an adherence to Platonic ideals as evinced in Plato's *Republic*. The symbolic mirror in the Platonic cave of ignorance reflects only indirect subjective knowledge of a world outside; whereas those outside in the true light have real objective knowledge. This concerns the totality of art, an aesthetic harmony that each facet – sculpture, architecture, furnishing – should be interrelated, a development of the philosophy of William Morris's British Arts and Crafts movement.

In *Nuda Veritas*, the white figure of Truth is partly set against a white backdrop filled with beautiful swirls of organic creativity and two flowers flank the figure in the black background. Conversely, in *Jealousy* (1898), Klimt powerfully reverses the black-and-white areas to emphasise the polarised negative emotion.

Jealousy (1898) Courtesy of Historical Museum, Vienna. (See p. 81)

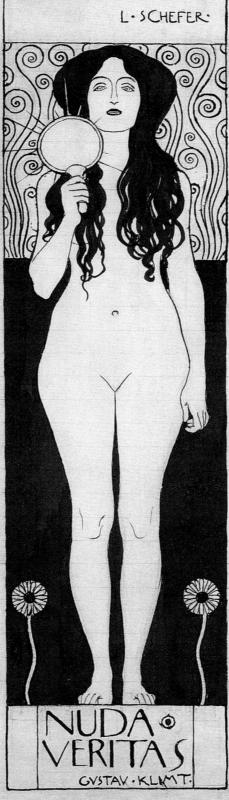

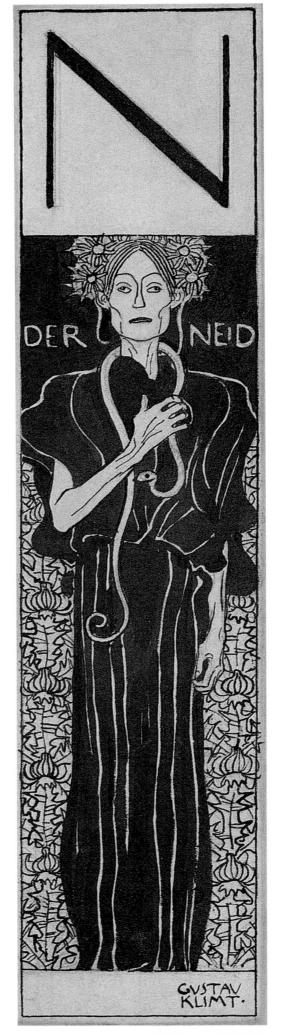

JEALOUSY (1898)

Courtesy of Historical Museum, Vienna

ERE, jealousy is seen as evil countermanding the influence of spiritual truth. Instead of naked truth's white purity, a black-draped figure stands ominously against a white, densely vegetated thorny section, reminiscent of *Love* (1895), and is topped by a black background with the reversed-out letters of 'Der Neid' – Jealousy. The biblical snake round the haridan's neck connotes knowledge; but this is no idealist truth from the Garden of Eden but carnal knowledge, represented by the poisonous thorns. The sense of oppression continues with the heavy, enlarged black-on-white 'N', capping the picture like a dead weight and truncating the head of the personified figure.

Printed opposite *Nuda Veritas* in *Ver Sacrum* in 1898, these illustrations express Secessionism's intents powerfully. Although there was no public manifesto of style, the editorial in the journal com-

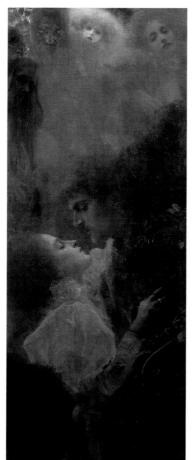

ments: 'We desire an art not enslaved to foreigners but at the same time without fear of hatred of the foreign ... We want to bring foreign art to Vienna ... to awaken the desire which lies dormant in the breast of every man for beauty and freedom of thought and feeling.'

Klimt's Nuda Veritas and Jealousy artistically identified this quest: with Nuda Veritas representing this statement of freedom and Jealousy representing the Viennese establishment's xenophobia.

Love (1895) Historical Museum, Vienna. Courtesy of AKG London/Erich Lessing. (See p. 49)

PALLAS ATHENE (1898)

Historical Museum, Vienna. Courtesy of AKG London/Erich Lessing

ALLAS ATHENE became the Secessionists' chief symbol of protection, inspired by a statue outside the Ringstrasse's Parliament building. Here Klimt's love of decoration is advanced with the pulsating gold on Athena's emblems of power, the burnished helmet, armour and spear. As well as being goddess of war and wisdom, Athena was patroness of arts and crafts – concepts that encapsulated the Secessionists' battle against authority for their new 'transcendental' art.

Critics enjoyed both the facial modernising of a traditional Neo-Classical image and the breast-plate's tongue-pointing Medusa, undoubtedly a gesticulation to opponents. The naked figure of victory, 'Nike', in the right hand, reveals another esoteric link, in its similarity to Piet Mondrian's (1872–1944) later female triptych, *Evolution* (1910), inspired by Theosophy iconography. This suggests Klimt's interest in this influential, turn-of-the-century spiritual movement, which was infiltrating world art and literature.

Pallas Athene's heavy gold-leaf also recalls William Blake's (1757–1827) highly symbolic poem, Jerusalem (1804–08), 'Bring me my spear of burning gold...,' influenced by Swedish mystic, Emanuel Swedenborg (1688–1722), whose ideals were absorbed by Theosophists and Europe's Symbolists. Gold also signifies Plato's mythical 'Golden Age' of perfection. Klimt's youngest brother Georg, a metalworker like his father, wrought Pallas Athene's armoured metal frame; he also created the dramatic bronze doors for the Secession's new exhibition hall.

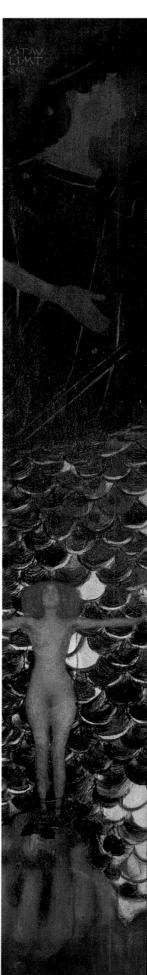

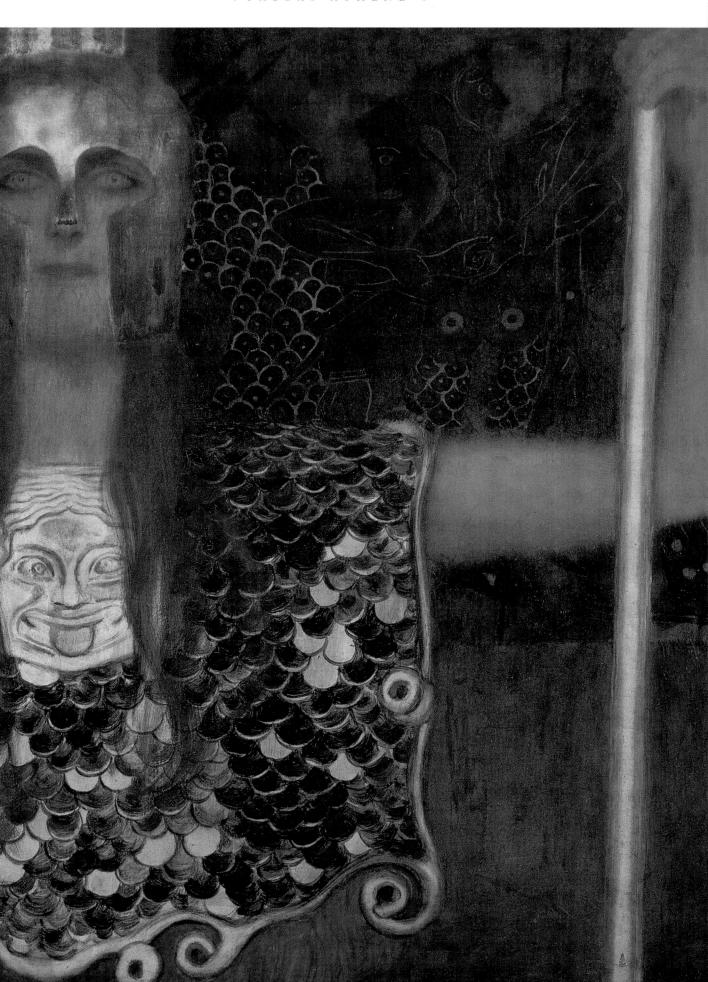

PORTRAIT (1898-99)

Osterreichische Galerie Belvedere, Vienna. Courtesy of AKG London/Erich Lessing

HE intensity of this Impressionist work, with its coarse brushwork, sits oddly with Klimt's contemporary high Symbolist aesthetic approach. As he plays with Impressionist light effects, notions of spatial depth are denied, stressing instead the painted surface. As in the *Portrait of Sonja Knips* (1898), the sitter stares eerily down at the viewer with an authoritative stance, but unlike Klimt's earlier attempts, such as the *Woman in Green* (1896), with its clumsy handling of light, this work achieves some tonal depth and a sensation of distinct form. This is mainly attained by the careful development of the red tonal palette and the blue-grey band of the hat, which separates and lifts the highlighted face from the darkened

background. As has been seen with earlier works, this portrait seems indebted to both Cézanne's and Whistler's techniques, with its subtle fusion of colours from a close tonal range.

The sitter for this dramatic work is not identified but the facial characteristics, notably the heavy eyebrows and downwardshaped eyes, are similar to those of Serena Lederer, whose portrait Klimt executed the following year. The Lederers, industrialist members of the wealthy bourgeoisie, became Klimt's most important patrons, collecting much of his most memorable work.

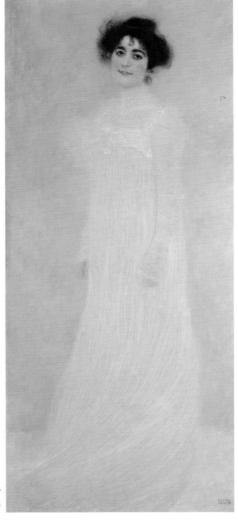

Serena Lederer (1899) Metropolitan Museum, New York. Courtesy of Artothek. (See p. 87)

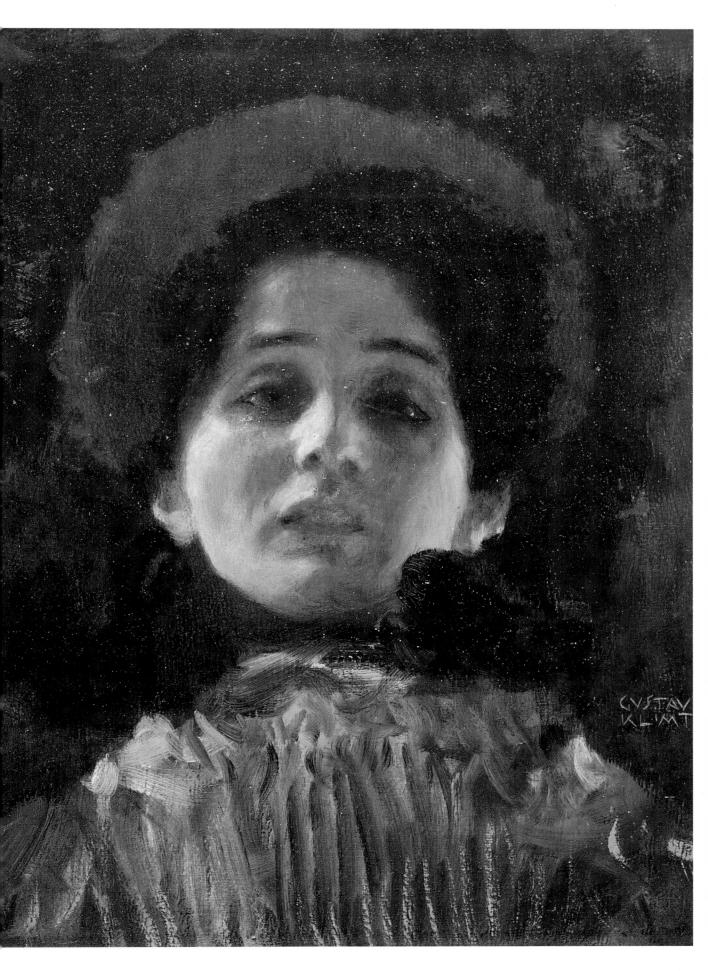

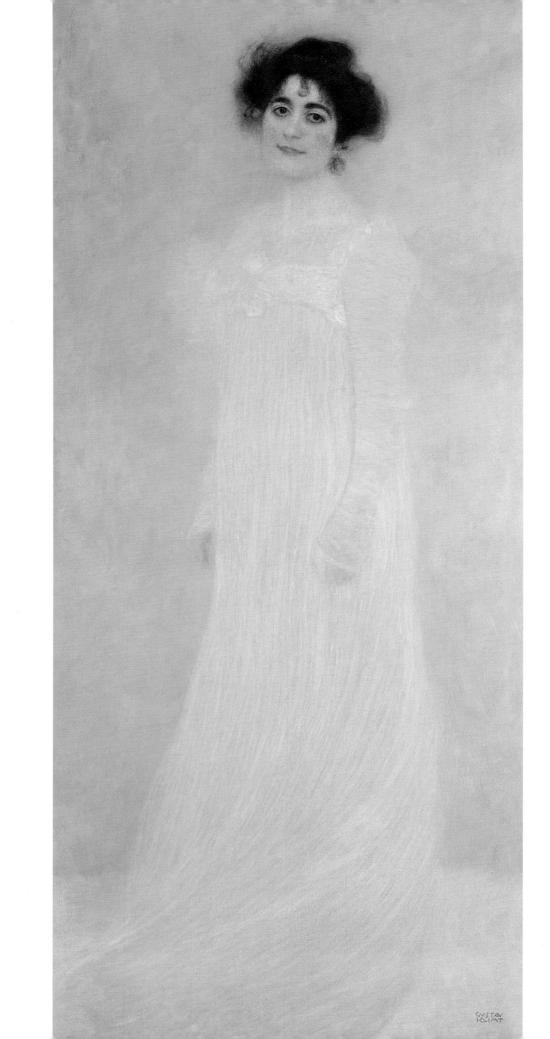

SERENA LEDERER (1899)

Metropolitan Museum, New York. Courtesy of Dr Brandstätter-Artothek

HIS simple, full-length portrait, with its delicate manipulation of white on cream, is again indebted to Singer Sargent's work, examples of which had been shown at Secession's exhibition. It also recalls *Helene Klimt* (1898), in the way that a superb polarised tension is generated by the contrasting white against the hair's vibrant density of colour, and the textured layering of tones from the white palette. There is a subsequent light, flimsy, almost floating aura about the work, now in the Metropolitan Museum, New York, which is possibly at odds with the immense scale of the painting.

At 188 cm x 83 cm (73 in x 33 in), the portrait is slightly bigger than life-size as Klimt returns significantly to techniques he learned during his early large-scale decorative fresco work. Here, the simple restrained background serves as a foil to the figure's dress, as in the *Helene Klimt Portrait*. However in his later, highly complex mid-1900's

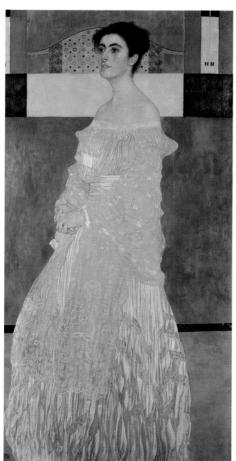

works, Klimt was to change his style: fixing the sitters superbly in similar life-size portraits but against a backdrop of highly codified decoration, as in the 1905 *Margarethe Stonborough-Wittgenstein* portrait. In the latter, the fabulous detail on the dress is enhanced by lighting techniques, which were just surfacing in *Serena Lederer*.

Margarethe Stonborough-Wittgenstein (1905) Neue Pinakothek, Munich. Courtesy of Artothek. (See p. 162)

NUDA VERITAS (NAKED TRUTH) (1899)

Osterreichische Galerie Belvedere, Vienna. Courtesy of AKG London/Erich Lessing

HIS fabulous work was converted from the *Nuda Veritas* (1898) illustration in *Ver Sacrum* into a large oil painting, displayed at the fourth Secessionist Exhibition in the Spring of 1899. The earlier Schefer quotation is now replaced by Johann Schiller's (1759–1805) profound and apt lines: 'If you cannot please everyone with your deeds and your art, please a few. To please many is bad.' The quotation is indicative of Klimt's increasingly estranged beliefs and his disillusionment with fame and glory since his brother's death in 1892. Klimt realised that super-stardom came with strings attached and that it infringed his freedom of expression.

The life-sized figure in Nuda Veritas recalls the sensuous creatures

from *Water in Motion* (1898), in its hair colouring and daring full-frontal exposure. The whole validity of the nude was being challenged at this time with the once-distinct line between classical art and pornography, blurred by the rise of photography. The female form also encapsulated paradoxical philosophical problems of flesh versus the spirit. The blue watery movement from *Water in Motion* suggests the Theosophists' evolution beliefs and the snake of truth, around the neck of *Jealousy* (1898), here lies subservient around her feet. This is the naked truth of ultimate Platonic knowledge and, significantly, the *Ver Sacrum* flowers are now plucked and in Truth's hair.

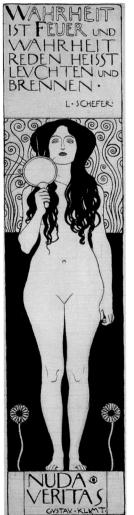

Nuda Veritas (1898) Courtesy of Historical Museum, Vienna. (See p. 78)

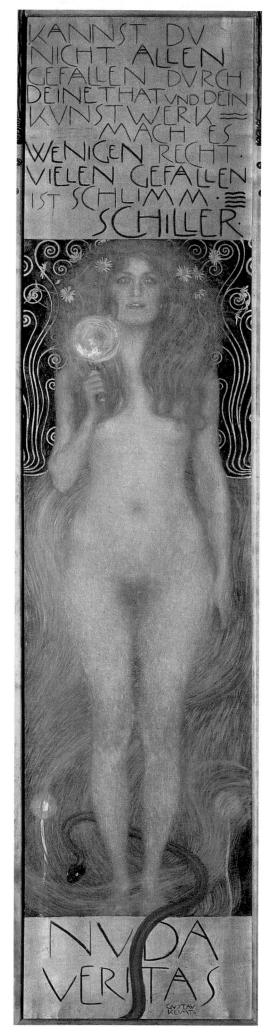

SCHUBERT AT THE PIANO (1899)

Courtesy of AKG London

LIMT'S radical style transformation resurfaces in this renewed experiment with Impressionism. It fuses an interesting use of photographic realism in the depiction of Schubert, with the ethereal Impressionism of the surrounding women. The commission, along with *Music I* (1895), was part of a sumptuous project to refurbish the magnificent palace on the fashionable Ringstrasse belonging to wealthy industrialist Nikolaus Dumba. The project was an interesting blueprint for the celebrated Art Nouveau-style Villa Stoclet commission in Belgium in 1905–09, which became a universal statement of the Secession's *Gesamtkunstwerk*: the notion of total unity in arts.

Klimt started experimenting with this 'harmonised art' formula in the Dumba project, exquisitely designing coloured marble, ornate precious metal grilles and mahogany, as well as painting the two works. Sadly, the contents were sold in 1937 after the death of Dumba's widow, though photographs show *Schubert at the Piano* hanging in the music room. Dumba adored Schubert's work, owning many original manuscripts by and pictures of the master, hence the theme.

This work, like others seized during the SS's attempt to make all Germanic art look Aryan, was deliberately destroyed by fire at Schloss Immendorf, in Lower Austria, where the Nazis stored their war booty. It was torched in 1945 to prevent it falling into the hands of advancing Russian troops at the close of the Second World War.

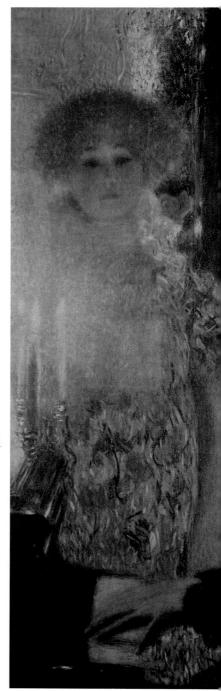

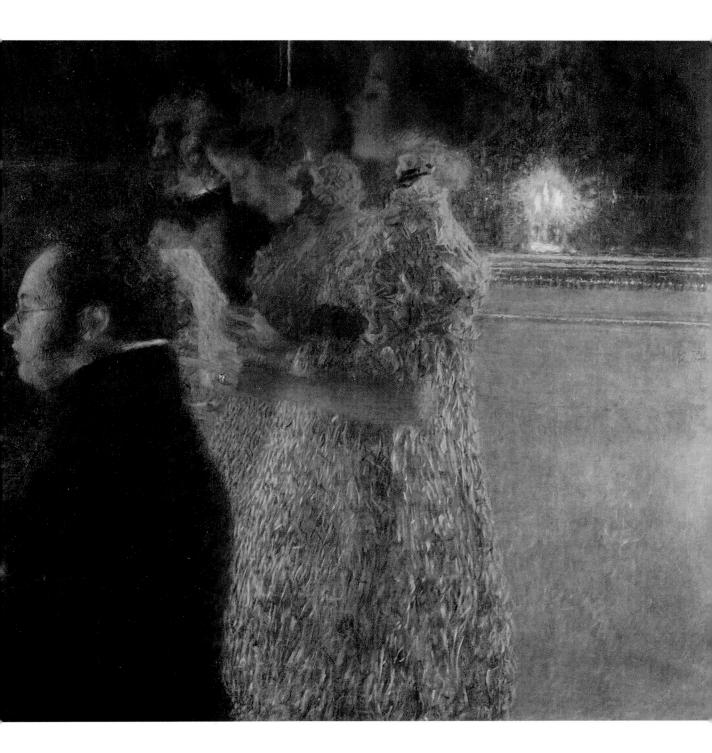

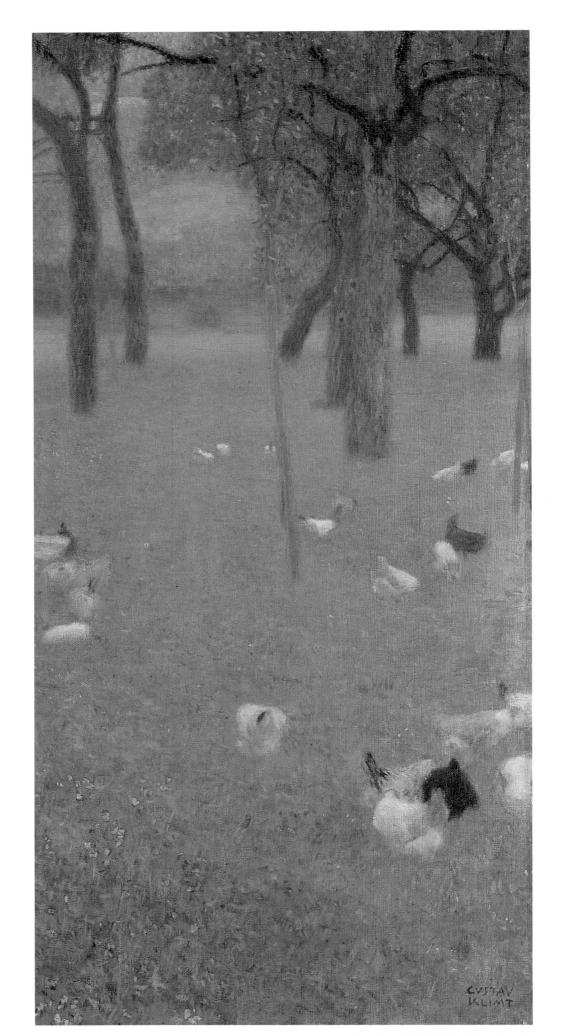

AFTER THE RAIN (1899)

Osterreichische Galerie Belvedere, Vienna. Courtesy of AKG London/Erich Lessing

HIS is one of Klimt's first known landscapes, a genre which was to absorb the great decorative artist for the rest of his life. Here he used a technique known as Pointillism, which involves the subtle deposit of pure but fragmented colour particles in dots or dashes, which at a distance blend harmoniously. The theory suited Klimt's methodical approach and enabled the achievement of certain Impressionist effects of colour reflection and form that had previously

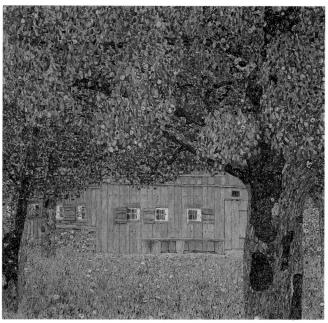

Upper Austrian Farmhouse (1911)Osterreichische Galerie Belvedere, Vienna.
Courtesy of AKG London. (See p. 206)

caused him difficulty. It also helped him to experiment with decorative abstraction, as can be seen in 1911's *Upper Austrian Farmhouse*; for instance, both works employ a blue-green overlay to construct spatial depth from a colour framework, though more successfully in the later work.

The Impressionists were renowned for working 'en plein air' to capture spontaneous impressions of a timeless world. This spontaneity rarely suited Klimt's preference for studio work and his need for deliberation. He turned to landscapes quite late in his career, while on

holiday, and they ironically came to represent a liberation of style. Summer breaks were usually spent with Emilie Flöge and his family on the Attersee in the Austrian Alps, where he returned almost every year until his death in 1918. There he painted many of his landscapes.

PHILOSOPHY (1899-1907)

Courtesy of Galerie Welz, Salzburg

NE of the controversial University Paintings series, this work represents Klimt's fall from grace – the time when the authorities became scandalised by his progressive Symbolism and explicit nudes. He was first approached by the Ministry of Education during the early 1890s, in the highly fashionable historicism period of his Künstlercompagnie, to submit designs for the decoration of the ceiling in Vienna University's Great Hall. The prestigious project became tortuously extenuated: originally when Matsch and Klimt quarrelled over style, ending their collaboration; and followed by Klimt's clash with the establishment over Secessionism.

In 1900, in a bid to pacify the authorities, Klimt displayed the unfinished *Philosophy*. It was immediately obvious that this highly *avant-garde* work was far removed from the anticipated historicism. Klimt's mystical and unconventional interpretation of intellectual truth, with his 'stream of life' column and emerging Sphinx – a favourite Symbolist image for the cosmic riddle – caused instant uproar.

Thanks to pro-Klimt critic, Ludwig Hevesi, we learn of the painting's marine-green colour harmony-like 'dreaming', which conjured up notions of 'cosmic dust' and 'whirling atoms of elemental forces', to represent the philosophical mind. Sadly, only black-and-white copies

now survive. The original was destroyed by retreating Nazis, but rivalled '*Hygeia*' from *Medicine* (1900–07) in intensity of colour.

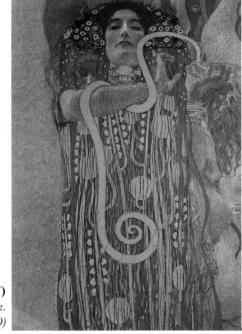

Hygeia (1900–07) Courtesy of Dr Brandstätter-Artothek. (See p. 100)

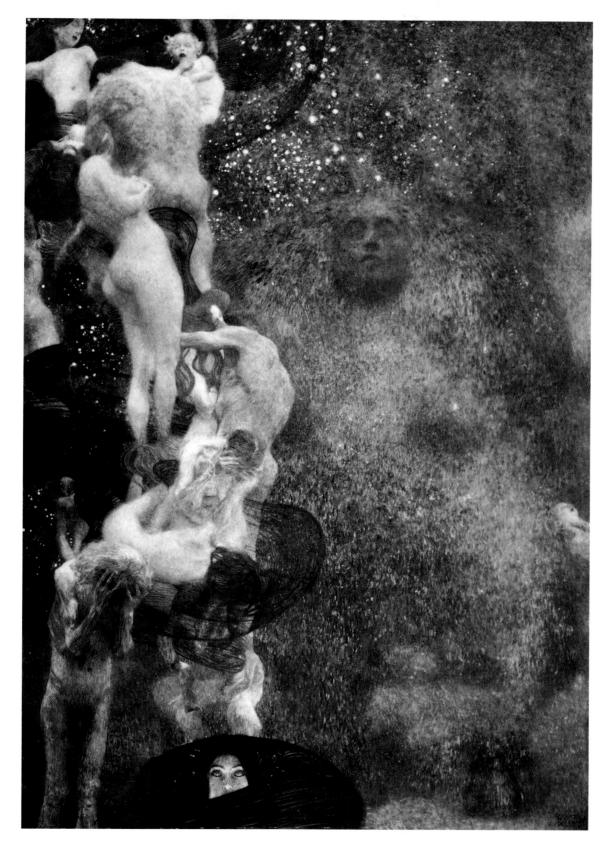

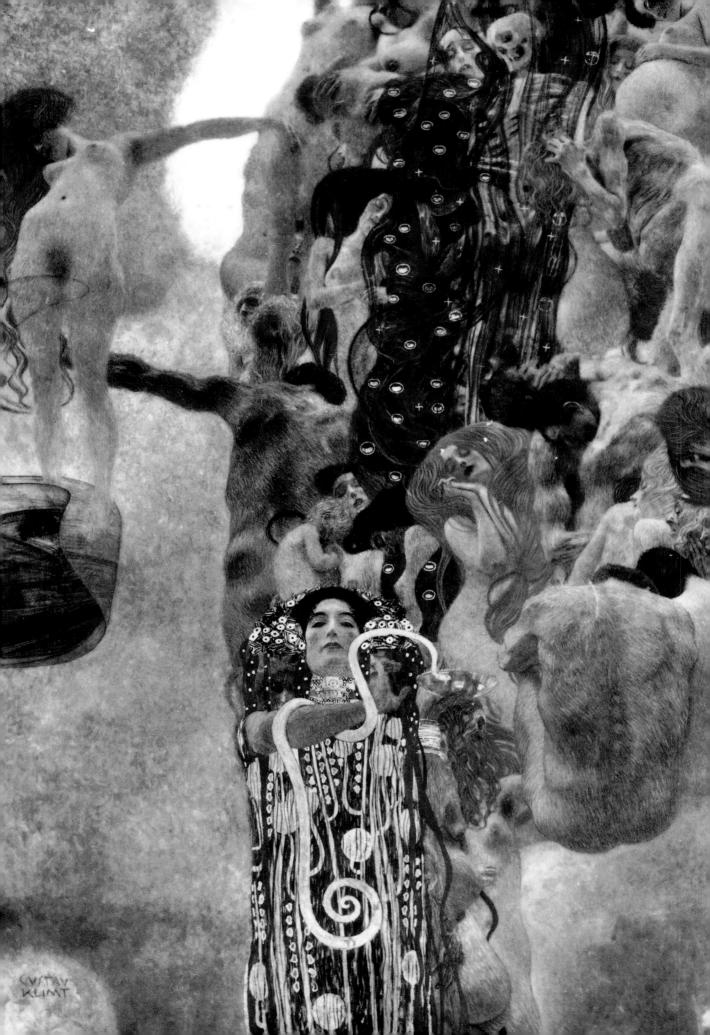

MEDICINE (1900–07)

Courtesy of Galerie Welz, Salzburg

HE Klimt Affair, as the Vienna University scandal became known, was refuelled when *Medicine* was publicly aired a year later at the tenth Secession exhibition in 1901. Originally planned for the ceiling corner opposite *Philosophy* (1899–1907), its cleverly reversed composition, red colour structure (compared to *Philosophy's* oppositional green), and dazzling centralised figure, Hygeia, daughter of the first doctor and goddess of health, is ethereal. Unfortunately the University doctors did not agree. Angry that the column's swirling allegories of death in life discredited their healing powers, they labelled Klimt's continued exploration of beauty as pornographic. The public prosecutor was called in and the ensuing public angst over the fundamentals of aesthetics ended in a debate in Parliament.

Despite a greater elaborate style, the draft was an amalgamation of many earlier techniques from acknowledged works already well exhibited. The sensuous female nudes appeared in *Nuda Veritas* (1898 and 1899) and *Water in Motion* (1898). The similar hazily lit background of *Love* (1895), like a mystical cloud of spirit animation, had previously featured the now repugnant gothic horror masks of death, and Hygeia's regal but compassionate downward look is an echo of Sonja Knips' authoritative figure (painted in 1898). It seems that the heated debate

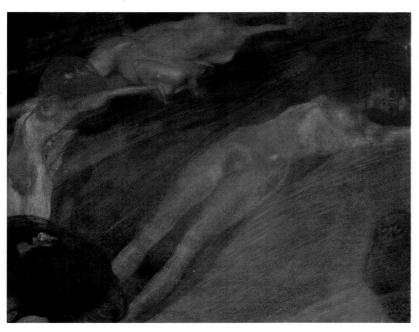

was more about prudishness and hurt intellectual pride than art.

Water in Motion (1898)
Osterreichische Galerie Belvedere, Vienna.
Courtesy of AKG London/Erich Lessing.
(See p. 76)

MEDICINE (1897–98)

Courtesy of Galerie Welz, Salzburg

HIS preliminary version of *Medicine* uncovers the changes that were made to the final picture, illustrated on the previous page. Here, the right side of the composition is absorbed with a mass of human bodies among which allegories of 'death' and 'pain' are recognisable. On the left, the free-floating, isolated nude is more

prominently featured than in the final work. Despite the covering of the pubic region by floating hair in this work, the nude was said to be 'indecent' and so perhaps Klimt decided to tone down its presence in the later version. He enlarged the column of life and death to take up two-thirds of the painted surface and crowded in more bodies. The nude still remains attached, caught by the male torso's muscular arm to suggest an everlasting renewal of mankind. This is emphasised by the inclusion in the final work of an unborn child above the head of Hygeia.

When comparing the two works, the persona of Hygeia is re-worked and strengthened in the final painting. As she rises from the centre of the painting, Klimt lets loose his language of adornment.

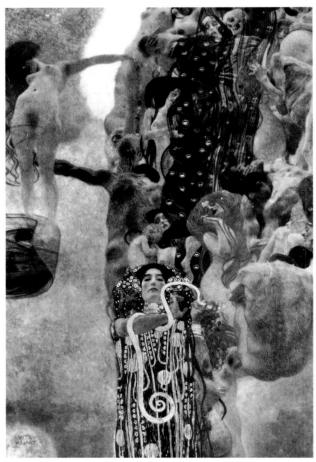

Medicine (1900–07) Courtesy of Galerie Welz, Salzburg. (See p. 97)

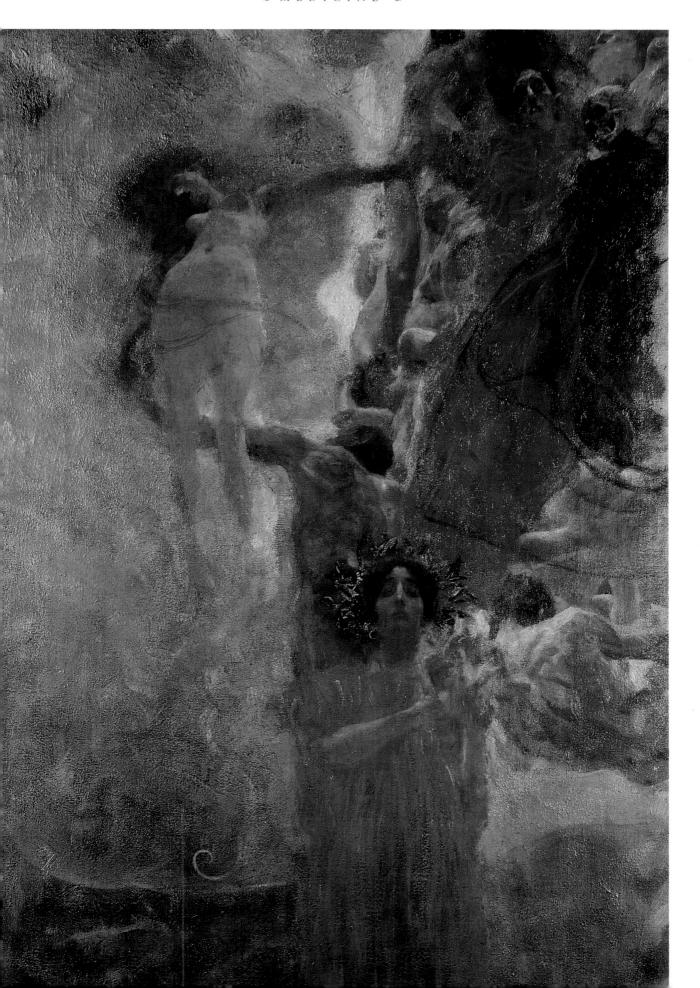

HYGEIA (1900-07)

Courtesy of Dr Brandstätter-Artothek

HIS resplendent regal figure of Hygeia, dazzling in gold-leaf and vibrant red, is lifted from the University painting, *Medicine* (1897–98). It is the only known surviving colour section of the finalised paintings, the works having been deliberately destroyed by fire when the Nazis set fire to the Schloss Immendorf in 1945, to prevent the Allies finding their booty at the end of the Second World War. One can only wonder about the spectacular brilliance of the other paintings, which, according to the critical appreciation at the time, equalled this one in resonance.

Klimt's absorption with Symbolist notions of the ideal reached an amazing climax in what was probably his most important official commission – and the last. A wonderful uplifting sensation, representing

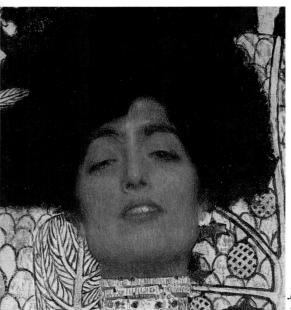

a higher spiritual power at work, is created, as in previous works, by a highly charged flowing brush movement. This transporting energy pours out of Hygeia's healing cup of life through the golden snake of knowledge, and courses down her body in strong rivulets. The energy ripples round her golden skin, depicted in heavy Pointillist brushwork, as though she is on fire; this sensation of flames continues to lick up the symbolic column of life. Daughter of the first doctor and goddess of health, she represents for Klimt the allegorical personification of medicine and continuance of life.

Judith with the Head of Holofernes (1901)Courtesy of AKG London/Erich Lessing. (See p. 112)

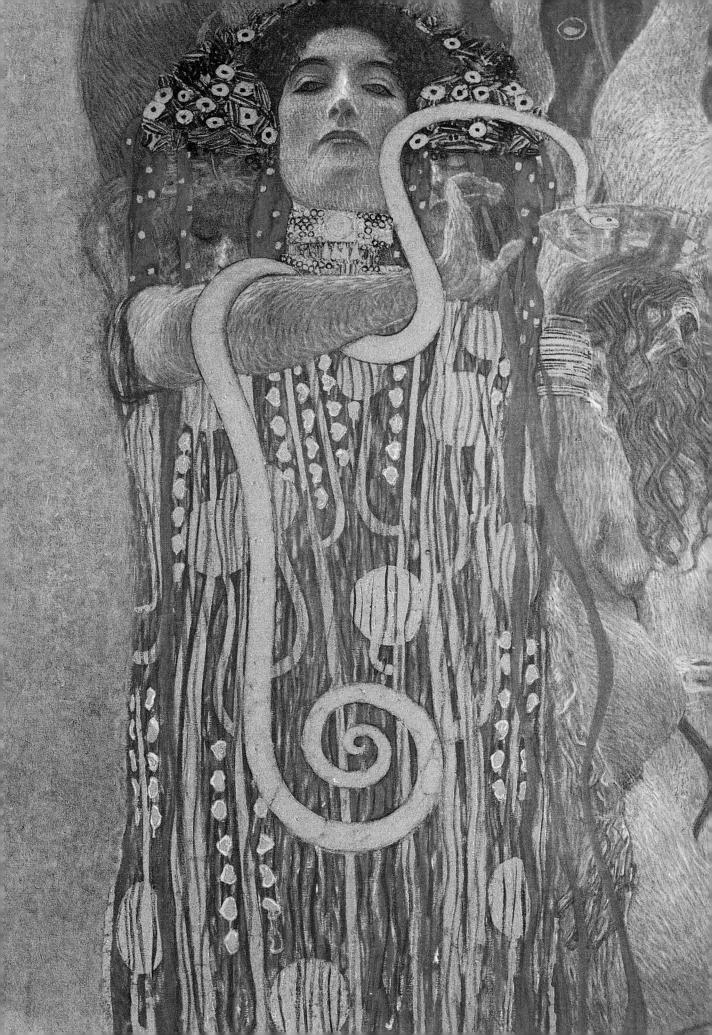

JURISPRUDENCE (1899–1907)

Courtesy of Galerie Welz, Salzburg

HE final University commission, Jurisprudence was shown with Medicine (1900–07) and Philosophy (1899–1907) at Klimt's collective 18th Secession exhibition in 1903, but despite final approval from the Ministry of Education – the minister having supported Klimt throughout – it was also derided. Again Klimt's allegorical content formed the heart of complaint. Here, three distanced female personifications of Truth, Justice and Law look down impassively on the pitiful naked offender below. He is surrounded by three weird beauties and consumed by squid tentacles, presumably haunting analogies of legal retribution. For the authorities, this was not the anticipated pictorial affirmation of divine justice.

This stunningly huge work, which like the others was over four metres (almost 14 feet) high – 430 cm x 300 cm (172 in x 120 in) – was, according to records, beautifully infused with large amounts of gold and black. Comparing it with the surviving colour section, *Hygeia* (1900–07), it was probably spellbinding. The rich mosaic patterning at the top against the textured swirling energy around the foreground

figures must have been a visual feast. Apparently it owed much to Danté Alighieri's (1265–1321) *Inferno*.

The work also marked Klimt's continuing elaboration of a flattened, decorative surface, culminating in his famous work *The Kiss* (1907–09). Despite final approval of *Jurisprudence*, an angry Klimt borrowed 30,000 crowns from the Lederers to buy himself out of the commission.

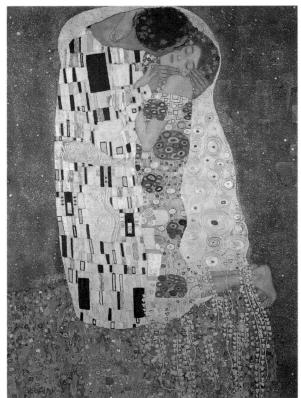

The Kiss (1907–1909)
Osterreichische Galerie Belvedere, Vienna.
Courtesy of AKG London. (See p. 191)

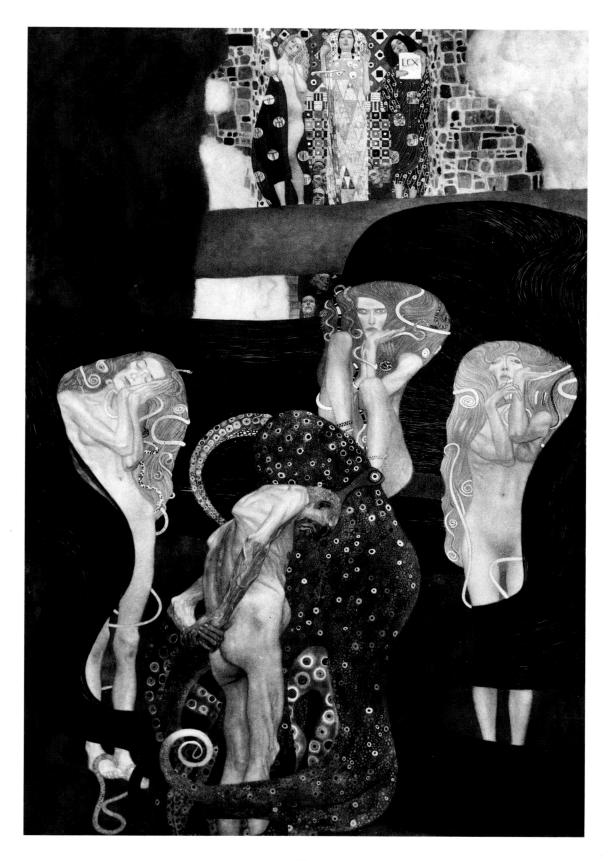

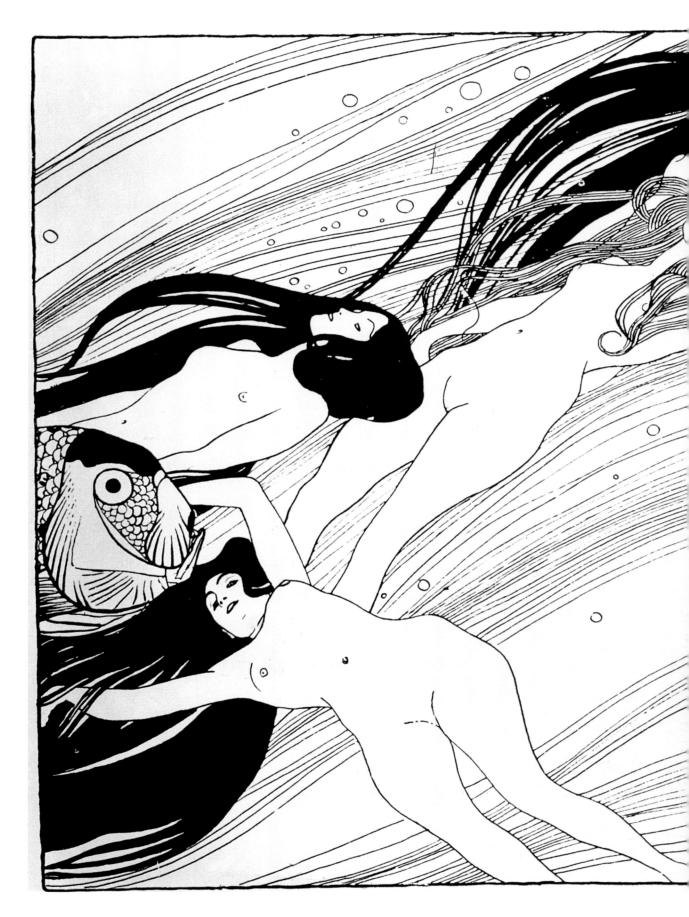

THE BLOOD OF FISH (1900)

Private Collection. Courtesy of The Bridgeman Art Library

LIMT, now on the board of *Ver Sacrum*, adapted imagery, built up since *Water in Motion* (1898) to create this illustration for *Ver Sacrum III*. Again he used the female personification of creative energy born out of an eternal moving flux as nude figures flow and course within the symbolic water of life. Because of their similarities, it is assumed that these two works were probably completed fairly close together. Klimt presumably realised that the original strong flowing lines of *Water in Motion* suited the reductionist requirements for engraving, whereas its colour scheme was appropriated for the controversial *Philosophy* (1899–1907).

The upward motion is exaggerated by the visual force of the diagonal line across this composition as the figures surge from bottom right to top left. The square format, which Klimt uses to greater effect in his subsequent landscape work, relates to Theosophist and Neo-Platonist obsessions with geometrical harmony as an expression of universal truth. The fish of life symbolism is also possibly linked to Theosophy, which adapted Oriental tales of transformation, such as stories of maidens whose souls were trapped inside fish. Here the young women represent the blood of this fish.

Water in Motion (1898) Osterreichische Galerie Belvedere, Vienna. Courtesy of AKG London/Erich Lessing. (See p. 76)

FARMHOUSE WITH BIRCHES (1900)

Osterreichische Galerie Belvedere, Vienna. Courtesy of AKG London

HIS farm scene is a development of an earlier work, After The Rain (1899), as Klimt took time off in 1900 to relax both physically and, it seems, artistically. Again he plays with Pointillism to construct sensations of spatial depth and colour harmony within the work. As in After The Rain, blue and green strokes are laid horizontally side by side in the background to create a greater sense of dimension. This is counterbalanced by a textured series of upward blue and green brush marks in the main section to accentuate the proximity of the foreground. Multi-coloured dots, depicting meadow flowers, also help lift this section, though overall cohesion is maintained by the exaggeration of the blue dots, the composition's predominant colour. From this lush effect, the cold silver lines of the birches run up the canvas, Klimt once again using his characteristic upward motion to denote spiritual energy.

The farmhouse is relegated to a white blob in the distance. For Klimt, a landscape became the signifier of an eternal organic cosmos and could portray another world autonomous of our existence. It is an extension of the Pre-Raphaelite 'truth to nature' concept to render the transitory as permanent through the structured patterning of colour and design.

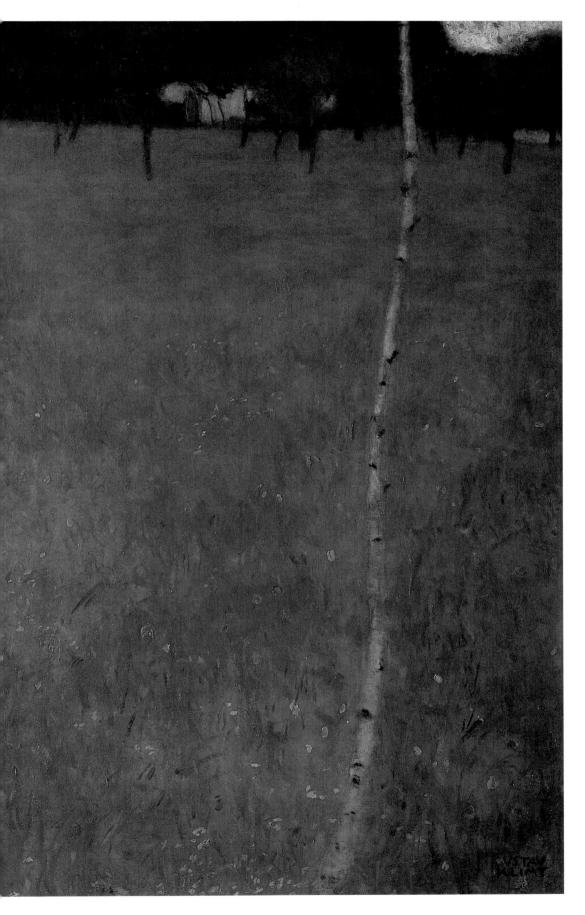

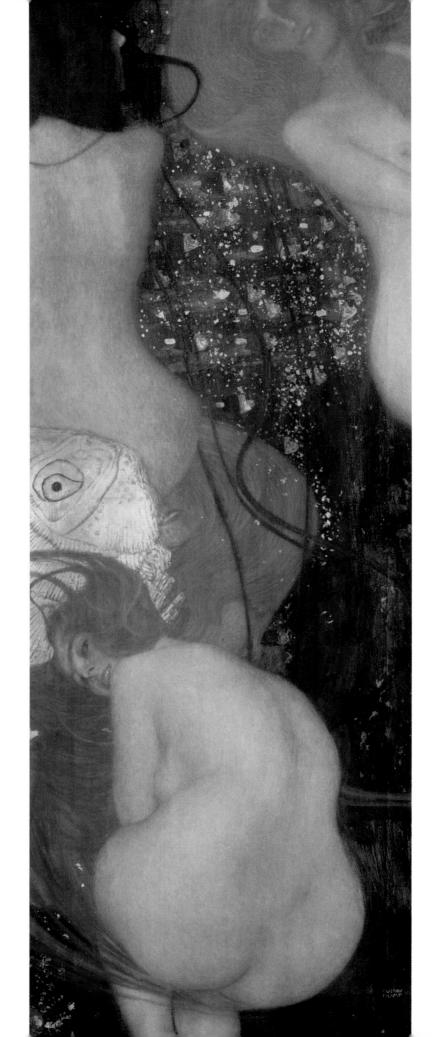

GOLDFISH (1901-02)

Kuntsmuseum Solothurn, Switzerland. Courtesy of The Bridgeman Art Library

HIS is Klimt's literal and figurative humorous response to the establishment's fury over his University painting commission. Apparently he wanted to call it 'To My Critics' and the nude's curvaceous form and liberated swirling hair would undoubtedly have been received as offensive because the main criticism against the University work was its pornographic content. However, despite the exaggerated bottom, the nude's expression is one of impudence rather than sexual intimation. The golden hair colouring is a recurring feature of other nudes from this period, such as *Nuda Veritas* (1898 and 1899),

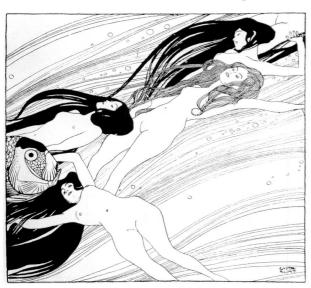

The Blood of Fish (1900)

Private Collection. Courtesy of The Bridgeman

Art Library. (See p. 105)

and the heavily embossed fish, with its cheeky grin, is a coloured version of *The Blood of Fish* (1900) illustration for *Ver Sacrum*. The back and front of two other nudes that float up through Klimt's creative ether are reminiscent of figures from the vital columns of life which spiralled up either side of *Philosophy* (1899–1907) and *Medicine* (1900–07).

Today the work has gained importance as the spectacular bejewelled mosaic of watery life that sparkles and shimmers like iridescence. It is probably the only colour example of the 'cosmic

dust' effect that Klimt worked into *Philosophy*, now destroyed. The deliberately large work, almost two metres (over six feet) high, was shown at the Secession's thirteenth exhibition in 1902.

Music (1901)

Private Collection. Courtesy of The Bridgeman Art Library

HIS woodcut was devised for a *Ver Sacrum* illustration. Like other Klimt contributions to the Secession's highly successful publication, it draws on earlier works; in this case the oil study submitted to secure the music room contract for the Palais Dumba, a residence on the Ringstrasse.

Klimt probably recalled this work when the magazine's compilers looked to feature musical contributions as part of its commitment to *Gesamtkunstwerk*: the notion of total unity of arts. This issue of *Ver Sacrum* featured 11 copies of songs, these were complete with lavish

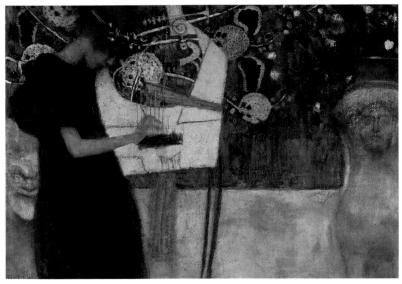

Music I (1895)
Neue Pinakothek, Munich. Courtesy of AKG London/Erich Lessing. (See p. 52)

decorations by some of Vienna's leading dissident artists. The woodcut format lends itself to the rigid lines of the player and the construction of the heavy lyre, but despite the limitations of this technique Klimt successfully incorporated an expression of delicacy and harmony. The original work's electrifying sensation of sound was generated by heavy

gold embellishment that curled out of the instrument. Here three dynamic sections of colour conjure up a similar emanation of sound.

Usually associated with 14th-century two-dimensional printing, the woodcut was displaced by line engraving until William Morris's British Arts and Crafts movement, which heavily influenced the Secessionists, revived it in the late-19th century because of its ability to capture subjective expression.

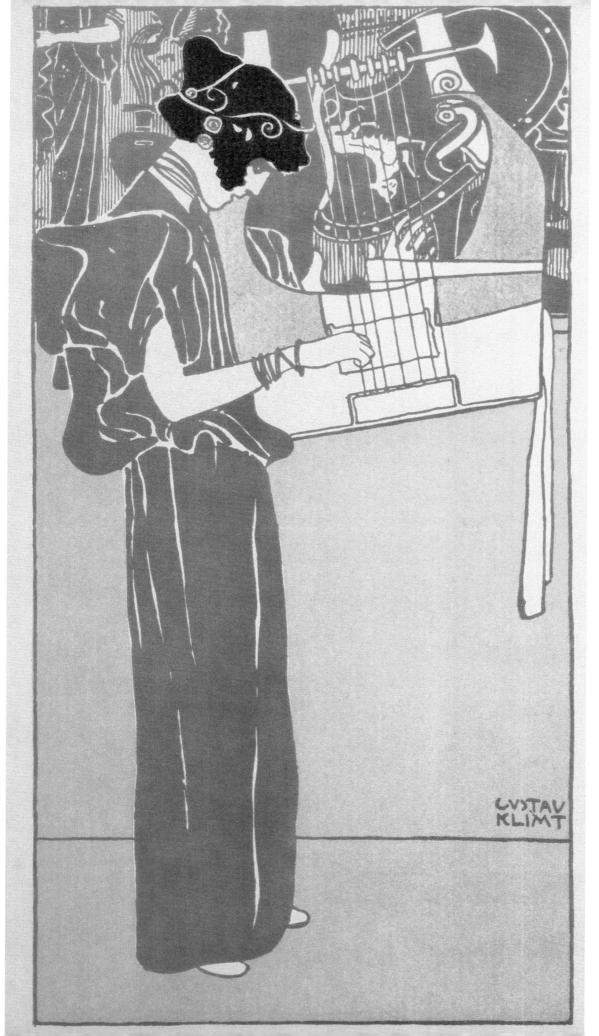

JUDITH WITH THE HEAD OF HOLOFERNES (1901)

Osterreichische Galerie Belvedere, Vienna. Courtesy of AKG London/Erich Lessing

Relative to be the considered to be Klimt's most erotic painting and is said to have been modelled by wealthy patroness, Adele Bloch-Bauer, whose sumptuous portrait he was to complete in 1907 and again in 1912.

Critics believe the couple continued a secret affair for 12 years, though Klimt also had countless discreet liaisons with other women, both socialites and lower-class models who worked for him. He apparently wore nothing but a long painting smock while at work and visitors to his studio often met models in a state of undress waiting to be artistically captured by the maestro. When Klimt died in 1918 several mistresses came forward with a total of 14 children that were allegedly fathered by him.

Much of his sketch work is certainly erotic and sexually explicit. Women were attracted to his deep, sensuous nature and they occupied a central place in his work. In this painting, Judith symbolises the femme fatale, an image that fuelled the Symbolists's fascination with sex and death. Instead of her traditional biblical depiction as the murderess of Holofernes to liberate the Jews, here she is a sexual temptress.

Reclining Female (1914–15)
Courtesy of Historical Museum, Vienna. (See p. 224)

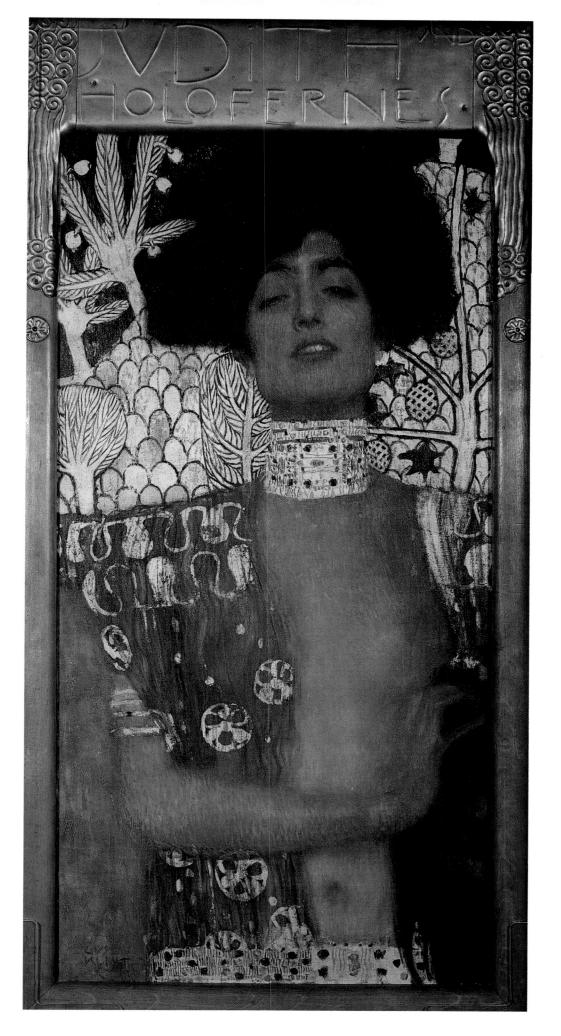

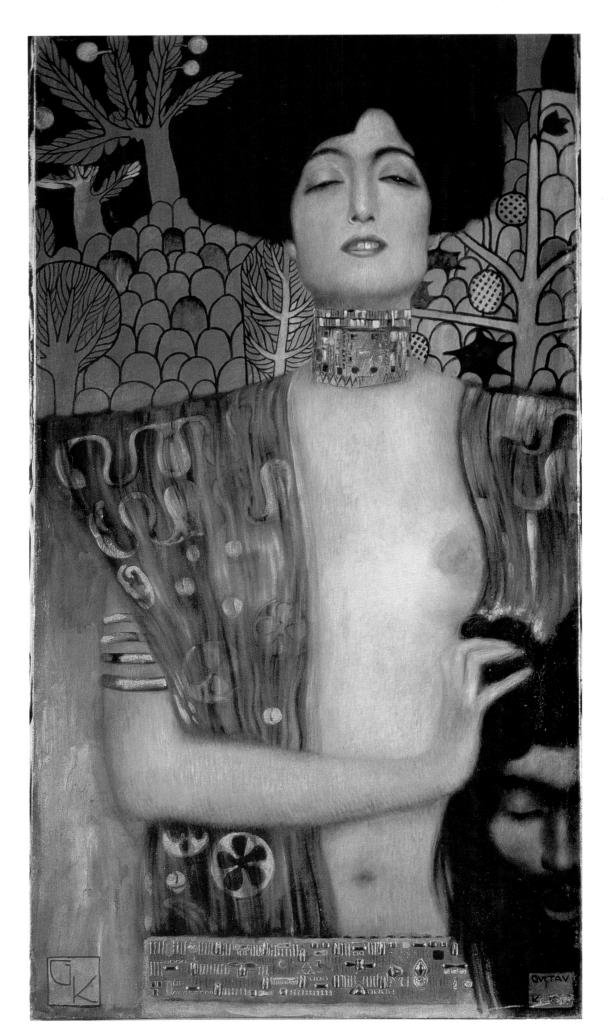

JUDITH WITH THE HEAD OF HOLOFERNES (1901)

Galerie Vytvarcho, Ostrava. Courtesy of AKG London/Erich Lessing

NOTHER version of this painting exists in the Ostrava collection in the Czech Republic. The pictures are almost identical except that the colours here are sharper and certain details, like the fabulous jewel-laden choker and gold inlays, are more pronounced. The choker is said to identify the sexually aroused woman as Adele Bloch-Bauer because it appears again in her fabulous 1907 portrait. It was apparently a gift from her husband, a leading Viennese merchant-bank director.

Judith here is no warrior heroine but is singularly a Symbolist femme fatale, a society hostess who sexually lures men to their death. Yet here, the main thrust of the work is the figure's disturbing state of arousal after the moment of death. Holofernes' severed head is barely featured and is iconically chopped off by the right edge of the composition. Again Klimt explores preoccupations with paradoxical concepts of ugliness, this time surfacing as cruelty, within beauty. The background biblical scene is reduced to a gold inlaid Art-Nouveau

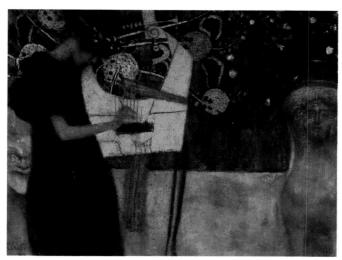

Music I (1895)
Neue Pinakothek, Munich. Courtesy of AKG London/Erich
Lessing. (See p. 52)

decoration, almost child-like in depiction, to contrast with the model's bizarrely modern made-up face. The fabulous turquoise and gold embossed robe, provocatively split open, recalls the colour schema from the highly lyrical *Music I* (1895) study.

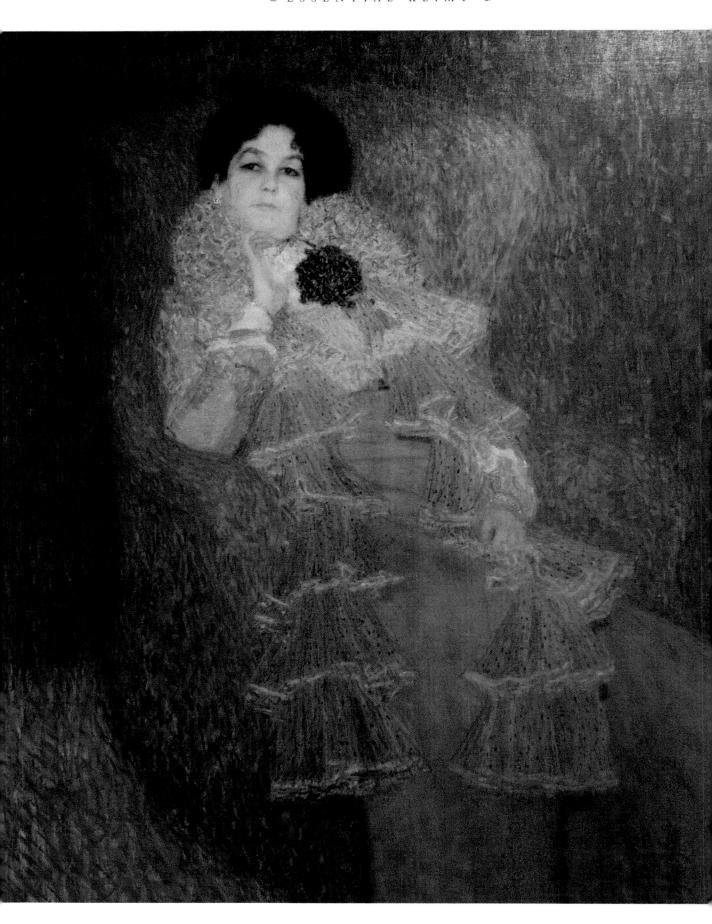

MARIE HENNEBERG (1901-02)

Galerie Moritzburg. Courtesy of AKG London

N this strangely lit composition, Klimt again tackles elements of Pointillism from his landscape work to establish spatial depth and a solidity of form. The portrait of Marie Henneberg, wife of the wealthy Viennese artist, writer and photographer Hugo Henneberg, was specifically commissioned to sit over a large mantelpiece in the entrance hall of their new palace.

Scottish designer and William Morris disciple, Charles Rennie Mackintosh (1868–1928), whose Art-Nouveau style had greatly impressed Klimt, Secession and Vienna, was responsible for the villa project, including furniture and interior decor. For Klimt, it represented a lucrative contract, which maintained important commercial links while the University paintings débâcle raged.

The diagonal lighting source from the top of the work, combined with the deliberate Pointillist brushstrokes, creates a glowing luminosity which would have been enhanced by the fireplace's powerful light source below. In an eerie composition, the tonal range gives the illusion of the armchair out of the background. In sharp contrast, the immense detail of the white dress, again reminiscent of Singer Sargent's portrait work, helps define spatial depth and lift the sitter's presence out of the colour blending around her, as she looks down haughtily with the idle social condescension of the wealthy.

EMILIE FLÖGE (1902)

Historical Museum, Vienna. Courtesy of AKG London/Erich Lessing

RITICS love to muse over the nature of Klimt's relationship with this beautiful stylish woman, his dead brother's sister-in-law, whom he met when he was 29 and she was just 18. She was his life-long companion, the one he truly adored, despite continual affairs with other women. They never married but lived under the same roof on their long annual holidays together. Klimt expert Susanna Partsch theorises that they probably subscribed to the then-fashionable propagations of free love without constraints of marital fidelity. Emilie and her sister were unusually independent for the era, establishing a

Detail from Portrait of a Lady (1917–18)Neue Galerie der Stadt, Linz. Courtesy of AKG
London. (See p. 244)

leading European fashion salon and travelling extensively for work. She shared many of Klimt's wealthy clients and they made a formidable artistic partnership.

Whether this impressive life-size portrait features a couture outfit is not known but the exquisite dress allows Klimt to experiment with radical portraiture techniques developed from his recent mural work. Consequently, the shimmering dress is filled with swirling jewel motifs and symbolic gold circles so that the fabric seems to move of its own accord, recalling Goldfish (1901–02), and probably similar effects from the now-lost *Philosophy* (1899-1907). The work is also influenced by Japanese woodblocks of kimono dresses which Klimt collected, and there is a monogram signature similar to Japanese seals set at the bottom right.

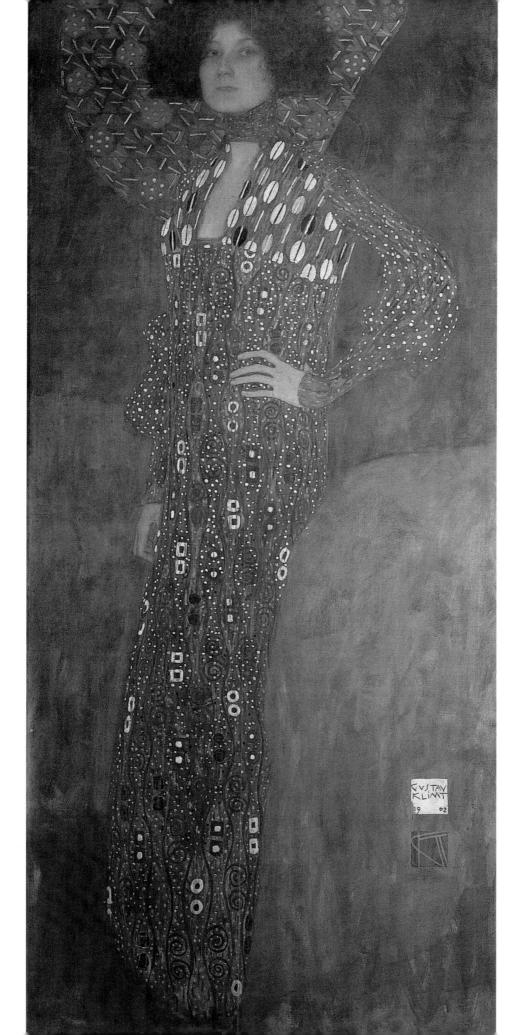

Women's Heads (1902)

Courtesy of Historical Museum, Vienna

HIS work is probably a preliminary sketch for the stunning Beethoven Frieze (1902), which today is the focal work of the Secession era. The frieze was designed by Klimt to run around a temple-like room, dedicated to the great composer, in the Secession's new exhibition building. The inspiration for this shrine was a massive sculpture of Beethoven by the German artist Max Klinger (1857–1920), portraying him as an artist-god. With the sculpture taking pride of place for the room's opening in 1902, Viennese composer and Secessionist Gustav Mahler (1860–1911) then conducted his own arrangement from Beethoven's Ninth Symphony.

The frieze represents Klimt's phantasmagorical interpretation of music as lyrical shapes and images run riot round the walls. Klimt's continual return to his Symbolist theories of life and art again provides a plethora of material that had surfaced in the University commission. The 1902 exhibition catalogue describes Klimt's stunning panels in the

light of Schiller's stirring *Ode to Joy*, sung in Beethoven's Ninth Symphony, to reflect the joy of pure happiness found in art and leading mankind to the kingdom of the ideal. Images of the femme fatale again feature in this drawing, as the beautiful woman's eyes stare out hypnotically, similar in style to final figures in 'The Forces of Evil' section of the finished frieze.

Detail from The Beethoven Frieze (1902)
'The Forces of Evil' Courtesy of AKG
London/Erich Lessing. (See p. 126)

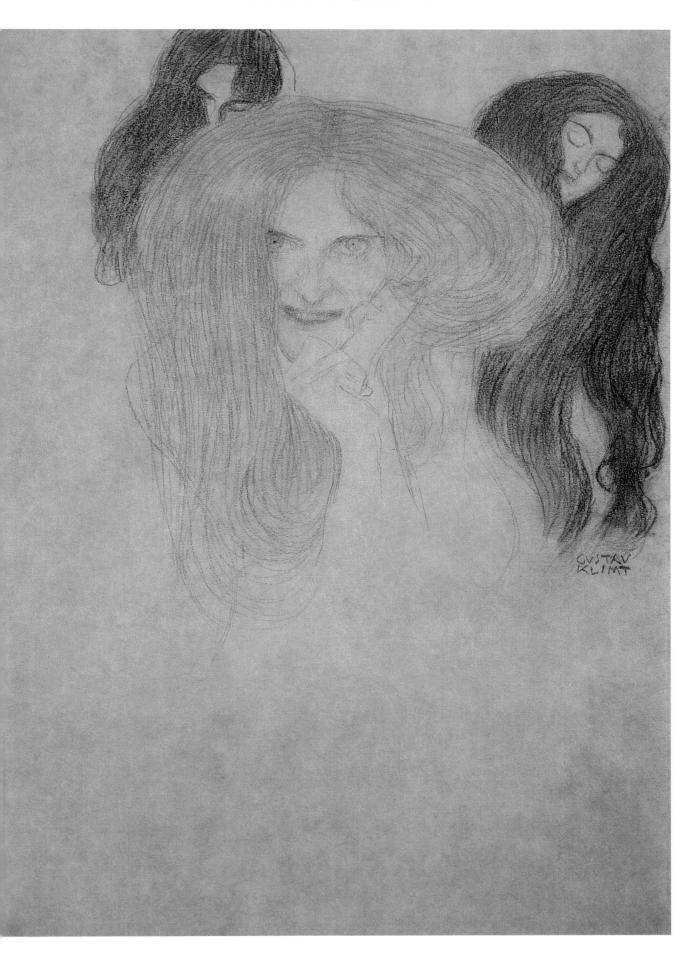

THE BEETHOVEN FRIEZE (1902) 'YEARNING FOR HAPPINESS'

Osterreichische Galerie Belvedere, Vienna. Courtesy of AKG London/Erich Lessing

HE Secessionists' unifying 'Total Work of Art' aesthetic finds its true voice in the Beethoven Room. Filled with music, poetry and sculpture, as well as Klimt's frieze, the project represents total harmony, an encapsulation of Schiller's poetic vision of the Kingdom of the Ideal.

Puzzled Klimt analysts bemoan the scarcity of data to interpret his personal symbolism. Klimt simply stated 'if you want to know me study my work'. Arguably this frieze represents the key. A consecration to his fundamental ideology, it demonstrates his transformation from

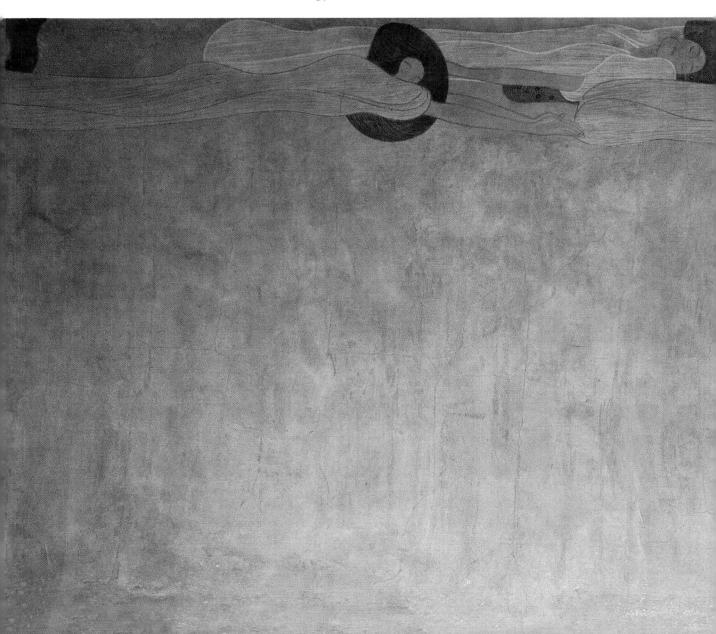

historicist to Symbolist. Sar Peladan's Parisian Idealism salon, La Rose Croix, influenced many of Klimt's mentors in the late 19th century, the 'Rose and Cross', or red cross, being a secret Masonic and Knights Templar symbol. Peladan declared: 'Artist – you are priest – seek the symbol behind the appearance, the eternal idea beneath the form.'

Here Klimt takes up the fight in this lyrically flowing section from the long right wall which culminates in the spectacular 'kiss to the whole world' motif. Each wall represented a Schiller quotation in the catalogue, this section signifying: 'Yearning for happiness finds relief in poetry. The arts transpose us into the ideal realm, sole source of pure joy, pure happiness pure love. Choir of angels in paradise. Ode to Joy.'

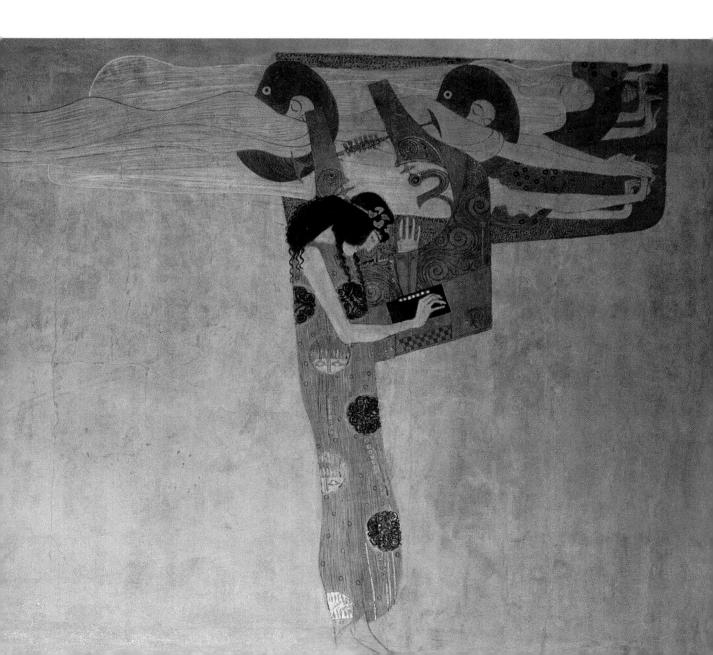

THE BEETHOVEN FRIEZE (1902) 'LONGING FOR HAPPINESS'

Osterreichische Galerie Belvedere, Vienna. Courtesy of AKG London/Erich Lessing

ERE, on the opposite long wall of the Music Room, the same figures lyrically flow hypnotically for a sensational 13-m (43-ft) spain to the resplendent majestic knight. He stands formidable, encased in gold, his avenging silver sword in hand. This is Peladan's symbolic Knight Templar of the mystic, esoteric world of his 'Rose and Cross' art. His call to the Symbolists to 'seek the symbol behind the appearance, the eternal idea beneath the form.' is answered by Klimt. Here, as art's knight, he takes up the fight. In the background, a female figure holds out the laurel wreath of success to crown him.

Klimt pours out his devotion to beauty as semi-precious stones, pieces of glass, mirrors, mother of pearl, gold and silver are lovingly inlaid in the work, painted on plaster nailed to lathes. The reductionist nature of the bare plaster throws the expanses of sumptuous decoration

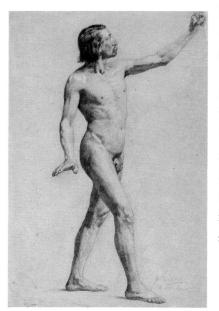

Male Nude in Walking Pose (1877–79) Courtesy of Historical Museum, Vienna. (See p. 17)

into stunning relief. It is a symphony of visual pauses, movements, textures and reflections.

In the catalogue, the picture is accompanied by a Schiller tract which reads: 'Yearning for happiness. The sufferings of weak mankind: mankind's appeal to the strong one in armour as the outer force and to compassion and ambition as the inner forces compelling men to take up the struggle for happiness'.

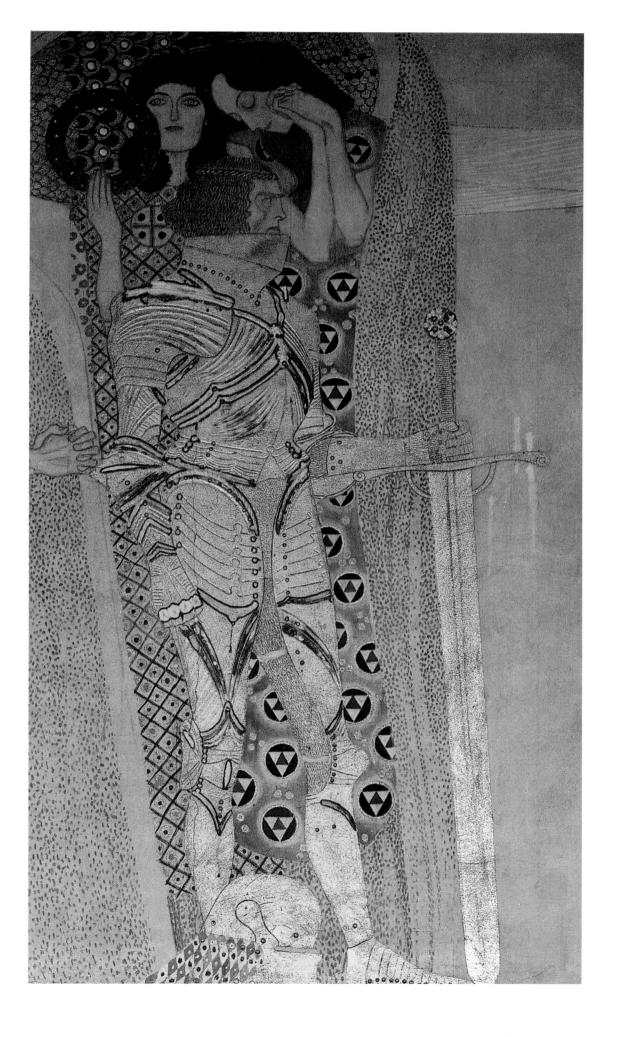

THE BEETHOVEN FRIEZE (1902) 'THE FORCES OF EVIL'

Osterreichische Galerie Belvedere, Vienna. Courtesy of AKG London/Erich Lessing

N the Music room's narrow back wall, six-and-half metres (20 feet) long, Klimt's imagination summons up images of horror and evil to illustrate Schiller's poetic vision. The catalogue quotes: 'The hostile forces. The giant Typhoeus, against whom even the gods fought in vain; his daughters, the three gorgons. Disease, madness, death. Sensuality and lechery, intemperance. Gnawing sorrow. The yearnings and longings of mankind fly over them'.

Here, in the first half of this evil vision, a gorilla portrays the giant, Typhoeus, personification of the typhoid which plagued European cities, including Vienna, in the nineteenth century. The three gorgons, as exotic, tempting sirens, with gold snaking through their hair, were to reappear in the controversial university work, *Jurisprudence* (1899–1907),

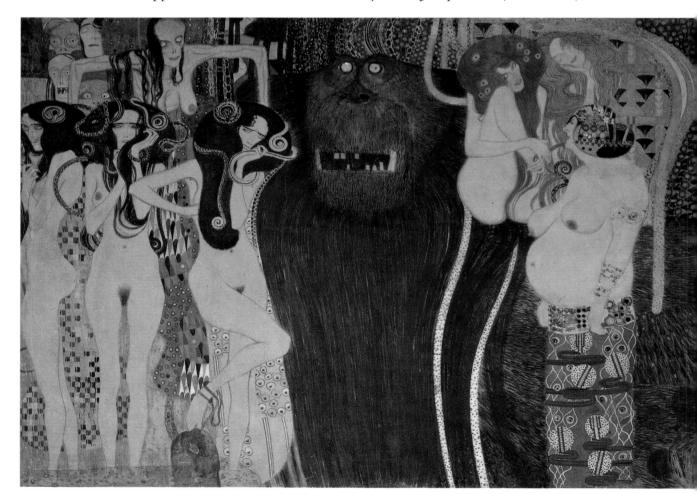

the following year. Above them, crazed, wasted faces of death and syphilitic disease, also prevalent in Viennese society, stare down. Klimt plays with paradoxical themes of ugliness in beauty and death in love, and the work's nudity, with explicit black pubic hair, re-incensed the Viennese establishment.

On the right of the gorilla, the concepts of Lust, Voluptuousness and Intemperance are personified in female form. The large, sagging figure of Intemperance, with her gaudy, bejewelled clothes, looks like a brothel madam; the electric blue skirt is the only resounding colour in the entire frieze.

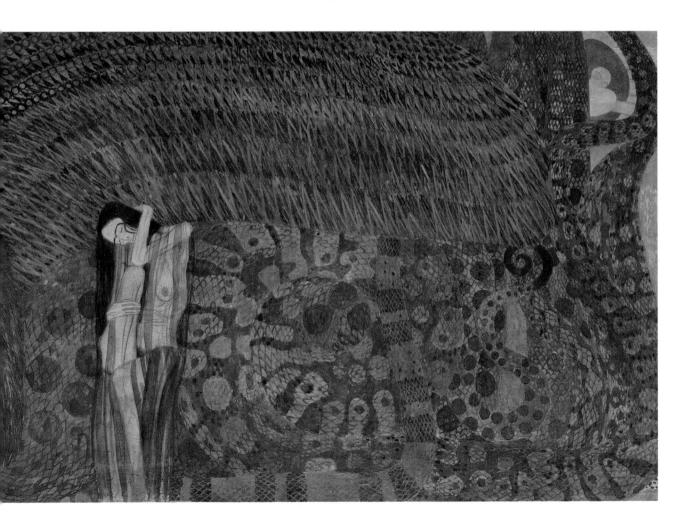

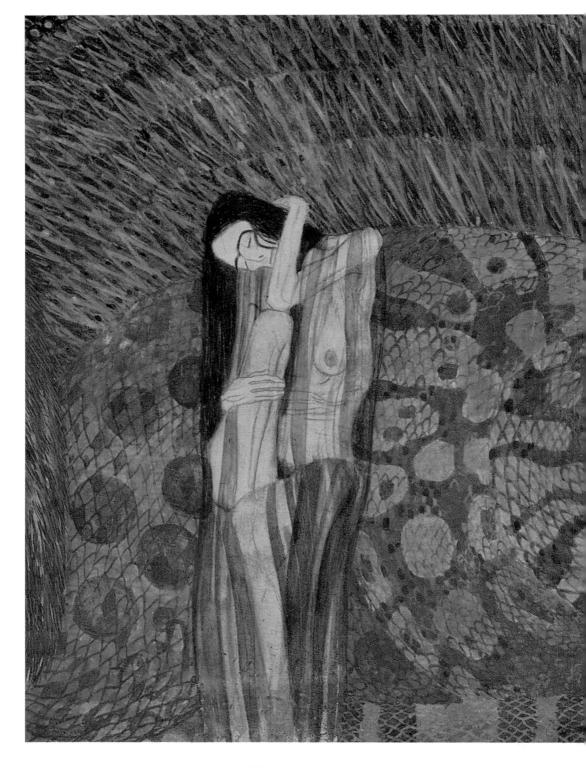

THE BEETHOVEN FRIEZE (1902) DETAIL FROM 'THE FORCES OF EVIL'

Osterreichische Galerie Belvedere, Vienna. Courtesy of AKG London/Erich Lessing

ERE in the second half of the 'Forces of Evil' section, spread over the Music Room's back wall, Klimt visualises Schiller's poetic vision of 'gnawing sorrow'. The swirling pattern drags the eye into its psychedelic depths as though plunging into the abyss of a soul in torment. The single, emaciated female personification of Sorrow is lost in this writhing mass of bestial imagery, generated out of the gorgons' snakes and gorilla's fur. Lurking behind these symbols of depravity lies the heart of evil, curled up like a serpent. The figure's long mangy hair, transformed into a black veil of gloom, is not a protective mantle, unlike the force of positive energy radiating from the Knight Templar.

The contorting mass is a variation of the snake of carnal knowledge that Klimt deploys in his *Ver Sacrum* illustrations, *Nuda Veritas* (1898 and 1899) and *Jealousy* (1898). This is in opposition to the knowledge of truth and beauty in Schiller's 'kingdom of the ideal'. Photographs of the frieze, reconstructed in 1985 in the Secession building, show that this rich section filled the back wall completely like a mural.

THE BEETHOVEN FRIEZE (1902) 'ODE TO JOY'

Osterreichische Galerie Belvedere, Vienna. Courtesy of AKG London/Erich Lessing

HIS crescendo of visual iconography completes the long section on the right-hand wall and acts as a counterbalance to the knight in golden armour on the opposite left wall. This is Klimt's interpretation of Schiller's *Ode to Joy*, as free-floating maidens, ecstatically transfigured, symbolise the 'choir of angels in paradise'. The vibrating pattern on their robes resounds from the walls connoting the sound of heavenly music visually. Each figure is subtly given individual form, but the uniformity of pattern with its moving wavy lines makes them blend harmoniously into the mass.

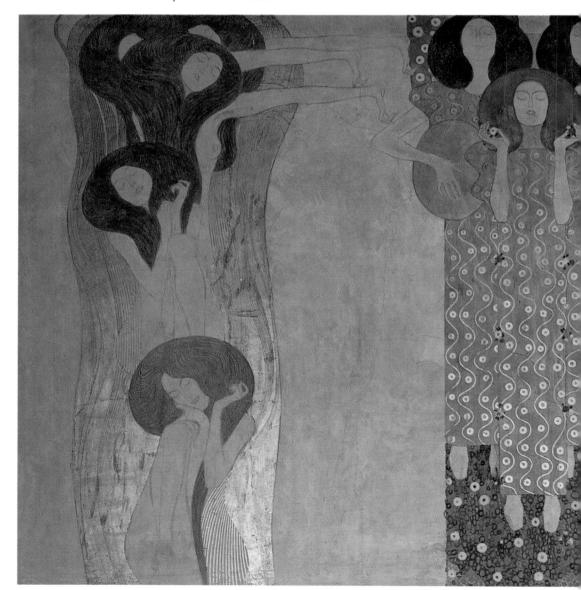

This is a celebration of art's harmonisation, a potent signifier of the Secessionists' unifying 'Total Work of Art' aesthetic, as well as the blending of the individual with cosmic consciousness. This ultimate union is finally symbolised by the following image of the kiss, known as 'the Kiss to the Whole World'. The celestial choir holds the rose of divine spiritual love, which is figured on their robes, before falling to water the fertile flowered earth below like notes of beautiful music. This ground's rich pattern is beautifully recorded in several of Klimt's later landscapes. On the left, a column of enraptured bodies ascends in a golden mist to join the throng.

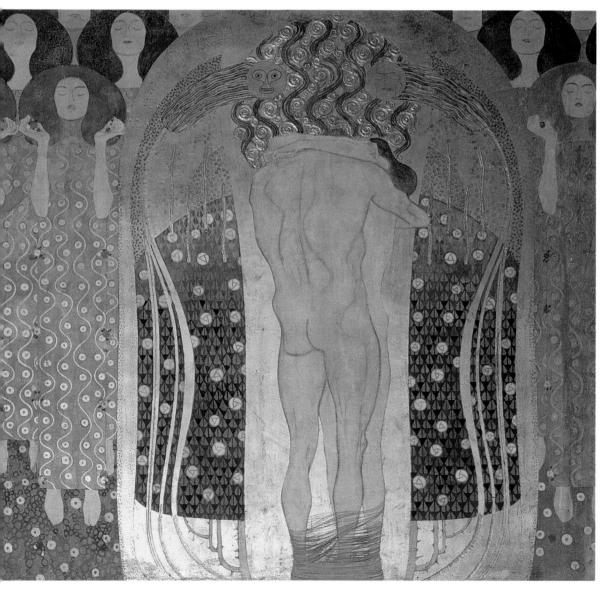

THE BEETHOVEN FRIEZE (1902) DETAIL FROM 'ODE TO JOY'

Osterreichische Galerie Belvedere, Vienna. Courtesy of AKG London/Erich Lessing

N a powerful finale, Klimt conducts Schiller's poetics of pure joy, happiness and love into a shimmering golden vision of the ultimate union, symbolised as 'the Kiss to the Whole World'. This is the emblematic marriage of the arts: aestheticism as religion or Peladan's 'artist as priest'. It is also the bringing together of the individual with the divine, the soul with cosmic consciousness.

Theosophists and Symbolists, adopting Swedenborg's esoteric mystic philosophies, suggested that sexual union equated to a religious experience, involving the marriage of two souls in heaven. So this is the ultimate merging of 'Eros', erotic sexual love, with 'Agape', spiritual love, the subliminal transcendence beyond the world of the flesh to the Platonic 'golden ideal' of perfect knowledge.

The 'Kiss' was undoubtedly influenced by Rodin's powerful sculpture of 1886, and Klimt revisits the theme in his seminal 1907 work, also entitled *The Kiss*. In contrast, in *The Beethoven Frieze*'s 'Kiss', the muscular male torso dominates and consumes the female figure, while the entwined couple in *The Kiss* is haloed by a protective, swirling golden energy. Round their feet the water of life, encoded from earlier works such as *Goldfish* (1901–02), and *Water in Motion* (1898), eddies as though they have emerged triumphantly from its force.

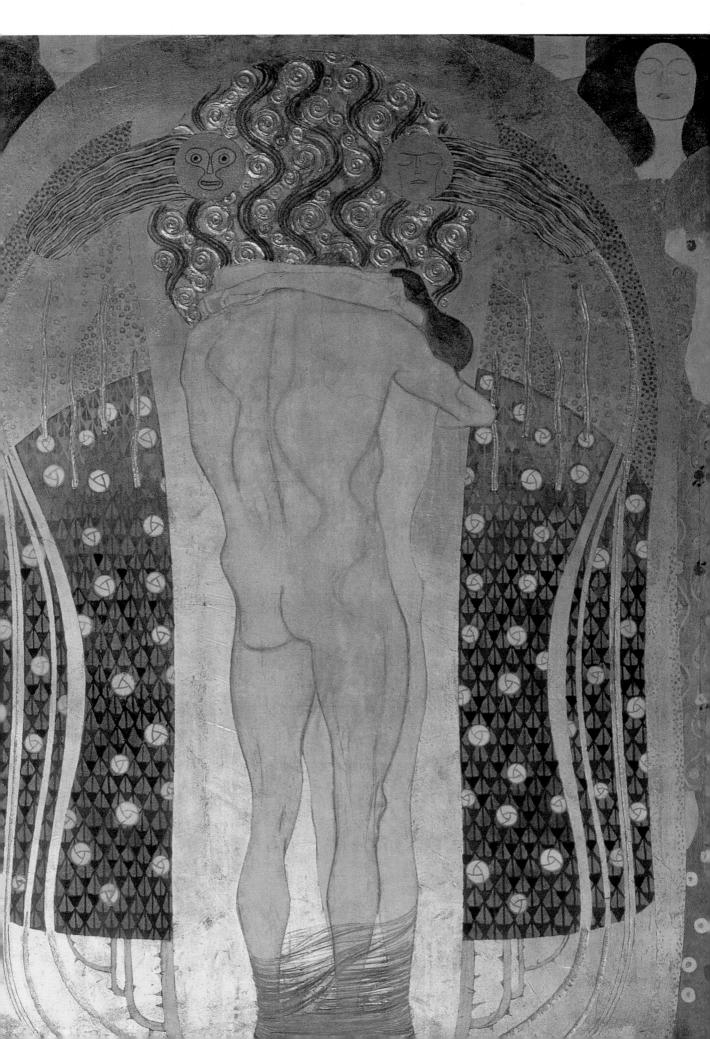

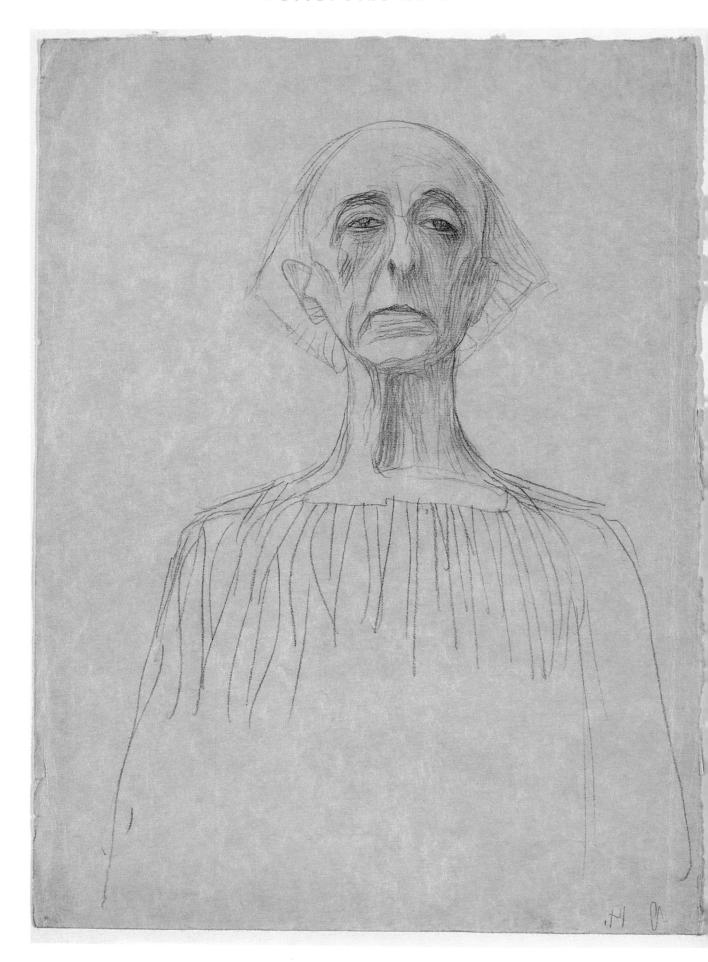

HALF-LENGTH PORTRAIT OF MAN (C. 1902)

Courtesy of Historical Museum, Vienna

HIS 1902 work recalls the 1898 *Ver Sacrum* magazine's illustration for *Jealousy*, the harridan with similar gaunt facial characteristics, though the figure here is male. Klimt did not forget his early draughtsmanship and his drawing skills show his quick assimilation of expressions or emotions using just a few lines. He usually completed large works from preparatory sketches like this, underlining his quest for artistic perfection and attention to detail. Little was left to chance and his painstaking work meant that he was not as prolific as many other celebrated artists. In the early years, his involvement with large-scale commissions was time-consuming, and valuable time was

spent in 'production' meetings with authorities.

This work could be a preliminary work for the wonderful Impressionist Study of the Head of a Blind Man (date unknown) but is similar. to Klimt's more accomplished Impressionism portraits such as Portrait of 1898-99 and Schubert at the Piano (1899). The face shape, angle, expression and lines behind the head to denote hair all correspond to the picture of the blind man, which means that this drawing and finished study could be dated nearer to 1898-99.

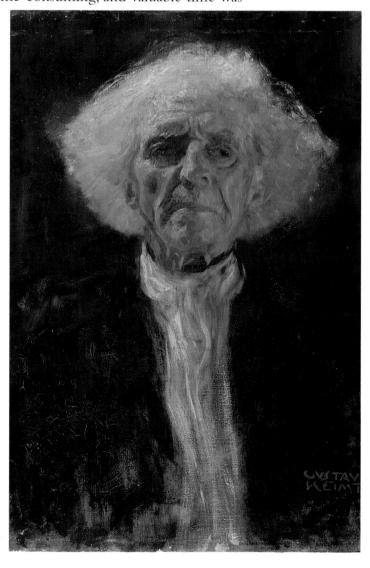

Study of The Head of a Blind Man (date unknown) Courtesy of The Bridgeman Art Library. (See p. 136)

STUDY OF THE HEAD OF A BLIND MAN (DATE UNKNOWN)

Private Collection. Courtesy of The Bridgeman Art Library

HE date of this work, held in a private collection, is not known, though its similarities with the previous sketch are remarkable in form and expression. Correspondingly, it is catalogued here at the same date, but affinity with works around 1898 and 1899 could place both pieces as being much earlier.

The study is unusual in that it is Klimt's only known realistic portrait of a man: he usually preferred to capture the charms of Europe's beautiful women with his brush. Deployment of Impressionist techniques and colour palette arguably make this his most advanced Impressionist attempt. As in early portraits, or *Schubert at the Piano* (1899), white is introduced to create notable sensations of light and tonal contrast in order to relay spatial depth and solidity of form. Unlike the early Impressionists' derision of black and brown, Klimt prefers to use a dark palette and heavy brushwork to generate shadow effects, relying on the profusion of white hair and the shirt for contrast.

It is likely that the creative possibilities derived from the hair's quality and remarkably expressive face were those that inspired Klimt

to paint the unknown sitter. As the sketch reveals, the triangulated hair mass creates a geometrical balance and emphasises the strong facial expression, accentuated by heavy brushwork.

Detail from Schubert at the Piano (1899)

Courtesy of AKG London. (See p. 90)

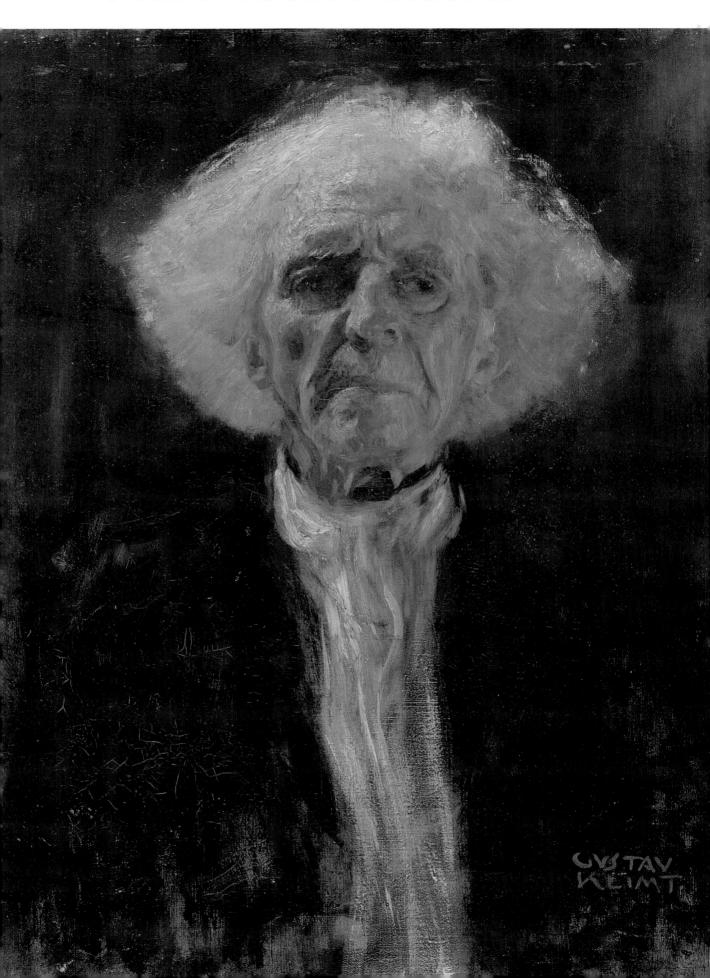

CHILD (1902)

Courtesy of Historical Museum, Vienna

LTHOUGH Klimt's main portrait and drawing repertoire saw the realisation of beautiful woman, occasionally he broke away if an interesting subject matter or composition presented itself, as in *Portrait of the Blind Man* (date unknown), or that of his niece, Helene Klimt, in 1898. Here, the beautiful innocent face of a baby girl framed by a bonnet fills the picture, its light colour framework, possibly crayon or even water-colour, allowing Klimt to develop effects such as texture and contrast. The pencil lining shows that it is quite roughly drawn, however, he still manages, using a few simple lines, to create the paradoxical sensations of delicacy and purity associated with childhood that were explored to great effect in the more substantial 1898 oil painting, *Helene Klimt*.

This child's identity is not known and the limited records kept by Klimt about his work do not reveal whether it was commissioned

by a wealthy client or if she was the child of a friend or model. The work, like the *Helene Klimt* portrait, was probably completed by the use of photography, as it would have been difficult for the small child to sit still for the work.

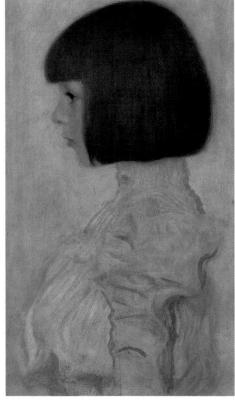

Helene Klimt (1898) Courtesy of Osterreichische Galerie Belvedere, Vienna. (See p. 66)

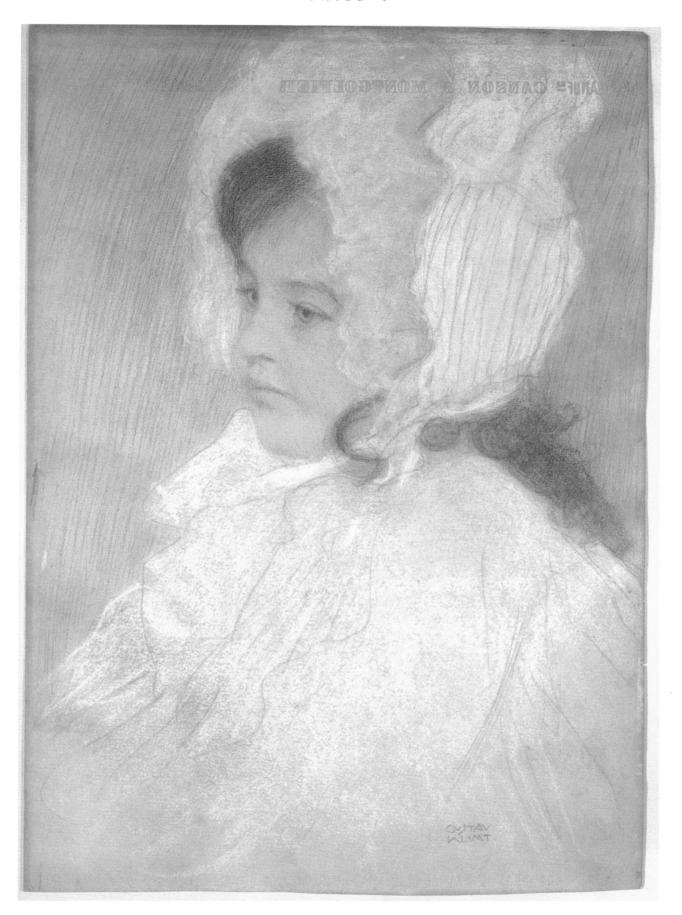

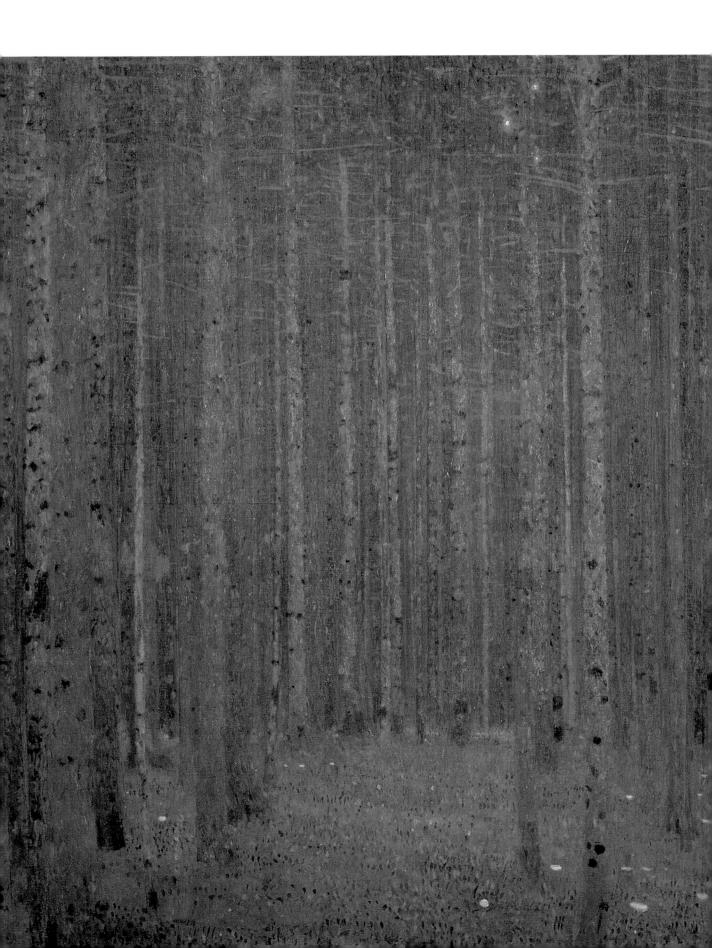

PINE FOREST (FOREST OF FIRS I) (1902)

Galerie Wuerthle, Vienna. Courtesy of AKG London/Erich Lessing

HE patterned effects generated by Pointillism continued to inspire Klimt during his Austrian Alps holidays with Emilie Flöge. The work is set, like all his landscapes, within a square composition, believed by mystics and Theosophists to be the symbol of perfected harmony and universal balance. *Pine Forest* shows the artist-priest at one with nature, communing with the divine through tranquil meditative contemplation.

The Romantics studied by Klimt were similarly inspired by nature. However, in a rare recorded comment, he also discusses how Paul Gauguin's (1848–1903) Post-Impressionist work influenced him, comparing Gauguin's South Sea Island 'life-frieze' works to a musical poem. This work enthralled Klimt during the period he spent recreating Beethoven and Schiller to visual music in *The Beethoven Frieze*. Yet, whereas Gauguin's transcendentalism is realised through exotic idealised figures, Klimt's independent universe is the beauty of the surrounding countryside.

Here, the eternal is reflected in the trees, which, despite independent form, grow and blend harmoniously with the overall patterning. As with the *Ode to Joy* chorus in *The Beethoven Frieze*, it signifies the blending of the individual with cosmic consciousness. We do not see the treetops as they are growing to a spiritual realm beyond the canvas.

Life: A Battle (The Golden Knight) (1903)

Private Collection. Courtesy of Dr Brandstätter-Artothek

doubt inspired by the resplendent majestic Knight Templar from the 1902 *The Beethoven Frieze*, the golden knight is now mounted and ready for battle. The helmet with its heraldic colours, by his feet in the frieze, is now on his head, the colours more vividly highlighted.

Despite the horse's lifted hoof, the work has a static medieval quality, as though lifted from an ancient frieze or mural. The probable influence was Klimt's two 1903 trips to Ravenna, Italy, to see the fabulous golden Byzantine mosaics. They had a profound effect on his work. Correspondingly, this painting has a gorgeous mosaic quality, expressed in the exquisite bridle, lance handle and helmet, as well as in the backdrop's rich stippling.

This effect, combined with the one-metre (over three feet) squared composition, recalls Klimt's landscape work and esoteric

belief in the square's balancing power. It also underlines the Knight Templar's esoteric symbolism, and the Symbolists' calling to 'seek the symbol behind the appearance, the eternal idea beneath the form'. Here, Klimt, as art's knight, takes up the fight. The painting, exhibited in the 1903 Secession Exhibition, was bought by the steel magnate, Karl Wittgenstein, whose daughter Klimt painted the following year.

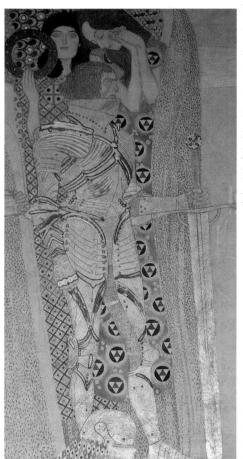

The Beethoven Frieze (1902) Detail from 'Longing for Happiness'
Osterreichische Galerie Belvedere, Vienna. Courtesy of AKG London/Erich Lessing. (See p. 124)

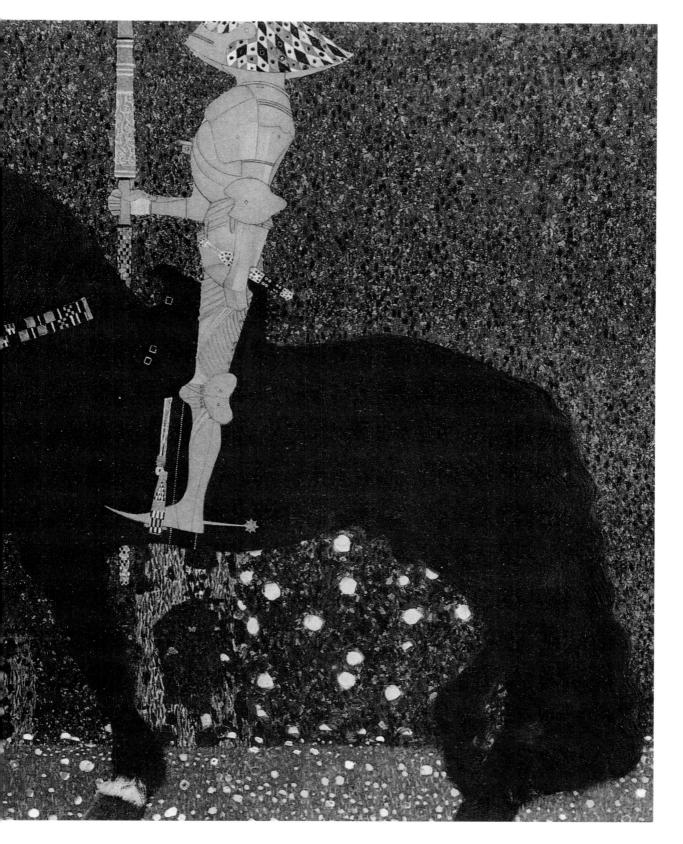

THE PROCESSION OF THE DEAD (1903)

Courtesy of Galerie Welz, Salzburg

GAIN Klimt plays with floating body imagery that features in the rising columns of life in the University paintings and runs across the Music Room walls in The Beethoven Frieze. There, the sensationally liquid women are a visual

'Longing for Happiness' Osterreichische Galerie Belvedere, Vienna. Courtesy of AKG

embodiment of Schiller's poetic 'yearnings and longings of mankind' that 'fly over' death, disease and decay. Here, in The Procession of the Dead, a year later, we see emaciated mankind flowing in the same direction but without the optimism and sensation of ecstasy associated with The Beethoven Frieze procession.

The images of the dead recall the kneeling figures from The Beethoven Frieze in supplication to the Knight, personifications of the suffering of the weak and of mankind's appeal to the strong. Yet here, their gaunt, hollowed bodies are barely recognisable as either male or female, as death annihilates Detail from The Beethoven Frieze (1902) all human characteristics. This is the destruction of the physical, as London. (See p. 124) the dead prepare for spiritual union with the cosmos, indicated

by the snake motifs which course alongside. These are not depictions of evil, but harbingers of perfect knowledge, as seen in Klimt's picture, Nuda Veritas, of 'naked truth' (1898). Sadly only black-and-white photos remain of this work, which was destroyed by the Nazis in the Schloss Immendorf fire at the end of the Second World War.

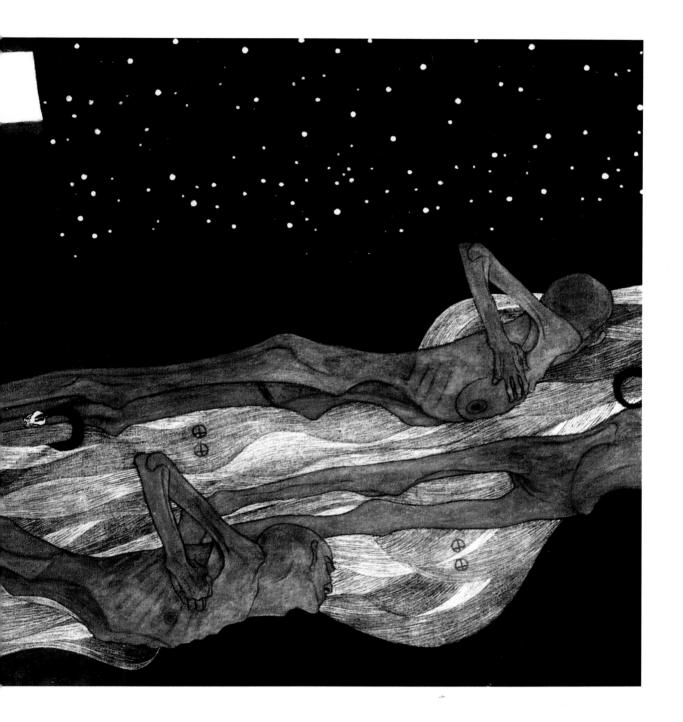

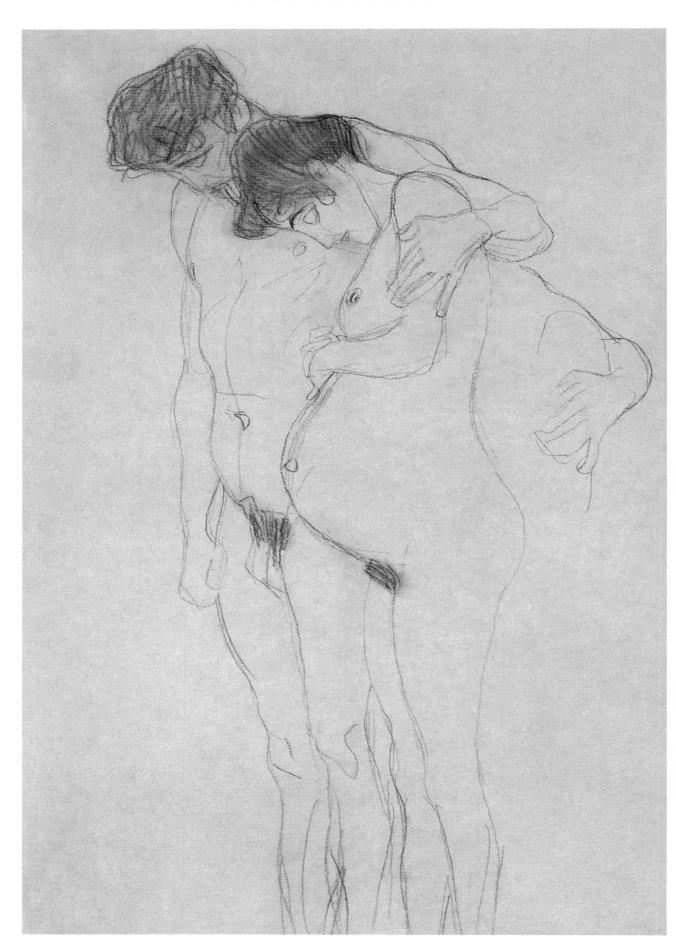

PREGNANT WOMAN WITH MAN (STUDY FOR HOPE I) (C. 1903)

Scottish National Gallery of Modern Art, Edinburgh. Courtesy of the Bridgeman Art Library

N contrast to The Procession of the Dead (1903), and the kneeling male and female nude from The Beethoven Frieze (1902), Klimt's universal couple are now filled with symbolic life in this preparatory drawing for the aptly named Hope I. Here, the naked father has his arm protectively around the heavily pregnant woman, as they both look down submissively. Their air is archetypal, as if they represent original man and woman: Adam and Eve. In the finished life-size oil, 181 cm x 67 cm (72.5 in x 27 in), the pregnant woman stands alone, her hands similarly clasped over her full-term belly. A stylised background features death imagery, including a skull and other grimaces of horror. The face and distinctive auburn hair of the model in Hope I recalls the full-frontal nude from Nuda Veritas (1899), which unlike the woman here, depicted with dark hair.

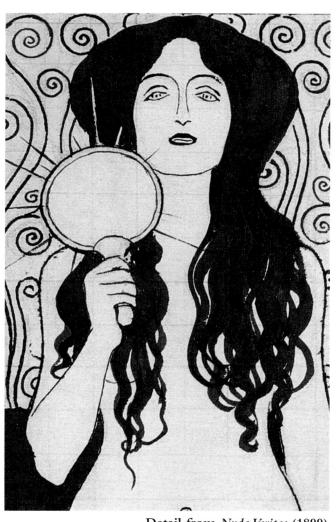

Detail from Nuda Veritas (1899) Courtesy of Historical Museum, Vienna. (See p. 78)

This auburn haired woman recurs in several works and is possibly Klimt's mistress and model, Mizzi Zimmermann. Their affair lasted from 1899 until 1903 and she bore Klimt two sons, Gustav and Otto, the latter who tragically died in 1902 at three months old. This could explain the death imagery in the final work of *Hope I*, as well as providing the motive for the *Beethoven Frieze*'s 'evil section'. Eventually, Klimt abandoned Mizzi and left her to impoverishment.

BEECH FOREST (1903)

Osterreichische Galerie Belvedere, Vienna. Courtesy of AKG London/Erich Lessing

LIMT'S beautiful delicate brushwork captures this eerie scene, a profusion of energy held in place by his sheer technical professionalism. Here, he has perfected his own adaptation of Neo-Impressionism and Pointillism aesthetics, resulting in the play of superb oppositional tensions across the painted surface.

A densely textured meshing of dots creates the golden carpet, as though the beeches' bronzed autumn foliage has fallen from the hidden tree tops. It is an explosion of separated atoms patterned into a unified mass. Crossing these dots are the striating horizontal lines of the tree bark. Klimt was undoubtedly fascinated that this series of horizontals,

piled up into a columnar structure, created the vertical lines of the trees. The resulting tension is further exaggerated by the deployment of the two powerful polarised colour blocks of red and green, whose oppositional forces accentuate the wood's stillness.

This colour tension also projects the trees dynamically out of the landscape so that they loom up translucently. Counterpoising the red floor, the trees ultimately blend into the vibrant green background, reminiscent of the intricate patterning from Life: A Battle (The Golden Knight) (1903).

Detail from Life: A Battle (The Golden Knight) (1903) Private Collection. Courtesy of Dr Brandstätter-Artothek. (See p. 142)

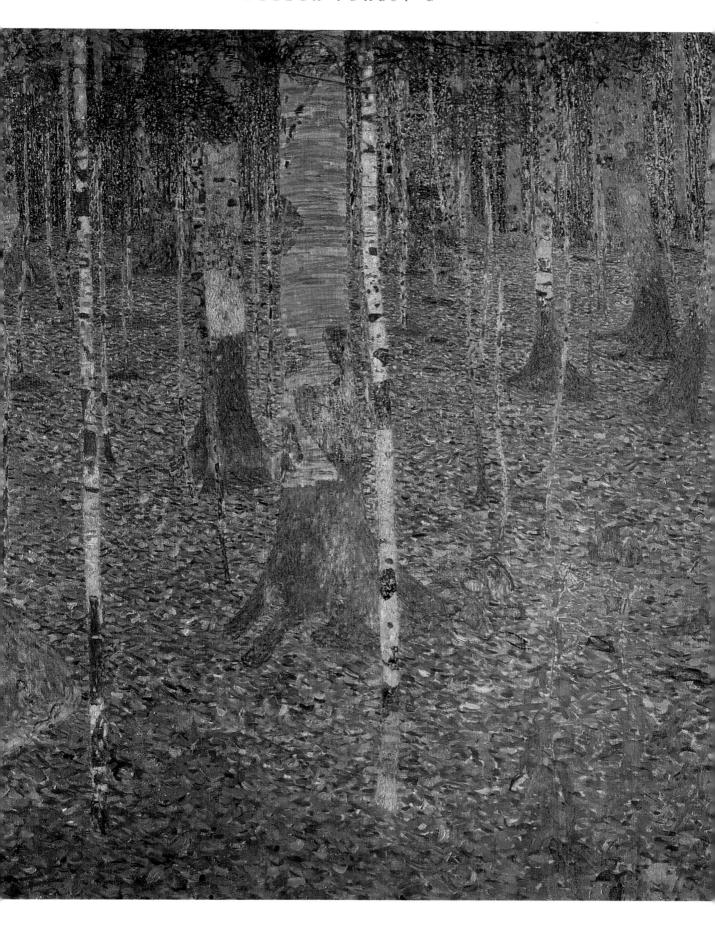

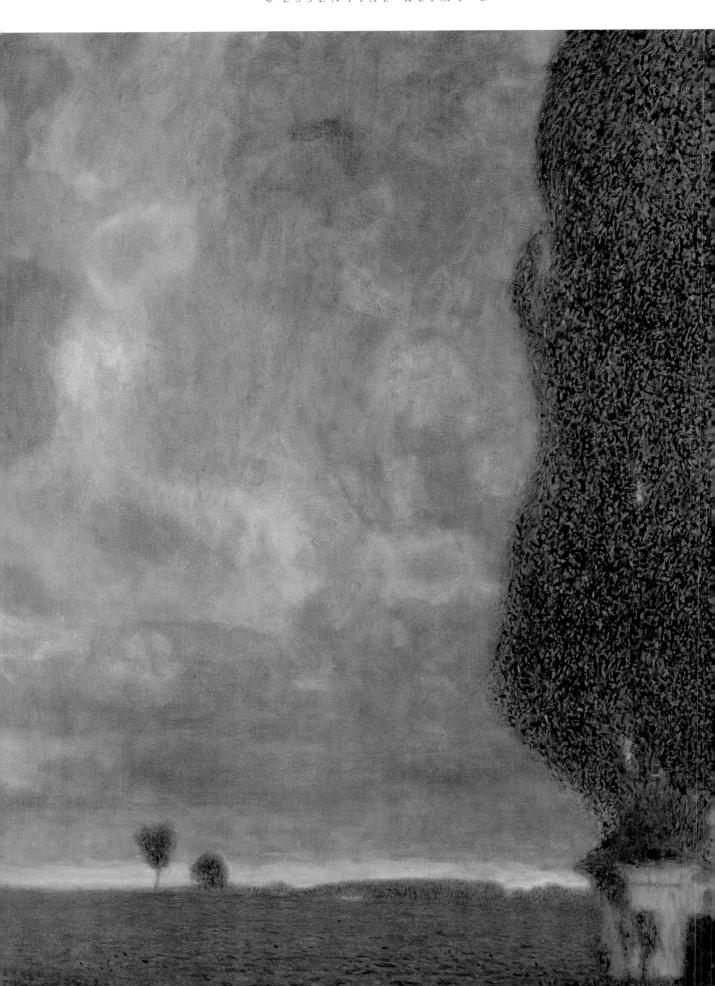

THE TALL POPLAR II (1903)

Leopold Collection, Vienna. Courtesy of AKG London/Erich Lessing

IKE a huge column of fire, this picture is full of smouldering cinders, the poplar tree shimmers in colour intensity. It is a stunning visual treat set against a smouldering moody sky, reminiscent of Joseph Mallord William Turner's (1775–1851) pre-Impressionist landscapes. The surrounding red earth bubbles and blisters as the diminutive house is consumed into the blazing mass.

In a 1903 letter to his mistress, Mizzi Zimmermann, Klimt describes how he painted this massive poplar at dusk while a big storm brewed. In a wonderful atmospheric picture he has captured the electric sensation of crackling air and the heavy oppression before such a tempest, as though the tree personifies the storm.

Some critics like to eroticise Klimt's landscapes, citing the pulsating phallic poplar tree as an example. There is a sensuality about Klimt's art, in which colour, texture and symbolism emanate from the canvas; however the result is of the Germanic pictorial concept *Stimmung*, or 'mood', which involves the centring of the artist's psyche in a subjective perceptual experience. The Russian and Secessionist artist, Wassily Kandinsky (1866–1944) later characterised it as 'psychic states disguised in the forms of nature'. The countryside for Klimt represented freedom from urban Vienna and from the confines of his studio, and the surrounding beauty heightened his senses.

BIRCH TREES (1903)

Courtesy of Galerie Welz, Salzburg

N another powerful and mesmerising landscape, Klimt excels in balancing colour and texture to construct depth, also insists on defining the painted surface as the large ghostly tree trunk pushes forcefully forward. The subtle use of red-green colour polarisation creates a tonal vibrancy so that the main tree is projected out of the landscape. As it looms up silvery translucent, the tree invokes reverse negative images of a black-and-white photograph. This could easily be mistaken for the work of a modern nature artist.

Klimt loved photography and used a camera to capture interesting effects. His interest in *Stimmung*, mood subjectivity, was enhanced by a telescope or a viewfinder, which was a cardboard box with a square hole cut out, that enabled him to focus directly on highly concentrated areas of detail. This resulted in bizarre close-up, patterned squares of perspective, like miniature snapshots of a grander panorama with timeless qualities of alienation and loneliness.

Usually Klimt would paint several times a day, rising early and returning for meals. Unlike his meticulously planned studio work, he would paint directly on to the canvas, often hiding the easel in the bushes so he could return to work later.

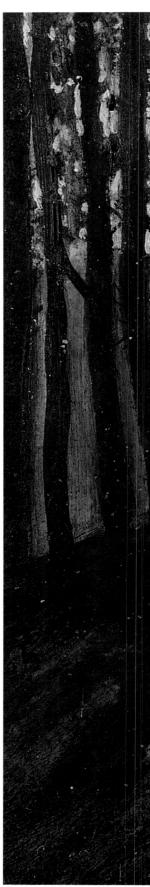

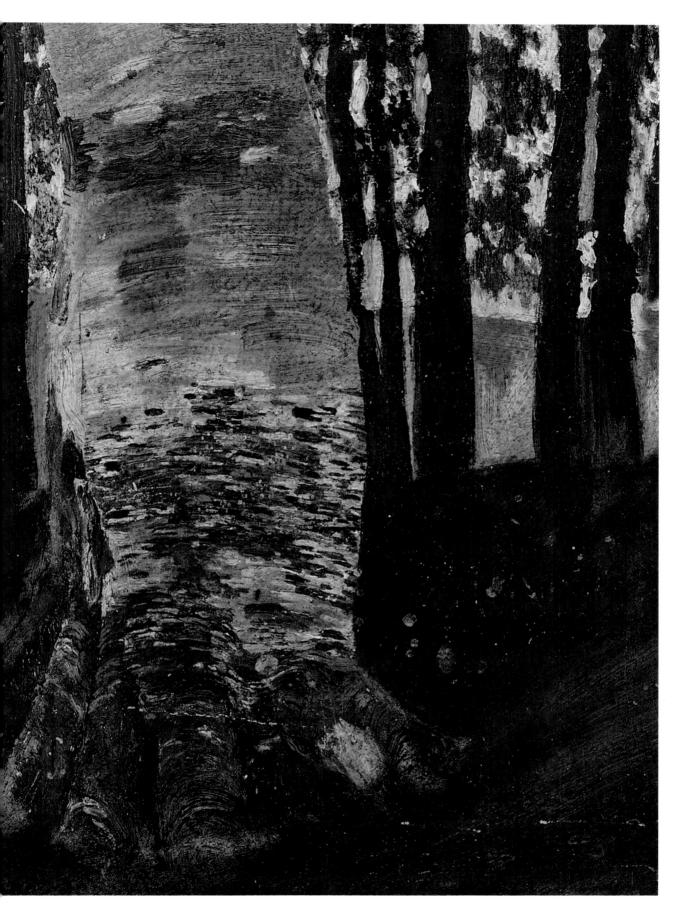

Drawing (1904)

Courtesy of Historical Museum, Vienna

HIS is probably a preliminary drawing for the portrait of *Hermine Gallia* (1904), and it is apparent when comparing the sketch with the finished article that Klimt had attempted to capture this sitter in different poses before settling on the assertive elegance of the final standing posture.

Klimt's adept draughtsmanship is evident here, as he plays with the folds and pleats of the dress's fabric to explore how it sits or falls

out of the form of the chair. The large ruffed collar and bulbous sleeves are exaggerated and he viewer can see how these details, as well as other textural aspects of the fabric, assume greater significance in the final work. The use of compositional space is crucial as the square format is split diagonally in half by the chair and sitter. The model's head is fills the top right corner while the flow of the dress takes the sight line down the diagonal to the opposite corner, bottom left. Again a few simple reductionist lines capture a sensation of facial expression and body stance as the sitter exudes an air of arrogant superiority, associated with extreme wealth.

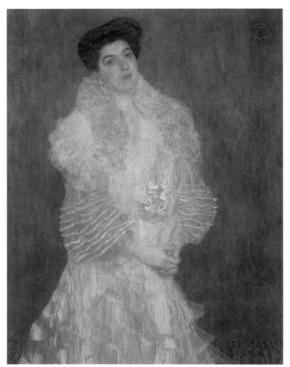

Portrait of Hermine Gallia (1904) National Gallery, London. Courtesy of AKG London/Erich Lessing. (See p. 157)

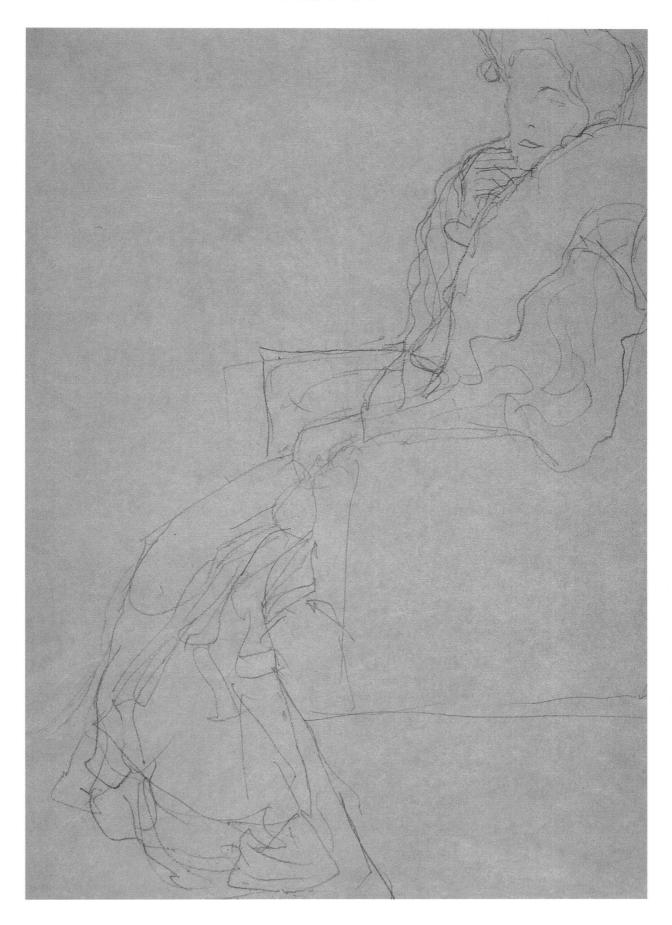

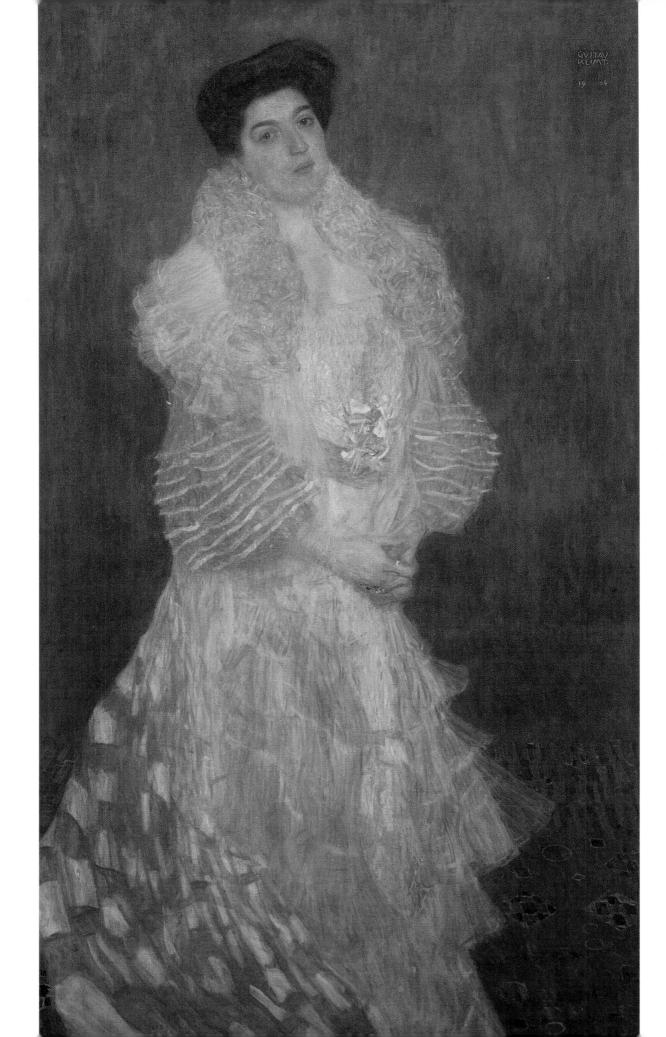

PORTRAIT OF HERMINE GALLIA (1904)

National Gallery, London. Courtesy of AKG London/Erich Lessing

N many respects Klimt's authority as a portraitist was reaching at this time its culmination, in terms of his ability to capture a realistic likeness and flattering perceptions of character. His handling of subject-matter and technical dexterity is apparent in the richness of the brushwork and colour manipulation. As has been apparent in earlier works, there is a piling of creams, whites and greys on this canvas, to create sensations of shimming light and to suggest opulence of fabric, though this is managed to greater effect in the *Margarethe Stonborough-Wittgenstein* portrait of 1905.

Colour layering also serves to construct a strong tonal armature from which the form of the sitter is built. The reductionist nature of the palette tends to deny depth, insisting instead on the painted surface and its decorative qualities. The only relief is the inclusion of a bright pink waistband which encourages the viewer's eyes to travel to the repeated colour in the facial detail with its full rose-bud lips and cheeks.

In a bid to reinstate a deeper sense of perspective, Klimt incorporated a patterned carpet in muted colours, which wash away feebly into the grey textured mass of the background. The sitter's pose is similar to that employed in the portrait of Margarethe Stonborough-Wittgenstein, completed one year later, in which Klimt's handling of luminosity is supreme.

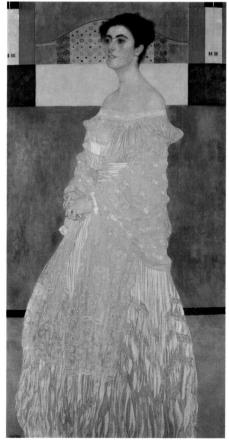

Margarethe Stonborough-Wittgenstein (1905) Neue Pinakothek, Munich. Courtesy of Artothek. (See p. 162)

WATER SNAKES I (FEMALE FRIENDS) (1904-07)

Courtesy of Christie's Images

HIS work marks a return to ornate symbolism with its mythological theme and heavy gilding. However, these entwined mermaids, a replay of Klimt's siren imagery, are femmes fatales with a difference in that they present an orgasmic

moment of lesbian love. Lesbianism is often portrayed as a voyeuristic male fantasy, and Klimt experts enjoy speculating whether this work fulfilled any particular sexual fascination for him. The cheeky face of the fish swimming into view from the right of the frame could even represent the male voyeur.

Like similar watery-themed works, such as Goldfish (1901-02), Water Sprites (1899) and Water In Motion (1898), a strong seminal movement conjures up swirling imagery to signify concepts of the primeval 'water of life'. The fabulous background of Goldfish is re-explored here as golden fronds of life sway in the currents against the black water mass. Klimt's visit to Italy's Byzantine mosaics at Ravenna, which first showed their impact on Life: A Battle (The Golden *Knight*), is fully articulated here: with blocks of intricate patterning layered into sections of floating spermatozoa-like vegetation. On a sardonic note, the artistic climax of the work is the explosion of the creatures' haloed gold hair, which involves the delicate striation of gold leaf.

Goldfish (1901-02) Kuntsmuseum, Switzerland. Courtesy of The Bridgeman Art Library. (See p. 109)

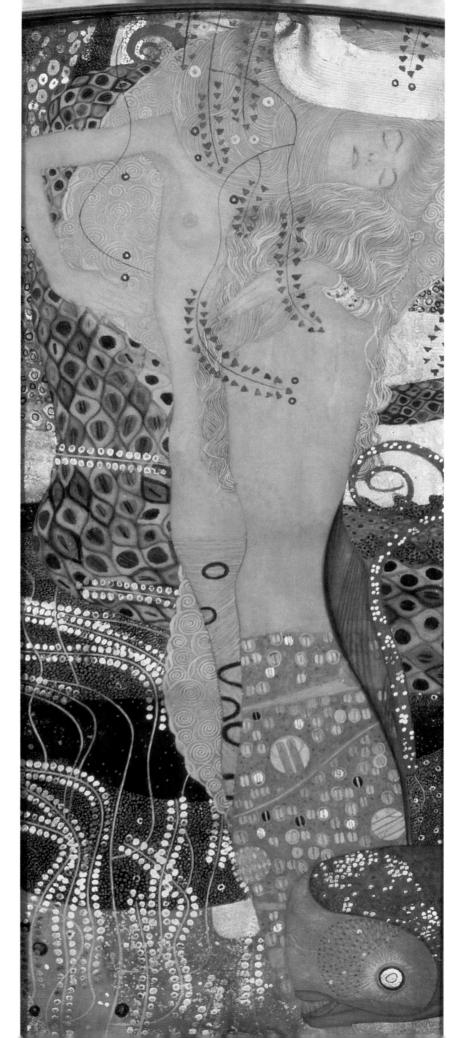

THREE AGES OF WOMAN (1905)

National Gallery of Art, Rome. Courtesy of Artothek

LIMT became absorbed with columnar structures depicting life and death after the death of his baby son, Otto, in 1902. In this work, the bright frieze-like centre section sits against an odd backdrop of horizontals, with its black cloud and panel of silver rain. This sombre expanse purposefully detracts from the splendour of the colour panel, so instead of a joyful vibrant celebration of life, the

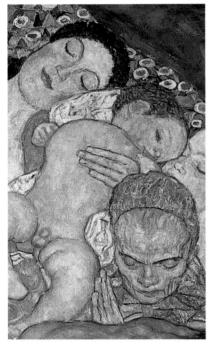

Detail from Death and Life (1911) Leopold Collection, Vienna. Courtesy of AKG London/Erich Lessing. (See p. 204)

impression is one of futility and hopelessness. This emptiness is incarnated in the bent figure of the old woman whose prominence is exaggerated by a return to detailed realism, as seen in the heavily veined ageing skin on the stretched arm. This is contrasted with the youthful complexion of the young mother, whose serene beauty is wasted and dissipated instead of uplifting, as is usual in Klimt's depictions of female loveliness.

The world seen here is one of decay, as in *The Procession of the Dead* (1903) whose emaciated figures relate to this sunken old woman. The theme recurs in Klimt's later Expressionist painting, *Death and Life* (1911–16), when Death is given an animated form, complete with skull and cudgel to beat out life, in the figure of a baby boy, possibly representational of Otto.

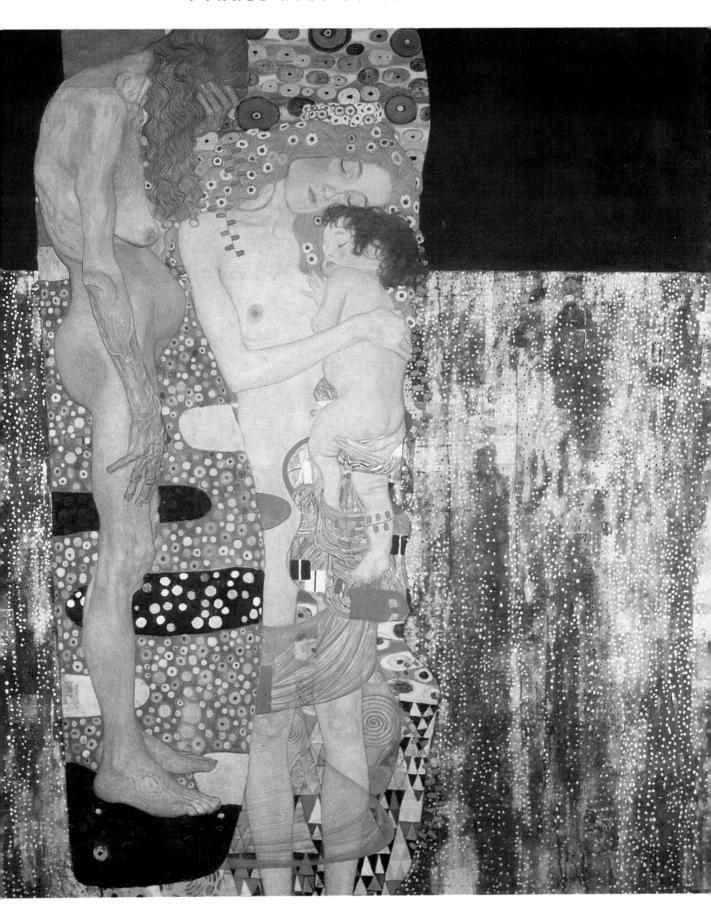

MARGARETHE STONBOROUGH-WITTGENSTEIN (1905)

Neue Pinakothek, Munich. Courtesy of Artothek

ITH regard to finesse, attention to detail and exquisite manipulation of light, this must rate as one of Klimt's best portraits. Perspective and spatial depth are carefully constructed from an arrangement of geometrical designs which were influenced by his Stoclet Frieze (1905–11) and Vienna Workshops projects. The *Jugendstil* 'total art' workshops were established in 1903 in response to

the success enjoyed by Charles Rennie Mackintosh and his wife Margaret after their Glasgow School exhibition in Vienna.

Considering the portrait's stunning presence – life-size at 180 cm x 90.5 cm (72 in x 36 in), it now seems staggering that Margarethe hated and neglected the work. The sitter was the daughter of millionaire steel magnate and Klimt patron, Karl Wittgenstein. She was a highly intellectual and independent woman, well read in the Vienna school of logical–positivism philosophy and in Freud, whom she helped emigrate to London in 1938. Brilliance ran in the family: her brother Ludwig was probably the twentieth century's greatest philosopher, and their brother Paul was a concert pianist.

This representation of Magarethe as an innocent young woman presumably offended her tough, resolute character. She was probably expecting a less conventional portrait from Vienna's then-notorious *avantgarde* maestro. The portrait was hung briefly at her home and then abandoned in an attic, before finally being sold in 1960 to the Neue Pinakothek in Munich.

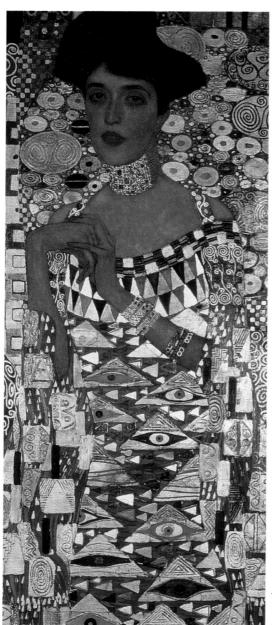

Adele Bloch-Bauer I (1907)

Osterreichische Galerie Belvedere, Vienna. Courtesy of AKG London/Erich Lessing. (See p. 184)

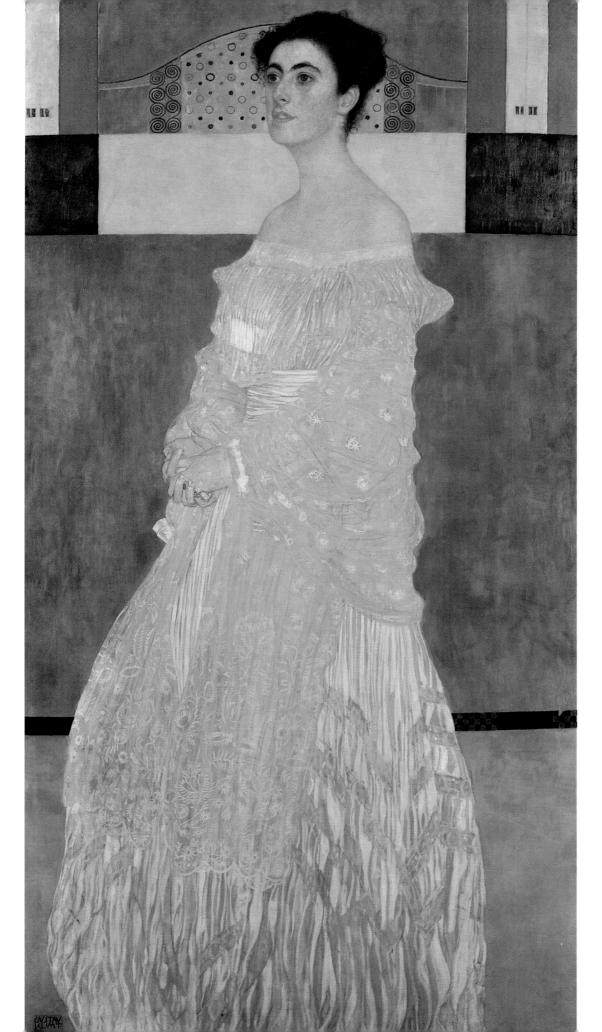

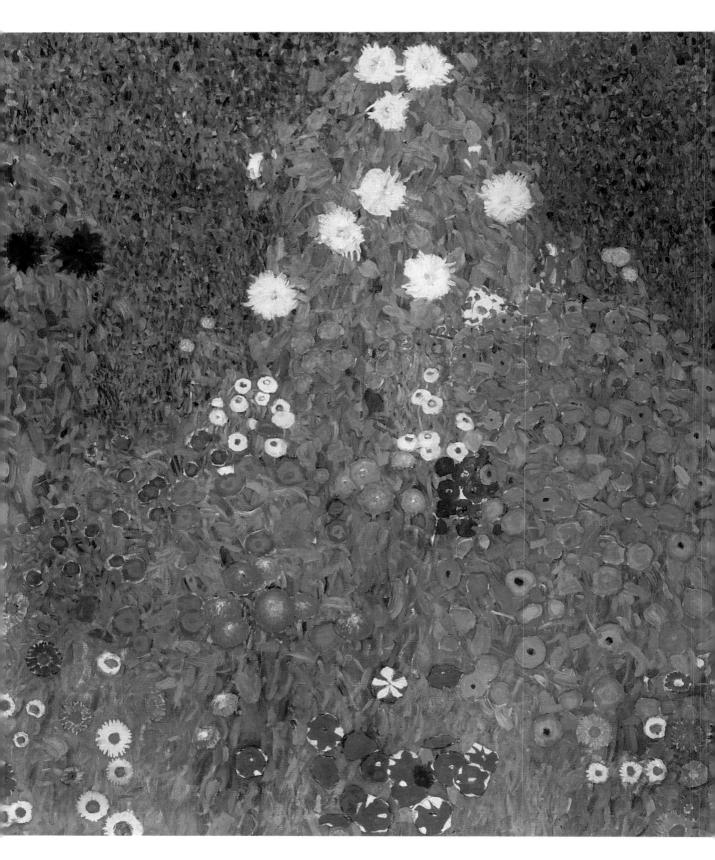

FLOWER GARDEN (1905–06)

Courtesy of Christie's Images

HIS close-up of a flower garden with its tight perspective and emphasis on the painted surface is an outpouring of Klimt's love of patterning and design. The riot of colours recalls backgrounds from some of his monumental frieze work, such as *The Beethoven Frieze* (1902), thrown down here in exaggerated profusion. The pyramidal structure gives form and shape to the intensity of patterning, which, like other of Klimt's landscape works, plays on the polarising effects of a predominant oppositional red-green palette. However, Klimt places the odd note of blue at the heart of this composition to act as a focal point within the colour confusion.

In early letters to his mistress, Mizzi, Klimt outlined how his holidays with Emilie were a whirl of constant activity. An energetic sportsman, he wrote of a punishing daily routine: of early rising, painting, breakfast, swimming in the lake, painting, lunch, nap, swimming or rowing and then more painting after tea. He revealingly wrote, 'doing nothing gets boring after a bit'. It is clear that he was an utterly driven man. Obsessed by his beloved work, he took no true holidays – every day was an artistic journey of discovery. Away from the confines of the city, this powerfully built man enjoyed 'shaking up the muscles' with a rigorous programme of physical exercise.

Detail from The Beethoven Frieze (1902) 'Ode to Joy' Osterreichische Galerie Belvedere, Vienna. Courtesy of Artothek. (See p. 130)

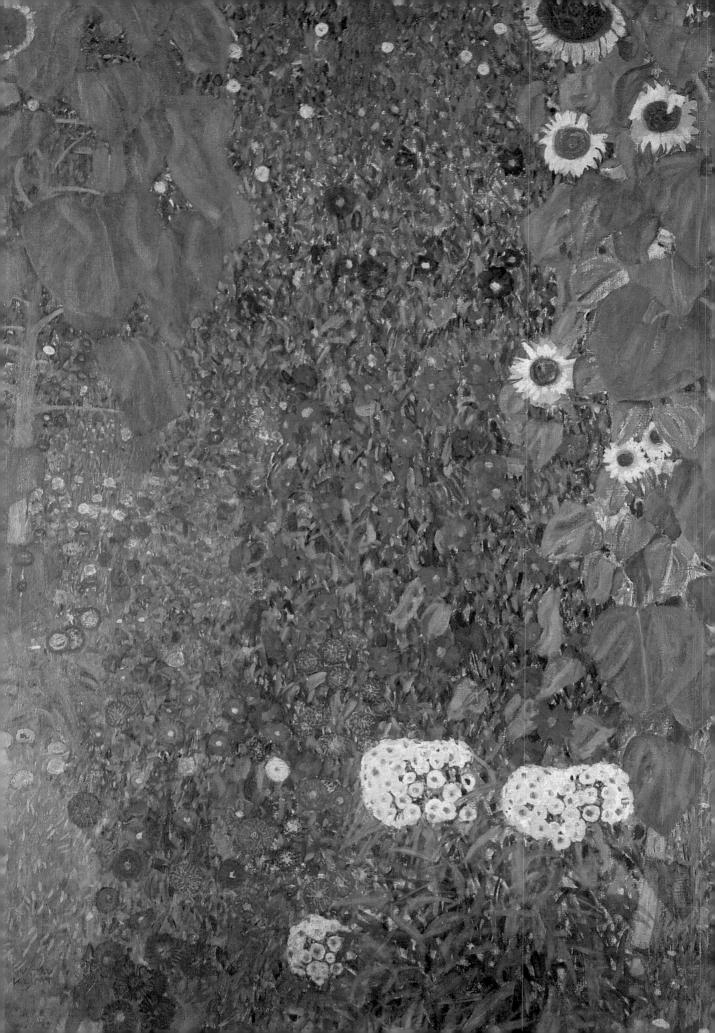

COUNTRY GARDEN WITH SUNFLOWERS (1905–06)

Osterreichische Galerie Belvedere, Vienna. Courtesy of AKG London/Erich Lessing

*UNFLOWERS in an Impressionist scene immediately make one think of Van Gogh. Here, Klimt's brilliance of colour and dextrous brushwork recalls aspects of Van Gogh's highly influential work; yet, Klimt's perspective forces the colours close to the picture's surface so they dazzle the viewer. As in Flower Garden, probably painted the same year, there is a strong polarising effect of a predominantly red-green palette, though here, Klimt uses contrasting bright yellow and electric blue to create a compositional structure out of this riotous mass. The deep indigo-blue, like opulent lapis lazuli, recalls the bejewelled effects of his frieze work and serves to establish a base from which the main sunflower rises up in a pyramidal structure, the yellow heads denoting the apex of the chief triangular format.

The cropped sunflower to the left suggests a pattern repeat as if this were a section of material or wallpaper. This reflects Klimt's interest in the Arts and Crafts movement of William Morris, and in Charles Rennie Mackintosh's Glasgow School, which took Vienna by storm and saw the formation of the Vienna Workshops. Klimt, a board director, worked on several Workshop interior design commissions during this period, notably *The Stoclet Frieze* in Brussels.

WORKING CARTOONS FOR THE STOCLET FRIEZE 'TREE OF LIFE WITH BUSH' (1905–1911)

Osterreichische Galerie Belvedere, Vienna. Courtesy of The Bridgeman Art Library

HE magnificent Palais Stoclet in Brussels is an important example of Art Nouveau and the only remaining house decorated by Klimt and his Vienna Workshops, the Wiener Werkstätte. Klimt, in a rare recording of his thoughts, recognised this commission's significance, stating it was the 'ultimate stage of my development of ornament to which I have devoted years of probing and struggling work'. Sensitive after the University paintings scandal and the mockery of his fabulous The Beethoven Frieze, he refused to let curious Vienna see his decorative climax, a huge mosaic frieze for the palace dining room, which featured these bushes as part of the central 'Tree of Life' panels.

Coal baron Adolphe Stoclet, an admirer of their work, ordered the construction of his extraordinary three-storey, 40-room house, using the most expensive materials available. Even today, the family cannot assess the project's total cost.

Palais Stoclet was the Vienna Workshops' first total arts integration commission: they were able to design a complete residence all the way through; from the architecture through to the cups and saucers. The

Workshops, influenced by the works of William Morris and Charles Rennie Mackintosh, were a response to the overwhelming predominance of machine manufacturing following the Industrial Revolution in Europe. Their philosophy idealised a return to traditional methods, with Klimt again as leader and board director.

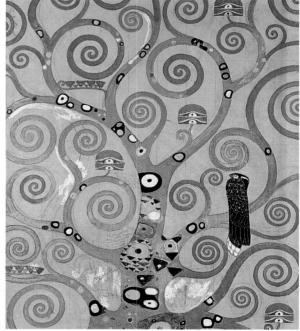

Working Cartoons for The Stoclet Frieze (1905–1911) 'Tree of Life' Courtesy of MAK – Austrian

Museum of Applied Art. (See p. 170)

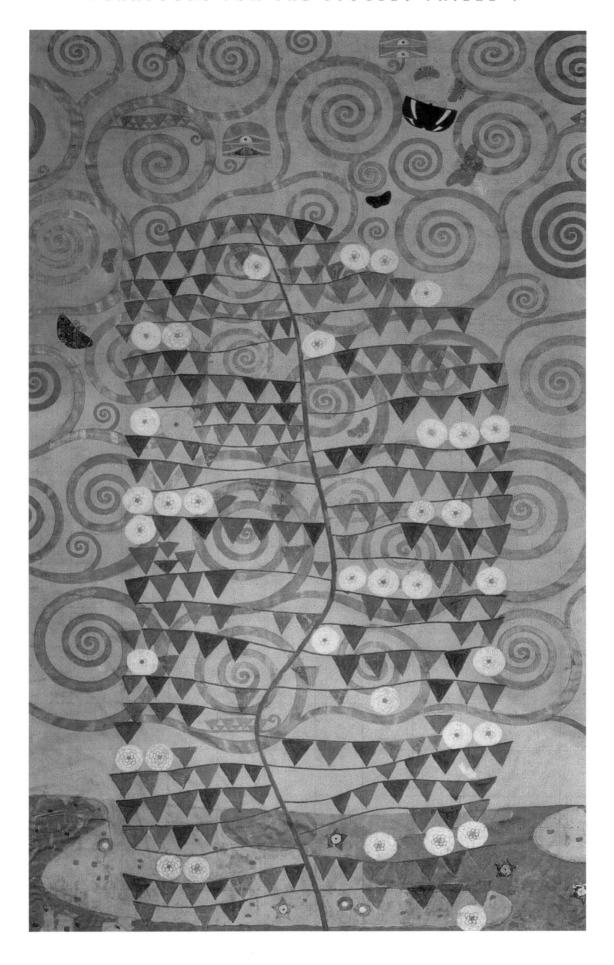

Working Cartoons for The Stoclet Frieze (1905–1911) 'Tree of Life'

Courtesy of MAK - Austrian Museum of Applied Art

LIMT worked on *The Stoclet Frieze* mosaics by preparing cartoons from which Vienna Workshops craft workers could construct the intricate panels. He laboured on these actual-size templates for five years and the finished mosaic was not completed until 1911. The immense dining room is 14 metres (60 feet) long with sideboards running down each side, over which sits the Klimt frieze. Down both sides, this 'Golden Tree of Life' organically spirals and scrolls, incorporating the female personifications of 'Expectation' and 'Fulfilment' who face each other at either end.

The frieze is a phenomenal celebration of Symbolism as Klimt's collective storehouse of enigmatic emblems, such as sacred Egyptian hawk-gods, Neo-Platonic eyes of Isis and esoteric geometry, is lovingly realised in the most fabulous materials possible. The cartoons, in tempera,

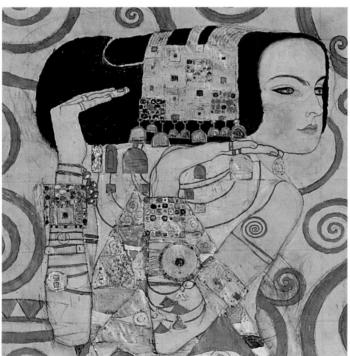

Working Cartoons for The Stoclet Frieze (1905–1911) 'Expectation'
Courtesy of Claus Hansmann-Artothek. (See p. 174)

chalk, water colour, gold, bronze and silver leaf, were translated onto 15 sheets of white marble, seven along each wall and one in the middle for the celebrated abstract section, all inlaid with copper, silver plate, corals, semi-precious stones, gold mosaics, enamel and coloured fäience, (earthenware and porcelain pieces). For instance, the two rose bushes contained 200 enamel leaves in different shades of green - the colours were precisely specified by Klimt.

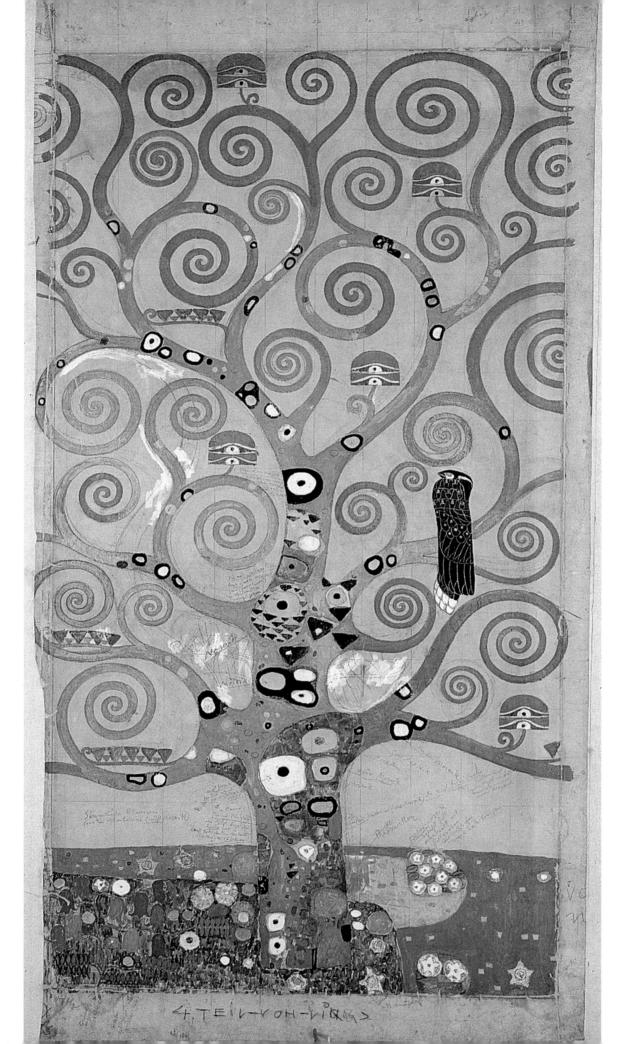

Working Cartoons for The Stoclet Frieze (1905–1911) 'Narrow Wall'

F. andewandte Art Museum, Vienna. Courtesy of Dr Brandstätter-Artothek

HIS amazing geometrical design presents the art world with a major conundrum: is this the 20th century's first abstract work? The revolutionary advancement of non-representational art is usually dated to around 1910, with works by Wassily Kandinsky (1866–1944) and Pablo Picasso's (1881–1973) Cubism. Critics argue this cartoon is not really a painting but a decoration, in which case it would not count – but that seems ridiculously petty.

Set in the narrow end of the dining room, this mosaic's beautiful abstraction provides a stunning contrast to the two swirling elongated

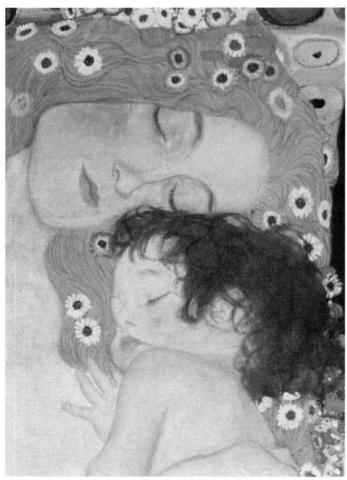

Detail from Three Ages of Woman (1905)National Gallery of Art, Rome. Courtesy of Artothek. (See p. 160)

panels along either side. Elements recall previous ornamentation devices: Emilie Flöge's portrait dress, the floral kiss section from The Beethoven Frieze (1902), and Three Ages of Woman (1905), all come together into another Klimt columnar structure. Some critics believe that this abstract represents a human figure without eyes, which would associate it with late-Cubist figure-work. However, it is more like a geometric personification of the Tree of Life. The tree grows from the earth's subterranean depths, which is symbolised by the blue, square configuration; continuing through a green organic section and a multi-coloured column, and reaches the white light of cosmic union, symbolised by the square at the crown.

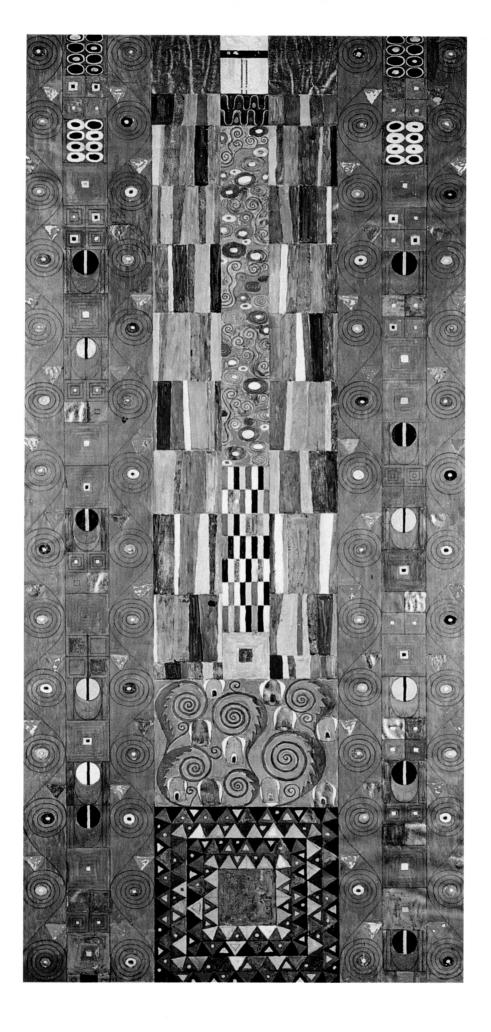

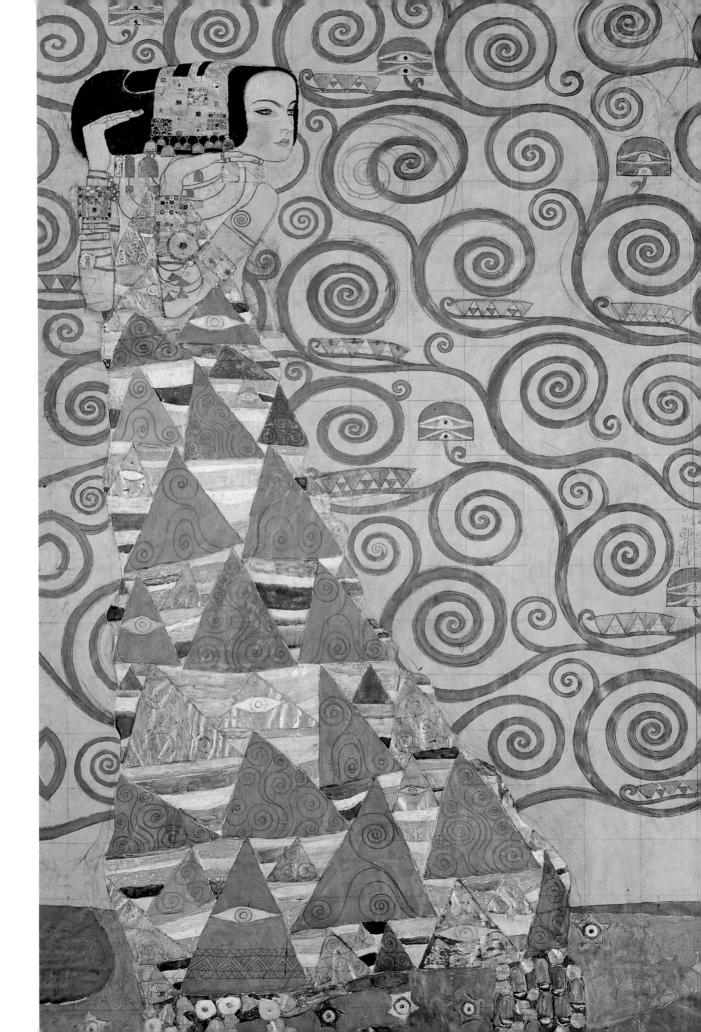

Working Cartoons for The Stoclet Frieze (1905–1911) 'Expectation'

Courtesy of Claus Hansmann-Artothek

NE of the two female personifications which face each other across the Stoclet dining-room, this image of 'Expectation' suggests strong Japanese influences, with its Oriental facial characteristics and kimono-like robe. The figure's poise and stance also recall Japanese woodblocks, which Klimt enjoyed collecting. The ornate dress is densely filled with the geometric abstract schema, a deliberate counterbalance to the organic 'Tree of Life' swirls, which stretched the whole length of the dining room walls and can be seen

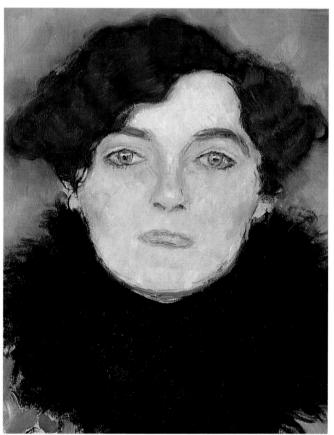

Portrait of Johanna Staude (1917–18)
Osterreichische Galerie Belvedere, Vienna. Courtesy of AKG
London/Erich Lessing. (See p. 241)

in the background here. To maintain a sense of harmony between the abstract and floral, the coiling motif, reminiscent of classical Indian and Islamic art, is repeated in the triangles. Esoteric symbolism is embodied in the Neo-Platonic 'Eye of Isis', a recurring image during this period in the work of artists interested in Theosophy.

The fabulous heavy jewellery recalls similarly adorned Egyptian queens and goddesses but probably also represented trinkets made by the Vienna Workshops; some worn by Stoclet's wife, Suzanne, and as seen in other Klimt pictures of women such as Adele Bloch-Bauer. This 'Life as Art' doctrine, preached by the Vienna Workshops, saw patrons wearing clothes and

jewellery co-ordinated with their new interior design. Stoclet also had many Egyptian and Chinese antiquities that could be accommodated in the designs, hence Klimt's final selection of motifs.

WORKING CARTOONS FOR THE STOCLET FRIEZE (1905–1911) 'FULFILMENT'

Osterreichische Galerie Belvedere, Vienna. Courtesy of AKG London

NCE again, as in the spectacular finale of *The Beethoven Frieze* (1902), Klimt returns to his ultimate expression of artistic perfection, the image of the kiss, which represents spiritual union and being at one with the cosmos. Unlike the figures in *The Beethoven Frieze*, the woman is now featured facially but her body is only granted full exposure in the final celebration, *The Kiss* (1907–08). This splendid precursor allows Klimt to explore the abstract patterning which makes the final 1907–08 painting so compelling.

The composition of the embracing couple again features Klimt's fascination with a columnar structure, produced from a layering of intricate geometric patterns, resplendently realised in a coat of many colours. It is a webbed gridwork of ornamental abstraction – squares,

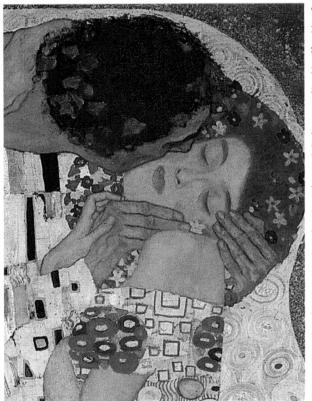

The Kiss (1907)Osterreichische Galerie Belvedere, Vienna. Courtesy of AKG London. (See p. 191)

circles, triangles and stars, fabricated in an extravagance of semi-precious stones and rich materials, with symbolic bird, fish and Isis eye motifs.

Stoclet deliberately destroyed all his financial records but it is known that Klimt's materials cost 100,000 crowns; his fee was probably a similar amount. This figure takes some shape when compared with a clerk's typical annual salary of 7,000 crowns. The monumental commission's expenditure ran into the equivalent of millions today, with its malachite, marble and onyx walls, inlays and matching carpets, as well as the secondary items such as furniture, china, chandeliers and curtains.

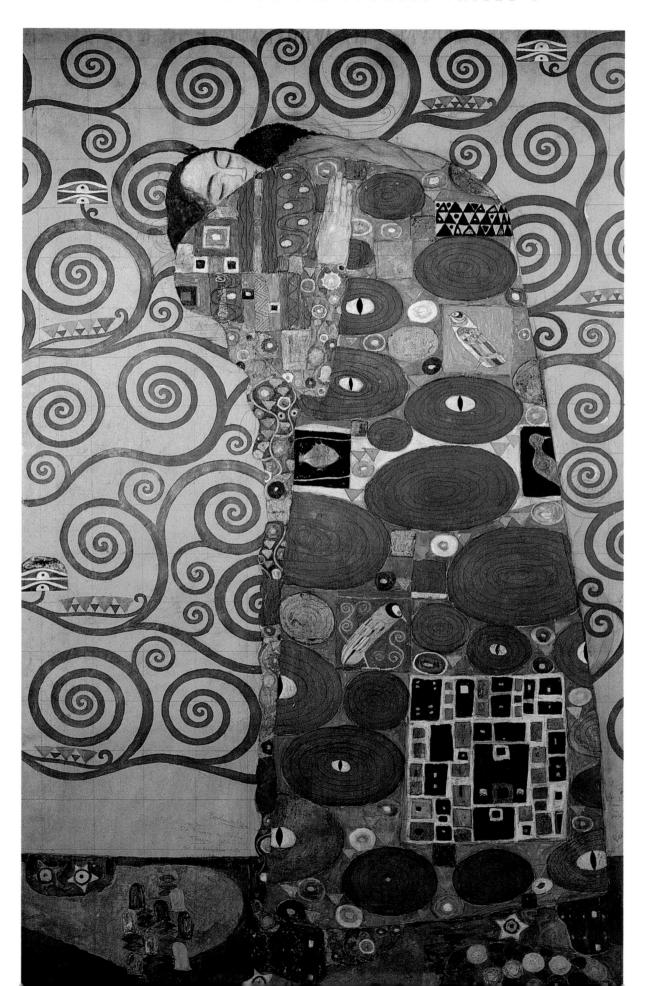

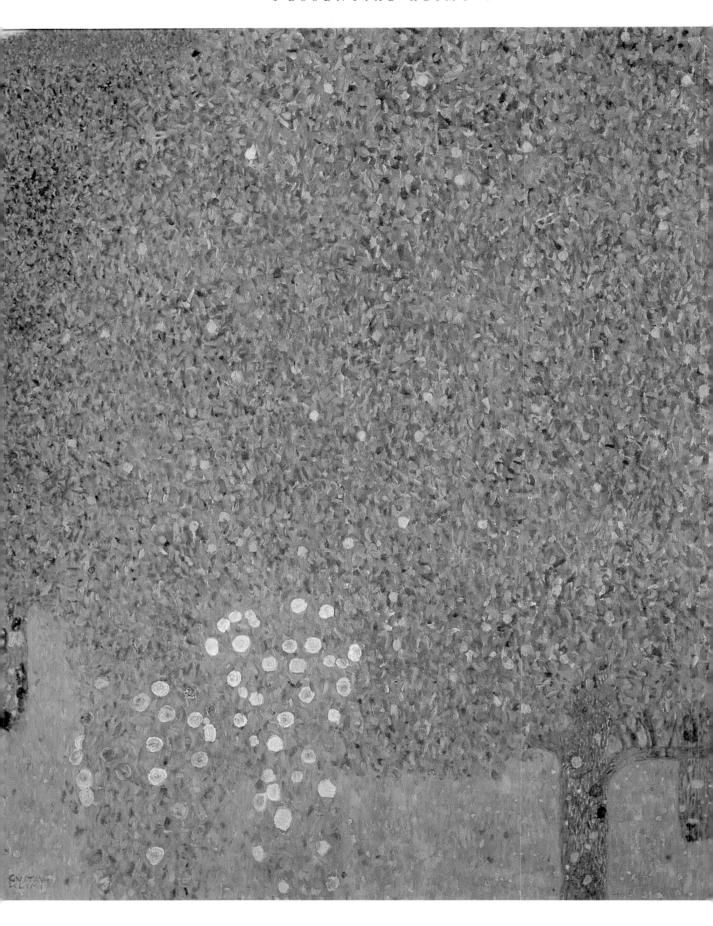

Roses Among the Trees (1905)

Musée d'Orsay, Paris. Courtesy of AKG London/Erich Lessing

ERE, the tight flower patterning, seen in works such as Flower Garden (1905–06), explodes on to a grander scale in a series of tree compositions, including Roses Amongst the Trees. A profusion of intricately deposited Pointillist-like daubs builds up in to dense foliage, a meshing of green and lilac-blue hues interspersed by the intense yellow smears of fruit. This blue-green eruption of fecundity creates a vibrant colour contrast, unlike the predominant red-green colour polarisation used in Klimt's previous land-scape works. Consequently, the perspective is almost obliterated as colours swell up on the picture's surface. To break up this profuse mass, the white climbing rose, a symbol of love portrayed on The Stoclet Frieze's (1905–11), 'Bush of Life' section, imposes its presence.

Like *The Stoclet Frieze*, the work is almost abstract in nature and is certainly at the vanguard of 20th-century Expressionism, with its need to distort reality in order to express emotion or inner vision. Correspondingly, the tree represents for Klimt, a celebration of life, instead of his typical eerie, alienated woodland landscapes with their

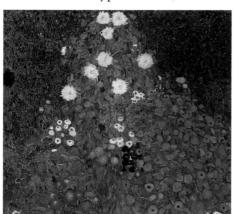

Flower Garden (1905–06) Courtesy of Christie's Images. (See p. 165)

spindly pillars of ghostlike trunks. A similar celebration is recaptured in reduced form in *The Stoclet Frieze*'s 'Tree of Life' imagery with its gilt organic spiralling.

THE SUNFLOWER (1905)

Private Collection. Courtesy of Dr Brandstätter-Artothek

HE sunflower here rises up as a symbolic central column, a lush succulent image of fecundity. The one large, solitary head, compared to the multi-headed plant in the earlier work, gives this flower an iconic bearing. This is nature's beauty at its height, both figuratively and literally. The iconic aspect is further emphasised by the darkly worked backdrop which throws the flower head majestically up to the picture surface. Compared to the joyous floral setting of Country Garden with Sunflowers (1905–06) this picture has a

sombre feel as the massive plant, symbol of sunshine, grows out of its pretty floral base toward some perceived light outside the picture frame. This base also helps to project the weighty plant out of its heavy blue and green environment.

The work recalls *The Stoclet*

Frieze's (1905–11) 'Fulfilment' panel where the floral base is mirrored on a more abstract level in the patterning of the female figure's dress. The fact that the paintings were being worked on at the same time demonstrates Klimt's inter-mingling of techniques and styles between landscape and studio work. It was all part of the 'probing and struggling', as he called it, when discussing his 'development of the ornament'.

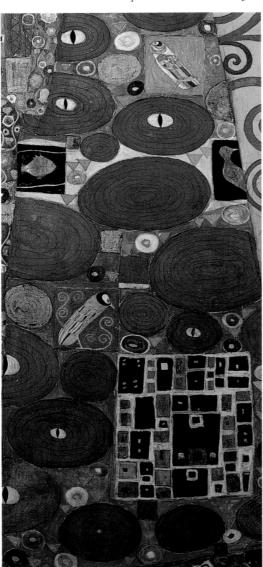

Working Cartoons for *The Stoclet Frieze* (1905–1911) Detail from *'Fulfilment'*

Osterreichische Galerie Belvedere, Vienna. Courtesy of AKG London. (See p. 176)

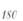

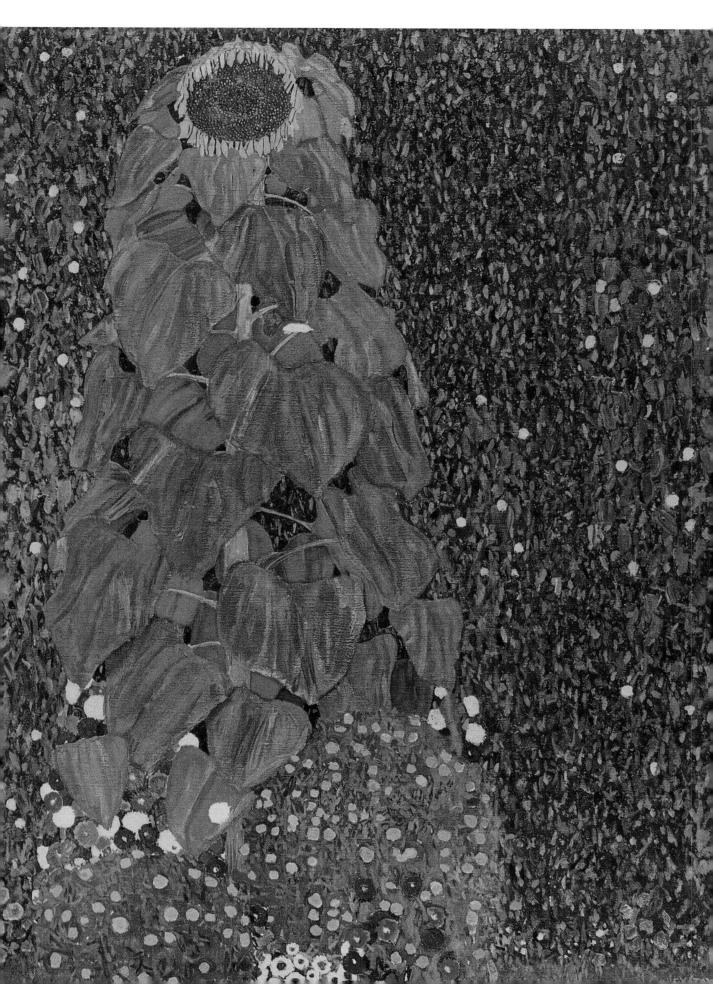

FRITZA RIEDLER (1906)

Osterreichische Galerie Belvedere, Vienna. Courtesy of AKG London/Erich Lessing

HE German wife of a Viennese privy counsellor, Fritza Riedler marks the start of Klimt's celebrated 'Golden Period', with which he is more popularly associated today. Sat rigidly in an abstract framework, she appears trapped by the ornamentation around her. As in Klimt's *The Stoclet Frieze* (1905–11) geometric exploration is now being assimilated into other studio work, whose output, apart from this portrait, diminished during this period because of his absorption in the time-consuming Stoclet commission.

Spatial depth is introduced in this picture by an interlocking series of rectangles and squares whose colour armature, particularly the polarising effect of the red-green oppositional force-field, lifts the white figure up to the picture surface. However, there is a strong counter-tension in the weight of ornamentation around the sitter, who seems to be trapped by the almost abstractly represented armchair with its resplendent symbolic Eye of Isis imagery.

Unlike the shining realism of the dress fabric in the 1905 *Margarethe Stonborough-Wittgenstein* portrait, the dress here, a year later, is Impressionistic in depiction, forcing the viewers' attention instead to focus on the work's intense decoration. For instance, Fritza's head appears to be framed by an elaborate head-dress – until one realises it is actually an intricate mosaic stained-glass window behind her.

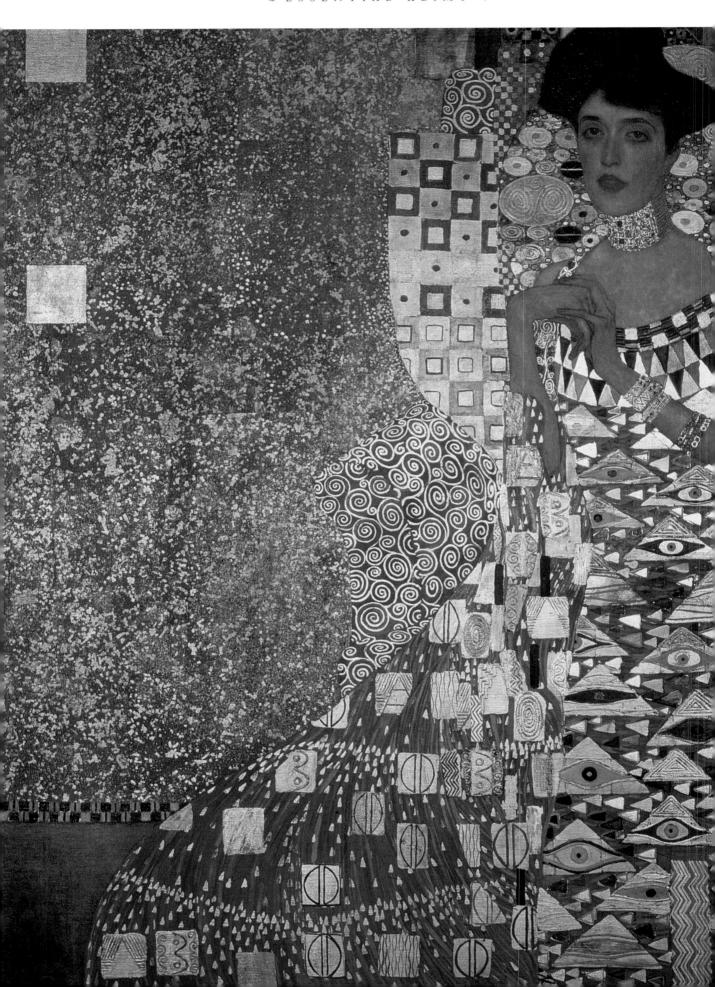

ADELE BLOCH-BAUER I (1907)

Osterreichische Galerie Belvedere, Vienna. Courtesy of AKG London/Erich Lessing

ERE the sitter, Adele Bloch-Bauer, wife of an industrialist and possibly Klimt's long-term lover, is almost completely subsumed by the weight of ornamentation around her. She appears consumed by this fire of gold, lovingly set around her, as gold-leaf is carefully laid down and then exquisitely etched to create a sense of visual perspective and depth. Produced at the height of Klimt's 'Golden Period', the portraitist shows Bloch-Bauer at one with her surroundings, as though fabricated by the artist and moulded into his setting. This is unlike the earlier Judith with the Head of Holofernes (1901), in which a younger Adele appears to be symbolically decapitated by the golden surround, representational of the fate of Judith's victim, Holofernes.

Klimt expert Frank Whitford believes this lavish painting speaks volumes about the declining years of the Austro-Hungarian Empire, with its elaborate political compromises and the ever-widening gulf between pretence and reality. The portrait can also be read as Vienna's tardy response to the late nine-teenth-century art movement, Decadence, with its emphasis on the isolated role of the artist and belief in the superiority of the artificial to the natural, as counselled by Aubrey Beardsley, a recognised influence on Klimt.

DANAË (1907)

Private Collection. Courtesy of AKG London

LIMT'S return here to the mythological story of Danaë is interesting at this mid-point of his career, as in some ways the erotic pose and hair colouring of the model recalls the *Goldfish* (1901–02), his cheeky response to detractors of his University painting series.

In 1907, he was being hassled by the Viennese art world to publicise *The Stoclet Frieze* (1905–11) which he adamantly refused to do. Whether the production of *Danaë* is a similar response to that shown with the creation of *Goldfish* is not known, but the orginstic facial expression is also an echo of *Water Snakes I* (*Female Friends*), (1904–07), which was also completed during this period.

Danaë was a popular topic with Renaissance painters, used as a symbol of the transfiguring effect of divine love. The subject was used notably by Titian (1485–1902) and Rembrandt (1606–69), whom Klimt would have studied as a student. Imprisoned by her father, King of Argos, in a bronze tower, Danaë was visited by Zeus in a shower of gold and later gave birth to Perseus, the slayer of the Gorgon. Classical pictures of her were often erotic, hence Klimt's stunning work in which the Zeus shower is signified by a seminal stream of gold particles flowing between her legs as she curls foetally in a royal purple veil, seen in earlier works such as *Medicine*'s figure of 'Hygeia'.

Water Snakes I (Female Friends) (1904–07) Courtesy of Christie's Images. (See p. 158)

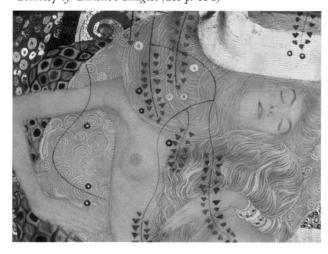

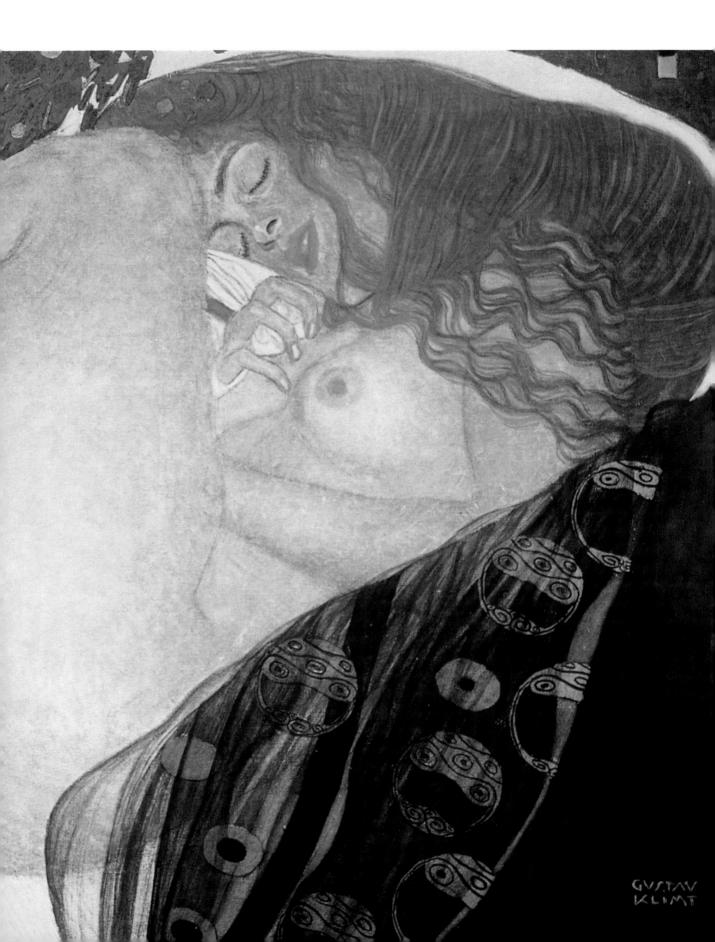

FIELD OF POPPIES (1907)

Osterreichische Galerie Belvedere, Vienna. Courtesy of Artothek

HE polarising effect of the red-green colour opposition comes into effect in this poppy-filled landscape, one of Klimt's few to present a long perspective and deep horizon. In fact, instead of a dense background throwing colours or subjects to the picture surface, as in *The Sunflower* (1905), this work features a tightly packed foreground, with red intensity, to emphasise the panoramic horizon.

Instead of finding ourselves confined within a close-up section of a landscape, we are treated to a lofty view, looking down on this luscious, fecund scene with its poppy explosion and fruit-laden trees. This, for Klimt, is his Garden of Eden, a world where he meets the divine through art. Again the work is reminiscent of Van Gogh's Impressionism and that of Pointillism champion Camille Pissarro (1830–1903).

Another interesting aspect is the myriad of greens which have been carefully selected and precisely placed to create an overall tonal, yet

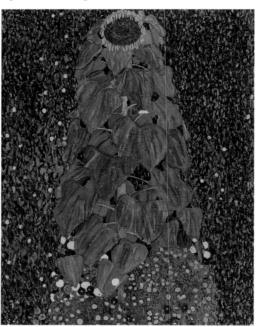

The Sunflower (1905) Private Collection. Courtesy of Dr Brandstätter-Artothek. (See p. 180)

decorative, armature. This exploration of a single colour is a feature of many landscape works, and became an important issue in the development of *The Stoclet Frieze* (1905–11), as records show. For instance, Klimt spent months specifying exactly the right green enamels to be used for the Rose Bush sections, leaving exact instructions to metalcraft workers about their implementation.

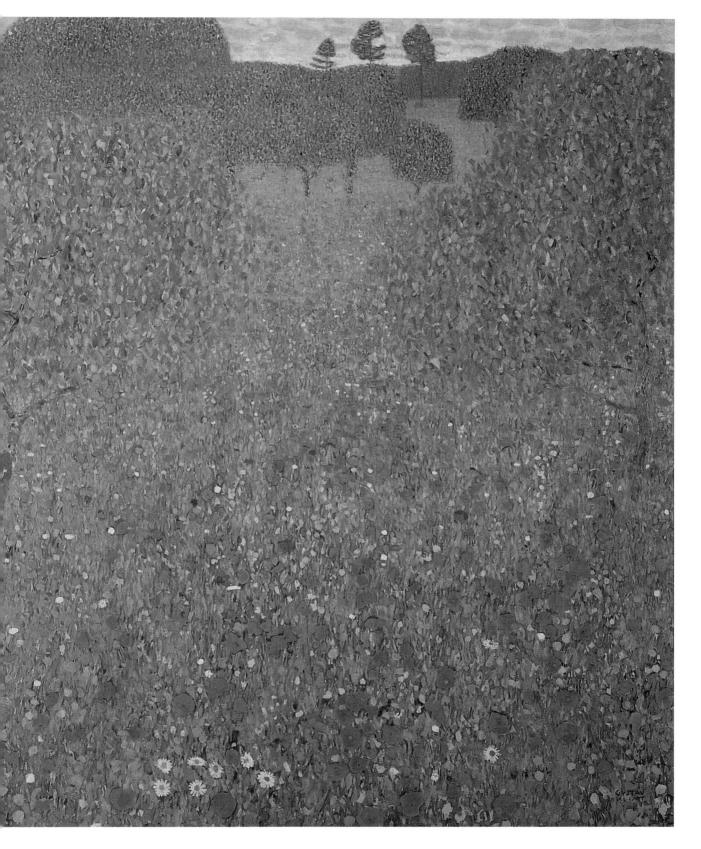

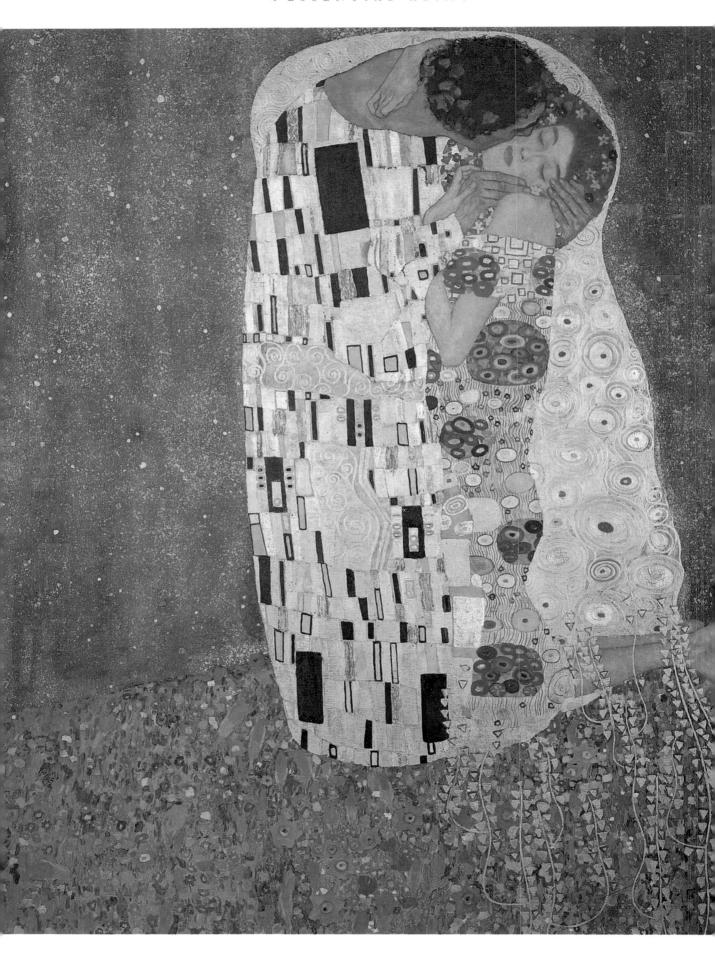

THE KISS (1907)

Osterreichische Galerie Belvedere, Vienna. Courtesy of AKG London

HIS is Klimt's most popular work and visitors flock annually to see it in Vienna's Austrian Gallery. At a remarkable 180 cm x 180 cm (72 in x 72 in), its powerful presence resounds from the wall as the life-size figures, wrapped in gold, embrace. Representing the apex of his 'Golden Period', this concludes similar thematic studies during his career, such as *The Beethoven Frieze* (1902), *The Stoclet Frieze* (1905–11) and his 1895 allegorical illustration *Love*, designed 12 years earlier. Each work aids final comprehension of the allegory, which represents the mystical union of spiritual and erotic love and the merging of the individual with the eternal cosmos.

Both figures are fully realised and symbolically blended as they face the golden abyss of perfection. The dominant male force is signified by the powerful coat of masculine black and grey blocks, softened by the feminine organic scrolling, reminiscent of *The Stoclet Frieze*'s 'Tree of Life'. In comparison, female energy is shown as spinning circles of bright floral motifs and upward-flowing wavy lines. From these vestments of artistic creation golden rain blesses the fertile earth, similar to the descending roses in *The Beethoven Frieze*. The triangular fronds also recall water imagery from paintings such as *Water Snakes I (Female Friends)* (1904–07). *The Kiss* is Klimt's artistic response to the Byzantine mosaics at Ravenna, Italy, which so profoundly affected him.

SALOMÉ (JUDITH II) (1907–09)

Modern Art Gallery, Venice. Courtesy of AKG London

HERE are many aesthetic differences underscoring Klimt's maturity, between this work and his representation of Judith produced eight years earlier, in 1901. Klimt's progression towards abstraction and Expressionism is significantly revealed here in the modular structure, strong colours and distortion of form. A flattened surface reduces the woman to a feature of the decoration rather than being fully realised. Instead of the erotic image of desire in *Judith with the Head of Holofernes*, in which Judith's hands almost caress the decapitated head, this is an image of evil as Salomé claws at the head of St John.

This painting is not always viewed as representative of Salomé. Some critics claim it is a re-working of the Judith theme, calling it *Judith II*. Whereas *Judith with the Head of Holofernes* records the start

of Secessionism, Judith II, commenced in 1907, sees the end of this 'Viennese Spring' period. The official break with Secessionism came in 1905 when members disagreed over exhibition protocol. This followed the establishment's refusal to allow Klimt's university paintings to represent Austria in a World Exhibition in the United States. A ballot, lost by one vote, saw Klimt spearheading another breakaway movement, Kunstschau, an echo of the Secession's formation after a similar fight with the authorities. As with early Secessionism the Kunstschau group founded its own exhibition pavilion. Ready in 1908 for the Emperor's 60th anniversary celebrations, the key room became a monument to Klimt's oeuvre. Here, The Kiss was exhibited for the first time.

Detail from Judith with the Head of Holofernes (1901)

Osterreichische Galerie Belvedere, Vienna. Courtesy of AKG London/Erich Lessing. (See p. 112)

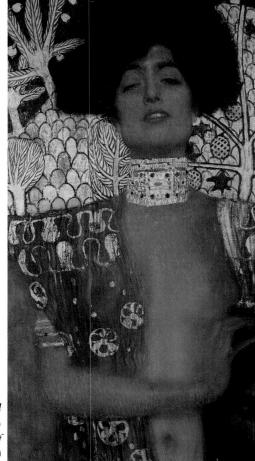

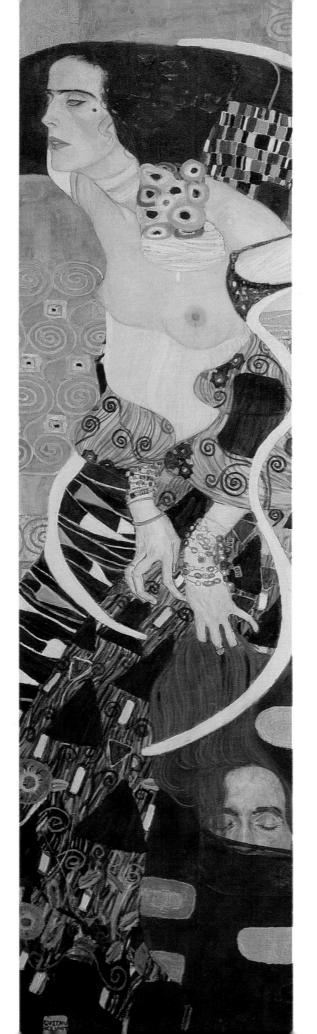

Woman with Hat and Feather Boa (1909)

Osterreichische Galerie Belvedere, Vienna. Courtesy of AKG London/Erich Lessing

HE influence of Degas' unique Impressionist concern with the depiction of people going about their working lives is evident here. It can be seen in the way *Woman with Hat and Feather Boa* captures the fleeting sideways look of a woman one passes in the street. Like many of Degas' figures, the woman is possibly a prostitute plying for business, suggested by the heavily rouged face and lips, and expression of provocative allure.

Unlike Klimt's earlier Impressionist images of women, mainly completed ten years previously, this work reveals a defter, more expert handling of form and definition through colour manipulation and lighting. Dimension is created by subtle inclusion of a red-green polarised central band whose energetic visual force-field provides a

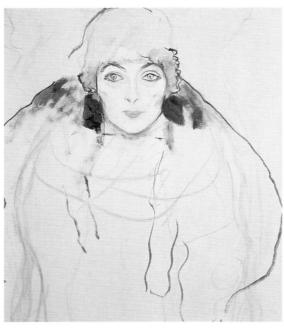

Head of a Woman (1917–18) Neue Galerie der Stadt, Linz. Courtesy of AKG London. (See p. 246)

dynamic contrast between the top and bottom darker areas. Coarser brushwork to denote the heavy black ruff, abundant hair and the stylish hat add superb impressions of texture, unlike recent works which have been notably flat in technique.

The work marks the end of Klimt's obsession with gold and jewelled ornamentation and the start of his becoming more involved with the burgeoning Expressionist movement, represented by his mentor relationship with the brilliant young Egon Schiele (1890–1918), whom he helped exhibit at the 1909 *Kunstschau* exhibition.

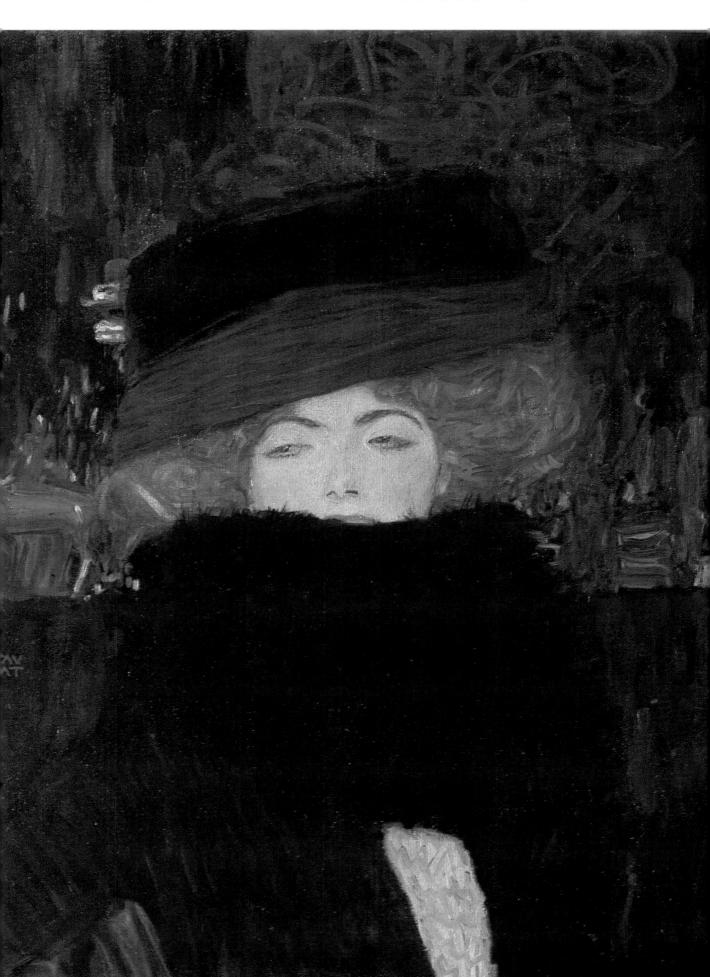

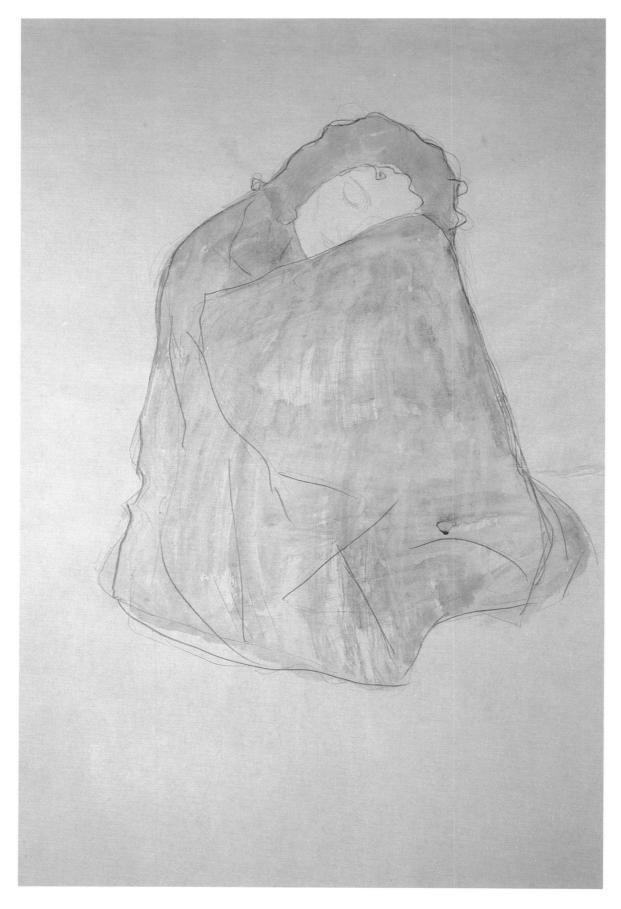

CROUCHING WOMAN IN DARK DRESS (1909)

Courtesy of Historical Museum, Vienna

HIS simplistic drawing and choice of subject matter is unlike anything else in Klimt's repertoire. With its image of poverty and helplessness, it reveals his interest in Expressionism through Egon Schiele and his young contemporaries, who were intensely concerned with the expression of human suffering and emotions. The work, probably coloured in crayon like other drawings, was a study for a larger painting, *Mother With Children* (1909–10), which was an evocative image of suffering similar to a composition Schiele was completing during this period. Elements of this study in realism, unlike Klimt's usual Symbolist work, were incorporated into the bizarrely coloured and emotional *Death and Life*, finished in 1911, but revised in 1915.

Klimt often sketched hundreds of drawings for one work, exploring posture, the drape of clothes or the fall of the model's hair. These were usually carried out rapidly, regarded as a means of working rather than a medium in its own right. Visitors to his studio witnessed piles of similar loose-leaf studies, higher than the height of a man, that often blew around in the wind or were urinated on by his menagerie of cats. Only 3,000 sketches are known to have survived, as many were burnt in a fire in Emilie Flöge's apartment.

Death and Life (1909–1911)Leopold Collection, Vienna. Courtesy of AKG London/Erich Lessing. (See p. 204)

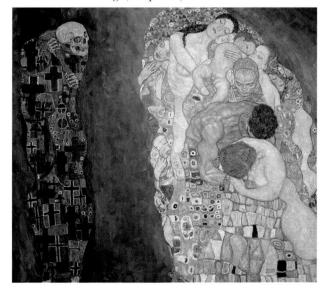

SCHLOSS KAMMER ON ATTERSEE II (1909–10)

Courtesy of Christie's Images

ANY of Klimt's images from the Salzkammergut district, where he stayed every year with Emilie Flöge, were of the spectacular alpine lake, the Attersee, which he first painted in 1901. These scenes, like the Schloss Kammer, were usually studied from the water, Klimt rowing out on to the lake to paint during lazy mornings or afternoons, with Emilie at his side.

Klimt's landscapes were primarily concerned with capturing a world unaffected by the rapid changes, both industrial and political, associated with his city life. Many landscapes featured only nature, a spiritualised world devoid of mankind. Although this work includes the castle, it is as a symbol of a bygone age, and, like buildings in other works, is gradually being absorbed into the scenery, as though consumed by the landscape. Nature is in command here as the highly decorative yellow-blue-green Impressionist mass rapaciously grows across the surface, engulfing all in its wake. The sensation is augmented by the flat perspective which reduces the castle's dimensions and helps merge it in to the colour mass. The bright green and yellow banding at the bottom heralds Klimt's important and influential discovery of Henri Matisse (1869–1954), whose revolutionary colourwork was first shown at the *Kunstschau* 1909 exhibition.

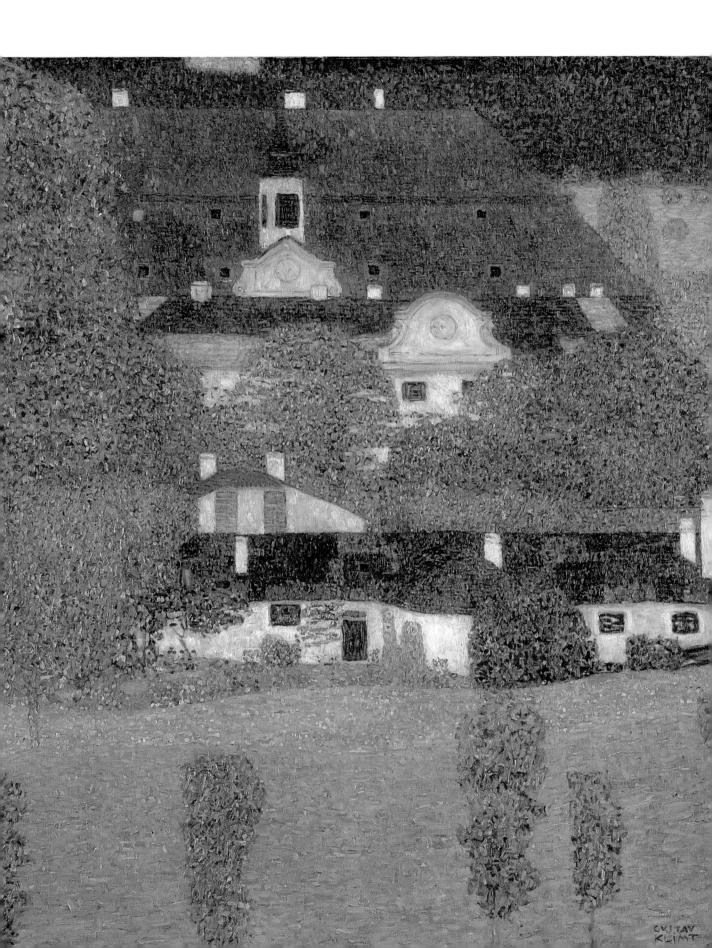

SCHLOSS KAMMER ON ATTERSEE III (1910)

Courtesy of Osterreichische Galerie Belvedere, Vienna

NCE more Klimt plays with a favourite holiday image, the castle, Schloss Kammer on the fashionable Austrian spa lake, Attersee. Like the previous picture the castle is studied from the water to create a vibrant grainy work with murky yellow-green reflections. In the early days Klimt rowed out onto the water to paint but in later years he was one of the first to own a sleek motor-boat,

which caused a local stir. He painted directly onto the canvas, enjoying the freedom this allowed from his studio work, and often focused on the chosen scene by peering through opera glasses.

This work's particularly fine fleeting sensation actually suggests the boat's transit along the front of the castle's walls, as though we can only glimpse the magnificent house between the trees as the boat glides through the shimmering water, superbly handled in the picture's foreground. The introduction of yellow mottling acts as a dominant counterpoise to his usual immense palette of greens, now dextrously handled after years of research in landscape and studio work. The work is reminiscent of Van Gogh in its colouring and brushwork, though this is more evident in Avenue of Trees in the Park at Schloss Kammer (1912).

Avenue of Trees in the Park at Schloss Kammer (1912) Osterreichische Galerie Belvedere, Vienna. Courtesy of AKG London/Erich Lessing. (See p. 210)

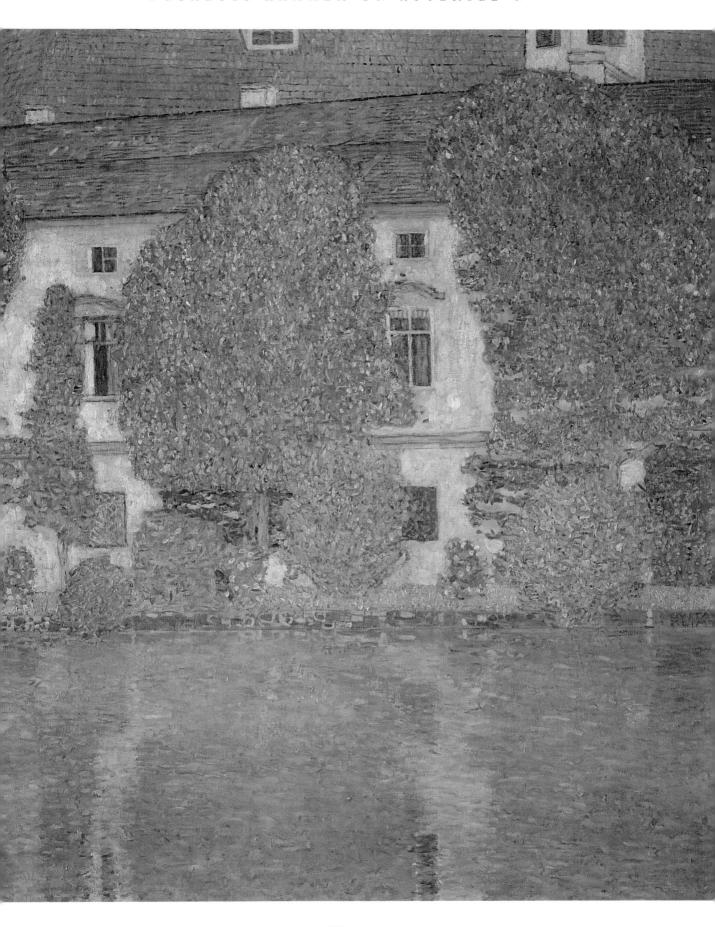

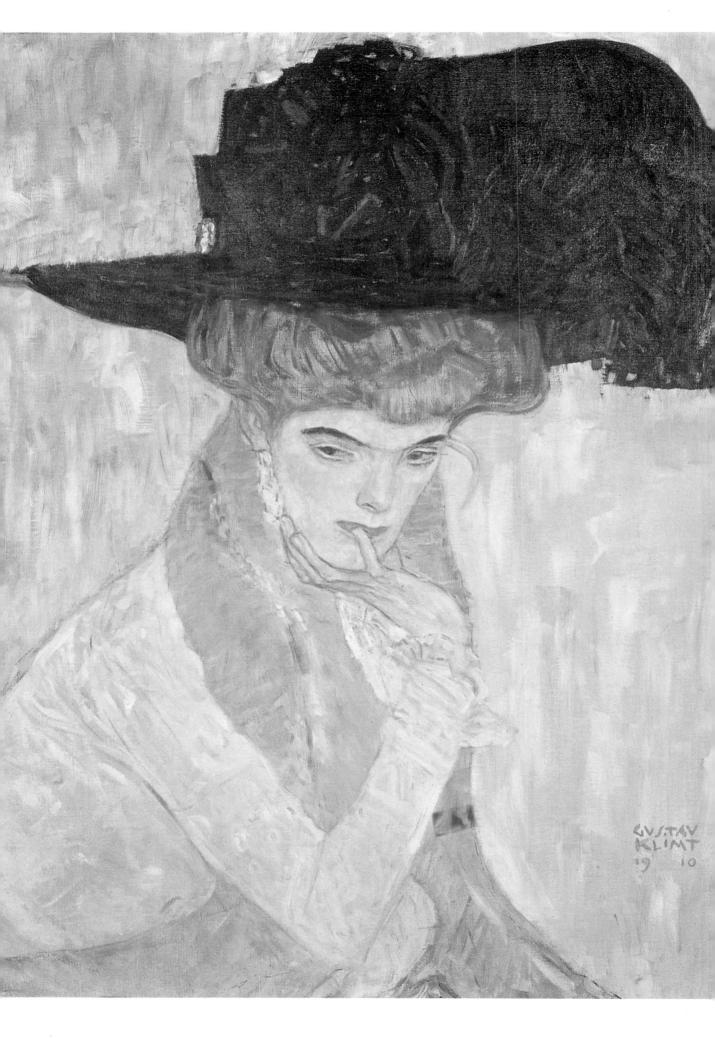

Woman in a Black Feather Hat (1910)

Private Collection. Courtesy of Artothek

HE monochromatic pinky-brown palette and highly stylised drawing of *Woman in a Black Feather Hat* demonstrates Klimt's growing interest in Expressionism through his friendship with the young Egon Schiele. The movement's growing interest was the expression of human suffering and emotions through the heightened impact of strong colours and distortion of form, with Van Gogh often regarded as a forerunner in the genre.

This particular simplistic work is a far cry from Klimt's complex paintings of the past ten years. With its monochromatic air and tapered fingers, it recalls Picasso's early 'Blue period', in turn influenced by the Mannerist-Expressionist works of El Greco (1541–1614). Klimt probably saw Picasso's 'Blue' work in his travels during this period to Brussels and Paris for *The Stoclet Frieze* (1905–11) commission. Important Expressionists included fellow Austrian genius, Oskar Kokoschka (1886–198), whose one-man show at the 1908 *Kunstschau* exhibition did not cause the predicted riot but was panned by critics thinking it another Klimt-inspired prank, like the University paintings scandal. They certainly did not foresee Kokoschka becoming the highest-paid artist in Germany by the 1920s.

The hat here, and in the earlier work, *Woman with Hat and Feather Boa* (1909) recalls a contemporary poster of a woman in Vienna Workshops attire, advertising the Cabaret Fledermaus, a celebrated

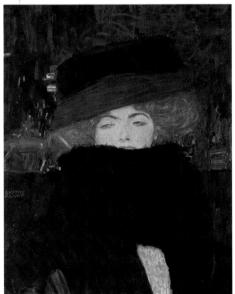

avant-garde night-club, established by the Vienna Workshops on the back of the Stoclet commission.

Woman with Hat and Feather Boa (1909) Osterreichische Galerie Belvedere, Vienna. Courtesy of AKG London/Erich Lessing. (See p. 194)

DEATH AND LIFE (1908–11)

Leopold Collection, Vienna. Courtesy of AKG London/Erich Lessing

HIS huge, square life-size canvas, 178 cm x 178 cm (71 in x 71 in), features many aspects of Klimt's earlier monumentals, with its allegorical nature, symbolic content and columnar structure. With the onset of Expressionism, stylistic attributes have altered, particularly the bolder colouring and a linear, rhythmical expression. Again, Klimt employs his wealth of allusive abstract and decorative motifs to explore issues of death and decay, imminently suited to Expressionism's concern for human suffering. However, instead of mystic Symbolist imagery, he develops a folkloric arrangement, in keeping with elements of the new German Expressionism group, *Die Brücke*, and the works of Nietzsche.

Here, the 'column of life' engulfs the figures. Some struggle to free themselves from its mantle, symbolically embodying Klimt's attempt to liberate himself from his aesthetic past. Significantly, he revises the painting's original gold background during many re-workings, to incorporate both this heavy green and his new style. The work was produced during the height of Klimt's international fame and recognition. He was a major exhibitor, with Renoir, at the renowned 1910 Venice Biennale, and was accorded his own room, winning adulation from a city keen to buy his work. Its allegorical significance, however, could reflect the period's uneasy political build-up to the First World War after Austria annexed Bosnia in 1908.

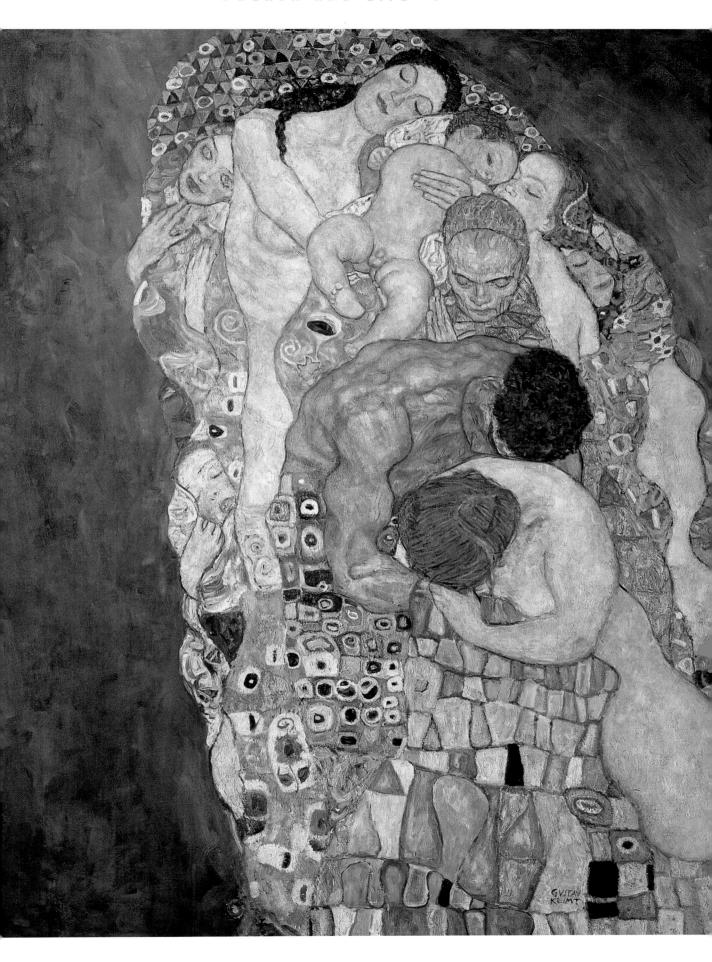

Upper Austrian Farmhouse (1911–12)

Osterreichische Galerie Belvedere, Vienna. Courtesy of AKG London/Erich Lessing

NCE again, the viewer is thrown into the middle of a picture as the perspective zooms in, drawing the viewer inside a forest, looking through to a farmhouse in a clearing. Unlike other buildings in Klimt's intense landscape work, the proximity of this farmhouse enables us to assimilate its detail, especially as the work's careful lighting brings it sharply into focus through the use of grey. The heavy blue-green bowers and thickly flowered meadow floor, however, relay the impression that this construction is going to be absorbed into the scenery, becoming another solitary Klimt world, devoid of mankind.

The work echoes certain aspects of Van Gogh and Cézanne. For instance, the brushwork on the overhead canopy of foliage imparts a looser sensation of coiling life

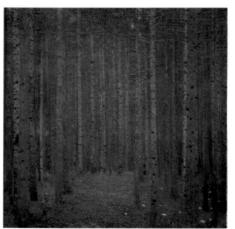

Detail from Pine Forest (Forest of Firs I) (1902) Galerie Wuerthle, Vienna. Courtesy of AKG London/Erich Lessing. (See p. 141)

and a feeling of deeper reality, associated in particular with Cézanne. Despite this more accomplished vibrancy, aspects of lighting on the two tree trunks, pillared either side of the composition, make them lifeless and clumsy, unlike the ethereal trunks in earlier pictures such as *Pine Forest (Forest of Firs I)* (1902). It seems that, in a bid to capture sunlight on the farmhouse, he underplays the importance of the foreground.

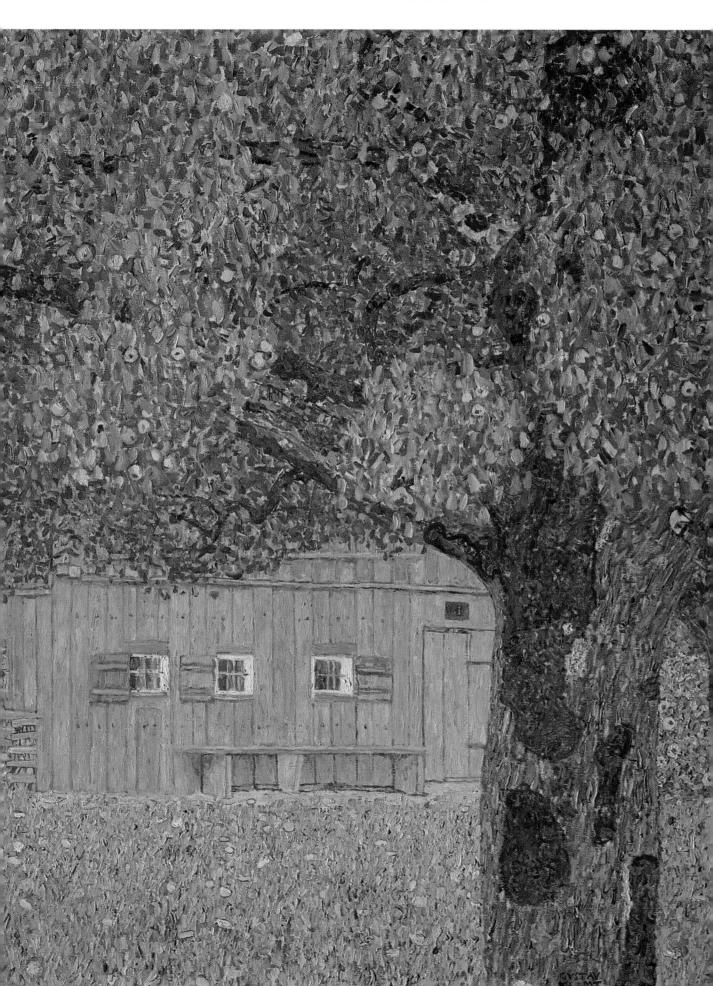

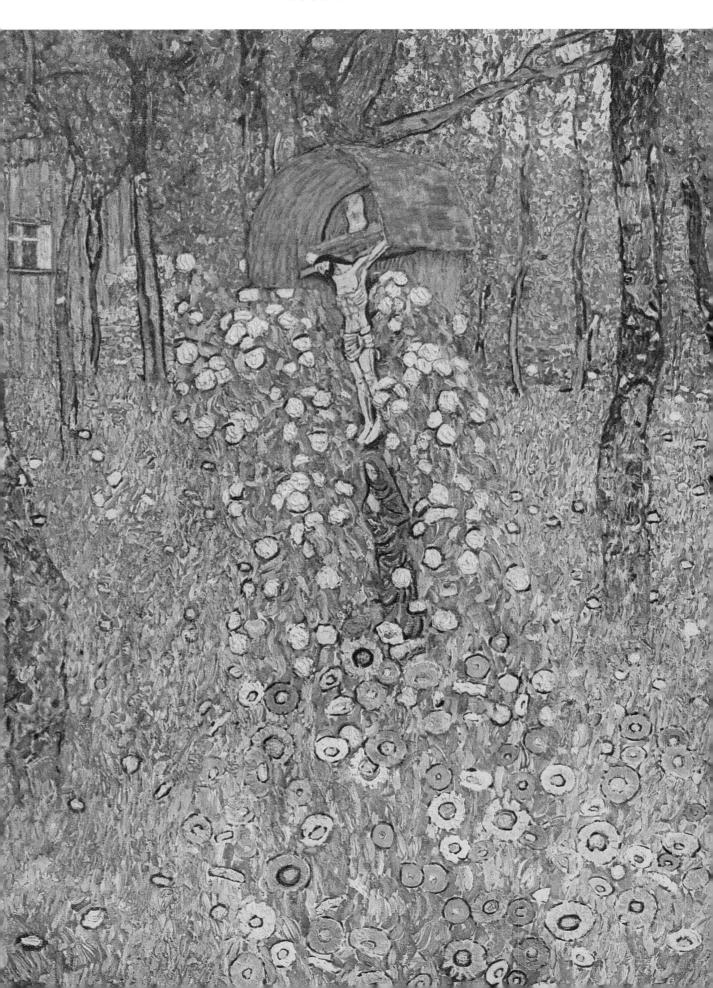

COUNTRY GARDEN WITH CRUCIFIX (1911-12)

Courtesy of Verlag Galerie Welz, Salzburg

HIS, the first of Klimt's truly religious paintings, in terms of depicting specific Christian imagery, has a haunting and powerful visual presence with the paradox of its simple rustic charm set against one of his typical decorative backdrop. The icons are fixed in a columnar structure of life which forms a wild vibrant floral mass growing up through the religious station. Unlike the previous farmhouse landscape from the same period, there is a greater sense of spatial depth and a brighter, more convincing management of light. The looser feel in this work is apparent as nature exudes a more rhythmic quality. Klimt's tentative moves in to Expressionism, with its strong linear feel and brighter colour range, are perceptible alongside the continuing influence of Van Gogh.

The historical significance of the work's period, painted as it was in the final years before the First World War, must not be forgotten. Tensions were mounting in the region as Austria's weakening, decadent empire completed its demise with misplaced aggression in the Balkans, plummeting Europe into the chaos of the war in 1914. The small simple crucifix, lonely and isolated in Klimt's beloved countryside haven, possibly appealed to him as a beacon of hope.

AVENUE OF TREES IN THE PARK AT SCHLOSS KAMMER (1912)

Osterreichische Galerie Belvedere, Vienna. Courtesy of AKG London/Erich Lessing

AN Gogh's impact on Klimt's landscape work makes its most powerful statement here. At last Klimt has broken free from the static quality of his outdoor work as the trees explode into vitality and writhe with movement. The expert manipulation of strong colours, lighting and perspective all contribute to the success of the painting. The heavy, thick-lined delineation of the trees expresses some essential aspect of form, Fauvist in quality, and the curvature of their arching across the avenue helps infer the obscured structure of the castle. This is superb compositional balance.

The slightly off-centre blue hole, featuring the red of the castle roof, is an artistic pivotal point, a focus from which the gyrating mass of greens and blues is allowed to wheel. This powerful, yet subtle, use of colour polarisation produces an overall sense of proportion and balance. However, the circular motion is checked by the oppositional force of the strong upward-flowing movement of the trees, a device Klimt has enjoyed from his early days to create the effect of spiritual elevation. Even though the tops of the trees are truncated, the viewer feels their spiralling energy will continue forever, unlike the castle, a symbol perhaps of a disintegrating empire.

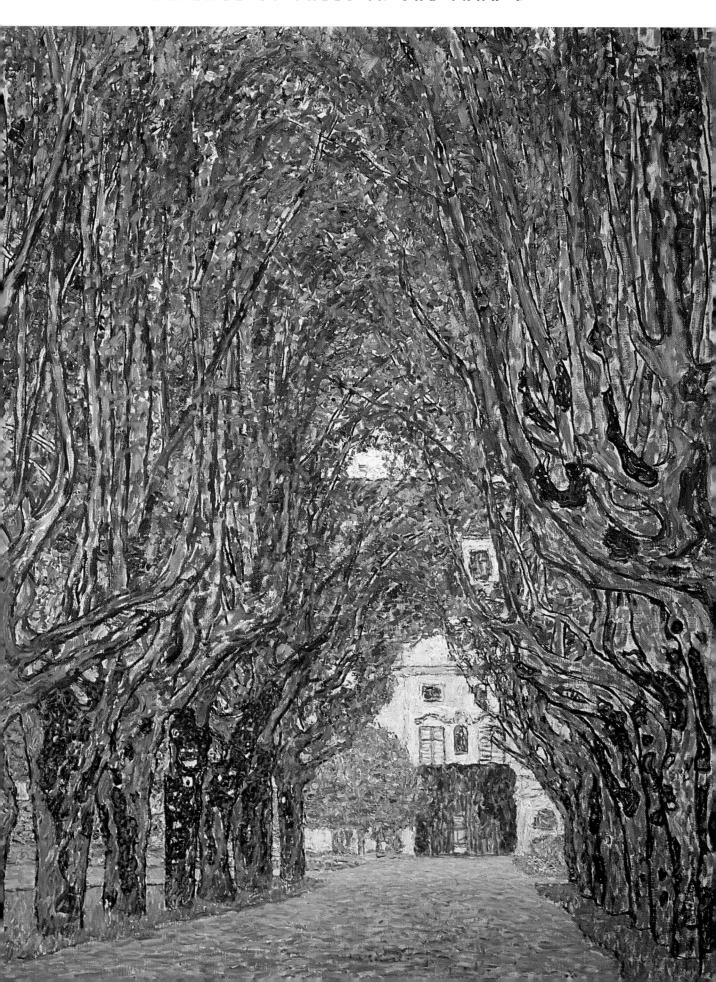

ADELE BLOCH-BAUER II (1912)

Osterreichische Galerie Belvedere, Vienna. Courtesy of AKG London/Erich Lessing

HE influence of Matisse, whose work Klimt saw at the 1909 *Kunstschau*, is superbly demonstrated here: in the strong, disturbing blocks of colour and busy patterning of Oriental and floral imagery. The design is messy and confusing, yet, like Matisse's work, oddly satisfying, as Klimt's new tonal style gains pace.

This is a far cry from the earlier 'Golden Period', evinced in the first official 1907 portrait of Adele Bloch-Bauer, where she is submerged in a claustrophobic weight of golden semiotics. Even here, she is still not truly individualised, as she stands very self-consciously hemmed in, her position dictated by the geometric outlines which define the proportions

of the work. The blending of the heavy green banding of her dress, with the background colours, still fastens her to the surrounding decoration.

Feminist historians often comment on how these portraits reveal much about Klimt's possible manipulative attitude to women such as Adele, his inspirational upper-class model, who was presumed to be his long-term lover. The only Klimt work in which a woman is ascribed emancipation is the sensational blue portrait of Emilie executed in 1902, which she detested. He never painted another portrait of his life-long companion, though many believe she is the female symbol of love in the series of 'Kiss' pictures.

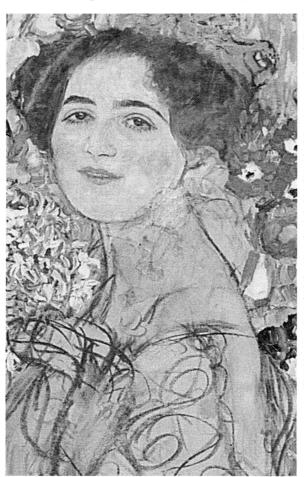

Portrait of a Lady (1917–18) Neue Galerie der Stadt, Linz. Courtesy of AKG London. (See p. 245)

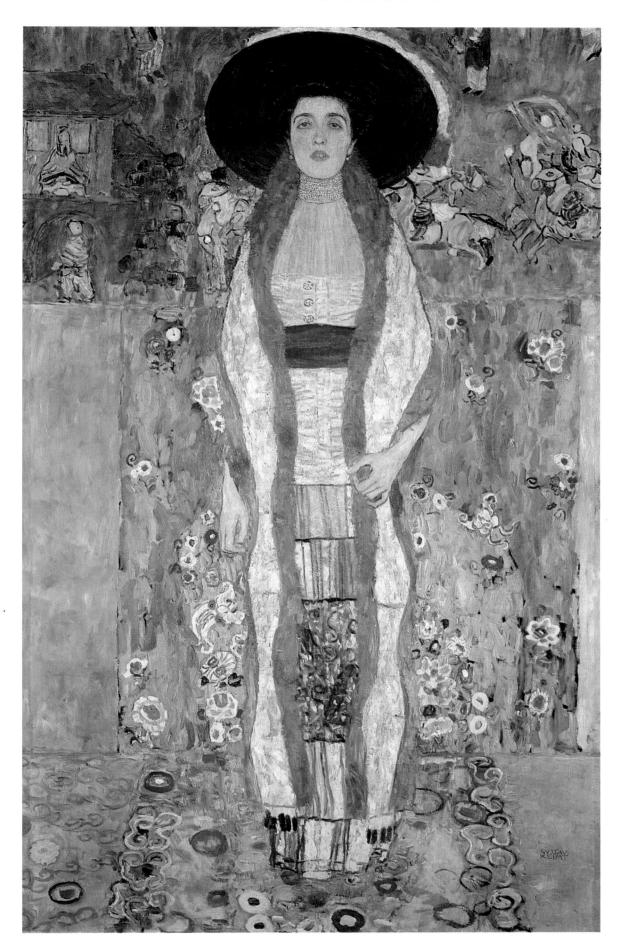

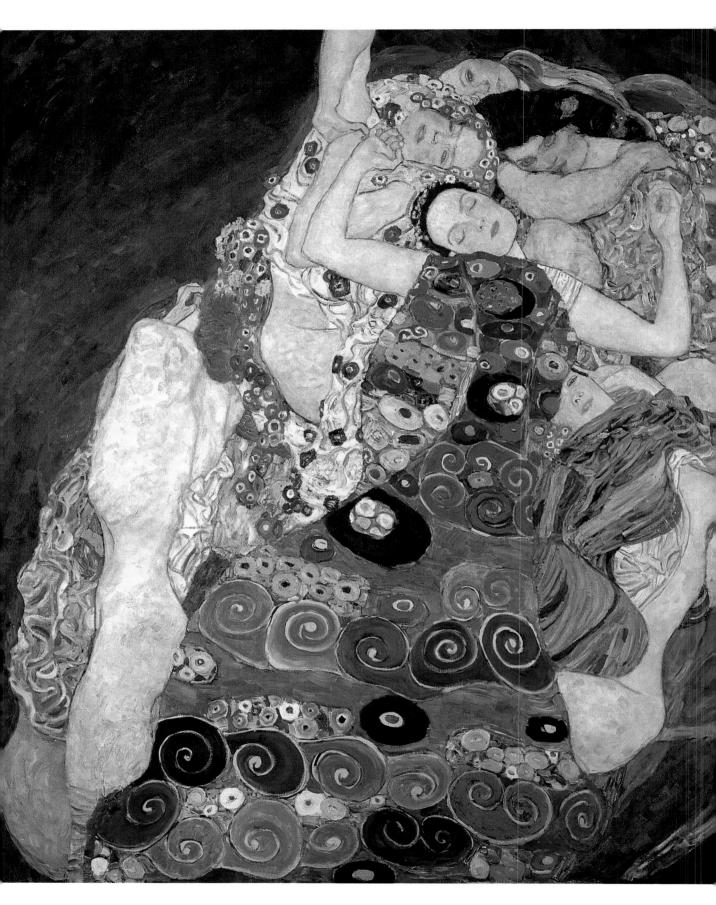

THE GIRLS (THE VIRGIN) (1912–13)

National Gallery, Prague. Courtesy of AKG London/Erich Lessing

N the final years, Klimt's break with ornamentation gained pace as he embraced many aspects of Expressionism while revisiting themes and images of the earlier years, as if to study their transformation with his new-found aesthetic style. Accordingly, there are similarities of design, colouring and content in this painting with works like *Death and Life* (1908–11), *The Kiss* (1907) and sections of the *Beethoven* (1902) and *Stoclet* friezes (1905–11).

The Girls (The Virgin), whose content is often pondered over, also identifies a pronounced return to eroticism and other explicit sexually orientated themes. The profusion of splendid colours and motifs has an exciting quality as the nubile figures emerge out of the central patterned form, which, rimmed with brown, is like an elaborate rug or covering. It is orgiastic in some respects as the naked girls, possibly lesbian, as in Water Snakes I (Female Friends) (1904–07), writhe around the sleeping outstretched figure in the centre. It is though they are siren femme-fatales beckoning the external erotic gaze of the artist or male viewer to take this helpless, yet available, virgin. Accordingly, the perspective is set back at a distance as though the viewer is looking down authoritatively and in control of the sensual mass below.

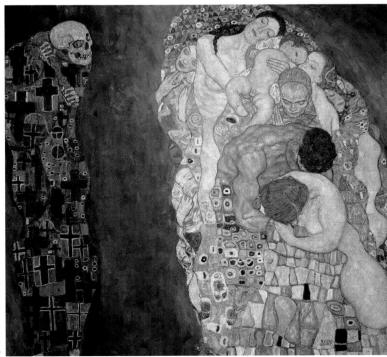

Death and Life (1908–11) Leopold Collection, Vienna. Courtesy of AKG London/ Erich Lessing. (See p. 204)

GIRL (DRAWING FOR MÄDA PRIMAVESI) (1912–13)

Courtesy of Historical Museum, Vienna

TTO PRIMAVESI was one of Klimt's wealthiest patrons who approached him to paint the portrait of his young daughter, Mäda. As discussed elsewhere, Klimt would often carry out more than a hundred drawings to capture the best pose, angle of outfit or fall of his sitter's hair. This process, in the early years, was undoubtedly

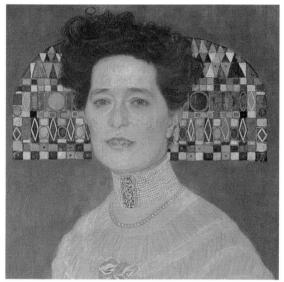

Detail from Fritza Riedler (1906)Osterreichische Galerie Belvedere, Vienna. Courtesy of AKG London/Erich Lessing. (See p. 182)

to establish how Klimt could express his esoteric interests within an elaborate design while still assembling some likeness and characteristics of the sitter. However, in these latter-day portraits Klimt became more concerned with exploring issues of psychological depth rather than capturing a true facial resemblance, as in the 1906 *Fritza Riedler* portrait.

Here, we see, from just a few lines, Klimt's ample capabilities in eliciting telling aspects of character. This young girl stands firm, hand on hips, with a proud head and an almost wilful sense of determination. The final painting exaggerates these traits further. The girl stands arrogantly, close up to the picture's fore-

ground, facing full-front rather than to the side, as here. Her legs in the finished work are stridently apart, again with one hand on her hip, and the facial expression manages to convey the image of a spoiled child.

MALCESINE ON LAKE GARDA (1913)

Courtesy of Galerie Welz, Salzburg

Attersee spa in the Austrian Alps, and went to the Italian Lake Garda instead, possibly under the increasing influence of Egon Schiele, who preferred to travel abroad. Whether as a result of the change of light or scenery, this work amply demonstrates its superb effect on him. As in Austria, Klimt paints the scene from a boat out on the water, yet the dramatic distinction of this landscape is the transformed handling of subject-matter, panorama, lighting and form. It is a wonderful light, expansive work unlike the usual claustrophobic style of his typically intense Austrian scenes. The atmosphere is of life and frivolity rather than the sombre, emotionally charged visions of home.

Some critics point to Cubism as the agent of change. Klimt came into contact with the movement during recent trips to Paris. Schiele's own landscapes during this period certainly explore a more Cubist approach and both artists probably discussed the dynamic implications of this new formal aesthetic. But in Klimt's case, comparison with Cubism is stretching a point. Here its influence was only experimental and conducted in a casual, limited fashion. Sadly, this singular work was also destroyed in the Schloss Immendorf fire.

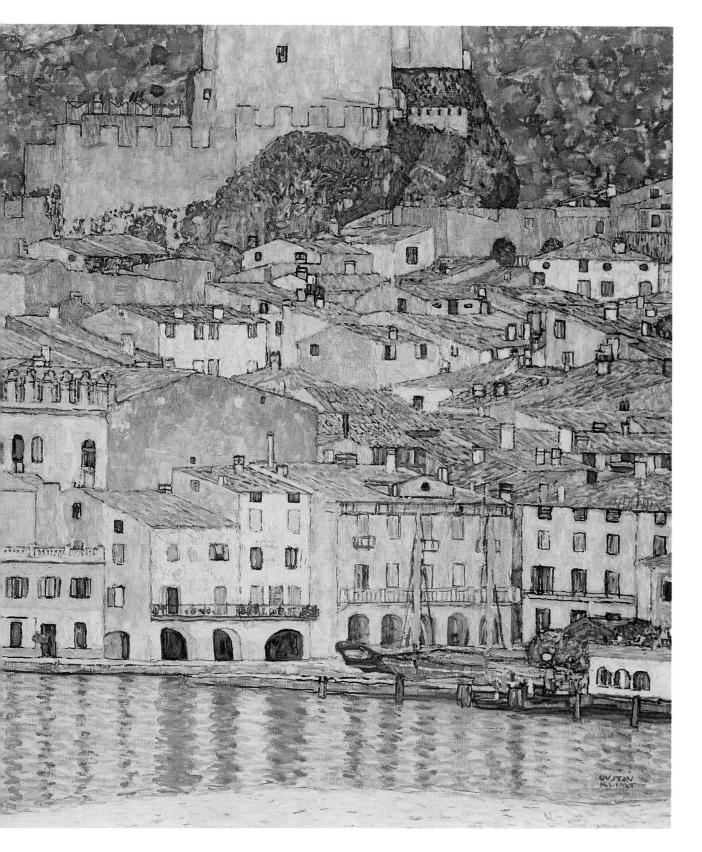

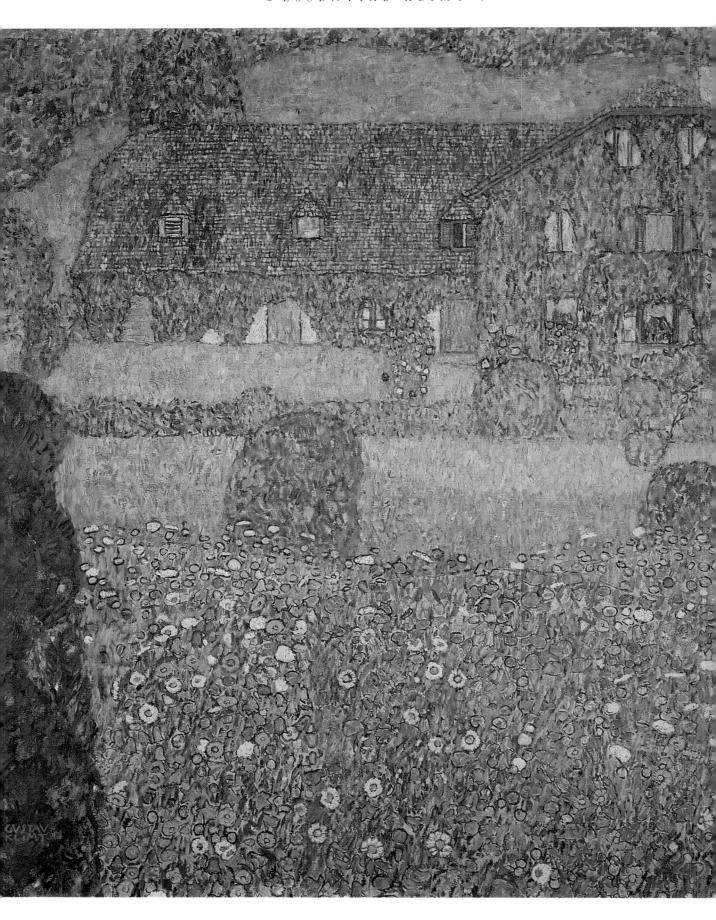

VILLA ON ATTERSEE (1914)

Osterreichische Galerie Belvedere, Vienna. Courtesy of AKG London/Erich Lessing

N 1914, Klimt returned to Attersee and resumed his traditional landscape style. A greater brightness of colour seeped in, while the foreground flowers are better animated, as in the *Crucifix* (1911–12), with the increasing use of black rimming to denote elements of individuality and form. The villa is possibly where Klimt and Emile Flöge stayed. Contrary to the artist's usual scenes of loneliness, there are odd displays of life around the house, such as open shutters and windows, the intimation of curtains and even a bunch of red flowers on a windowsill, but there are no people. This is as close as the viewer is allowed to penetrate the Klimt sanctuary. A carpet of flowers amasses in front like a profuse barrier, to cross them would be a violation, as their perfection would be trampled under foot.

Sadly the calm of Austria and the world was irrevocably rocked this summer, making this a portentous moment of stillness. In June 1914, the heir to the Austrian throne was assassinated at Sarajevo; by July, Austria had declared war on Serbia. It spelled the collapse of the Austro-Hungarian Empire and the end of Vienna, as Klimt knew it.

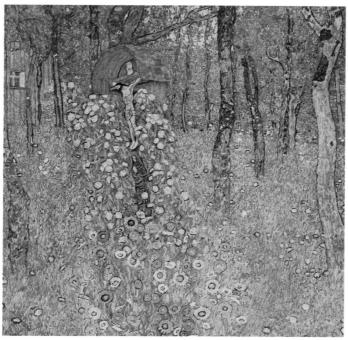

Country Garden with Crucifix (1911–12)
Courtesy of Galerie Welz, Salzburg. (See p. 209)

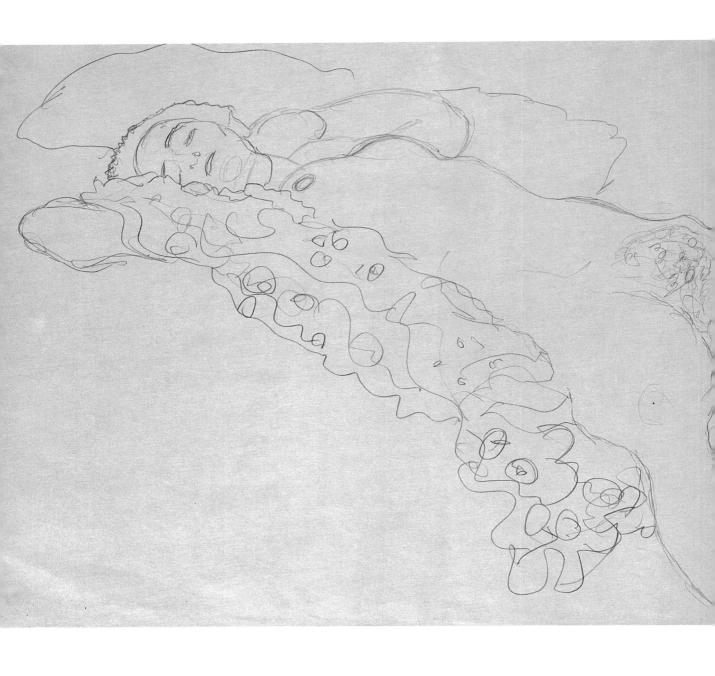

RECLINING FEMALE NUDE (1914–15)

Courtesy of Historical Museum, Vienna

HE erotic male gaze, asserted in many late nineteenth-century, early twentieth-century works, assumes greater significance in Klimt's later *oeuvre*, particularly in this series of drawings with their explicit and openly erotic images. It is not known if these

sketches were to be translated into a larger work; certainly there are some links between this and *The Bride* (1917–18), and *Adam and Eve* (1917–18), which were both found unfinished when Klimt died. Although the nude is reclining provocatively here, there are strong similarities in the depiction of the pubic region, the linear structure of the chest area and aspects of the leg shape, with the upright posture of the *Adam and Eve* nude.

The influence of Egon Schiele is remarkable in these explicit drawings. He was also exploring a similar erotic content in his sketch work at this time, including images of himself and girlfriend Wally in the act of sexual intercourse. Klimt was fascinated with Schiele's talent, nurturing it and introducing him to his top clientele, such as the Lederers. He invited Schiele to become a member of the prestigious League of Austrian Artists and in 1914 they exhibited together in Budapest.

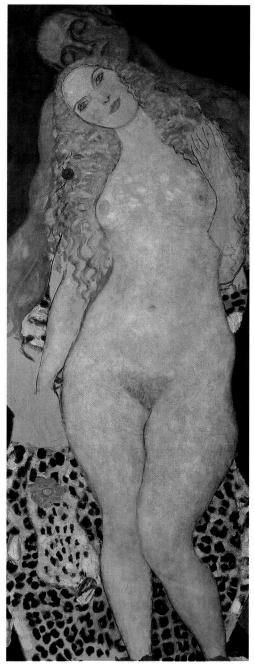

Adam and Eve (1917-18) Osterreichische Galerie Belvedere, Vienna. Courtesy of AKG London/Erich Lessing. (See p. 254)

RECLINING FEMALE (1914–15)

Courtesy of Historical Museum, Vienna

LSO part of the same erotic series of drawings, this sensual work contributes to Klimt's reputation as a lecherous womaniser. He wore an Arab-style burnouse while he

worked, apparently with nothing on underneath, and his studios were usually full of semi-clad models, often regarded as little more than prostitutes. There is no doubt he was a highly charged and sensual man who enjoyed stimulating and then sketching prurient moments like this. This is creative artist as sexual master, and an exploration of the blurring lines between sexual and creative energy, as seen in many of his previous allegorical works, such as *Danaë* (1907–08).

As in the previous sketch, Egon Schiele's own advances in this area deeply affected Klimt's work; possibly the 22-year-old man's presence and artistic energy renewed Klimt's vigour. On a visit to Schiele's studio Klimt stood silently gazing at the canvases, finally

Detail from Danaë (1907)Private Collection. Courtesy of AKG London. (See p. 186)

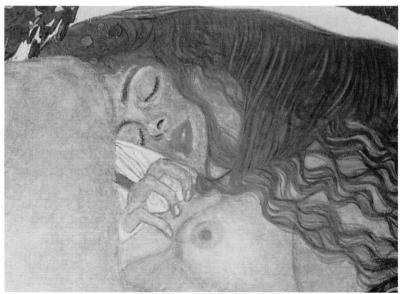

pronouncing, 'I envy you the expressions on the faces in your paintings'. The younger man blushed and smiled but a few years later, asking if he could acquire one of Klimt's drawings, was told: 'why do you want to exchange drawings with me? You draw far better than I do'.

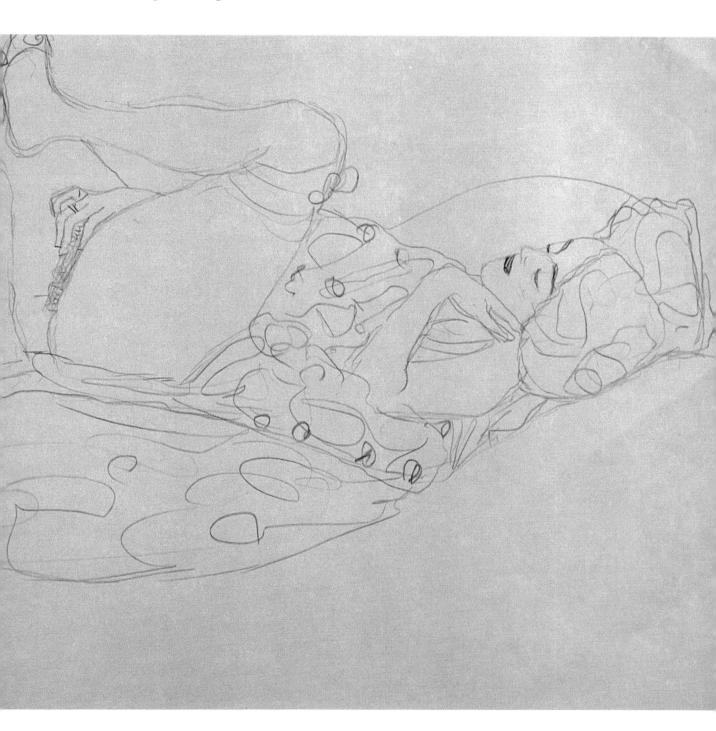

SCHLOSS UNTERACH ON ATTERSEE (1915)

National Gallery, Prague. Courtesy of AKG London/Eric Lessing

HIS work is similar to treatments of Schloss Kammer, another castle on Attersee, in the way the building is held spellbound at a distance across the water like a fairytale palace. Here, much of Klimt's matured landscape style is unaltered, in respect of the Pointillist-like depiction of foliage and the building's bland presence. There is scarce detail, despite some semblance of architectural form, to give it any sensation of vitality and life. It can be read as symbolic of a dead past. The devastation of the First World War was being felt all across the Habsburg Empire: many of its young men were leaving to fight at the front. Already young artists like Schiele and Kokoschka had left; fortunately later to return, unlike many others.

The most striking feature of this work is the fabulous handling of light and colour to conjure up a serene water effect. Instead of Klimt's typical yellow-green, or blue-green treatment of reflections, created by

Schloss Kammer on Attersee III (1910) Courtesy of Osterreichische Galerie Belvedere, Vienna. (See p. 200)

heavy brushstrokes and an exaggerated Pointillism, the lake's water is at last handled realistically. There is a sensation of stillness and subterranean depth as pale blocks of the reflected castle are elongated across the water's surface, creating an improved realisation of three-dimensional space.

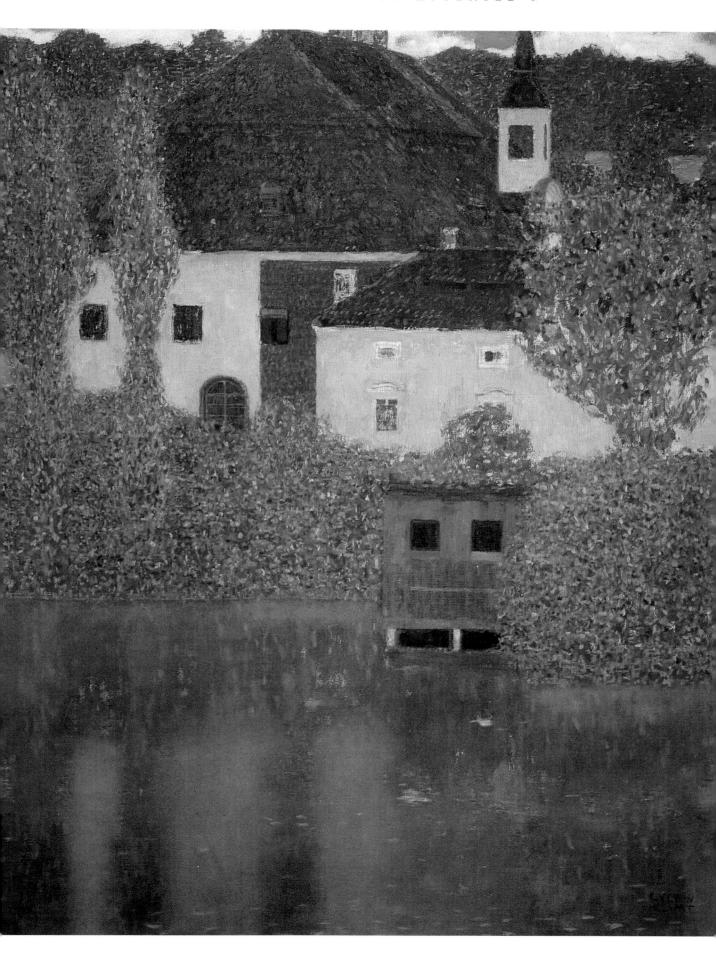

Unterach on Attersee (1915)

Residenzgalerie, Salzburg. Courtesy of AKG London/Erich Lessing

ERE, Klimt tackles a longer panoramic shot of the village of Unterach from far out on the lake during the same holiday. The work was probably painted using opera glasses, one of Klimt's favourite devices for capturing distant scenes, and consequently the proportions are noticeably different to other works. The village, although perceived at a distance, is, in reality, close to the foreground in order to stress the majestic form of the mountain side, which towers up the picture frame. The effect is broken by a small chink of sky, another rare feature in Klimt landscapes, which typically zoom in to small squared sections of interest.

The works of Cézanne and Van Gogh appear to have inspired the variegated blue and green brushwork that sweeps across the surface of *Unterach on Attersee*, but the application of larger-than-normal strokes helps to accentuate this long-range effect. The inclusion of a swathe of green meadow across the central band breaks the all-important central line of vision. This is the eye's point of entry so the band forces the viewer to look alternatively down to the village and up to the sky – careful manipulation of the visual aesthetic. This is a world of tranquillity, now separated from the viewer by the implied expanse of water.

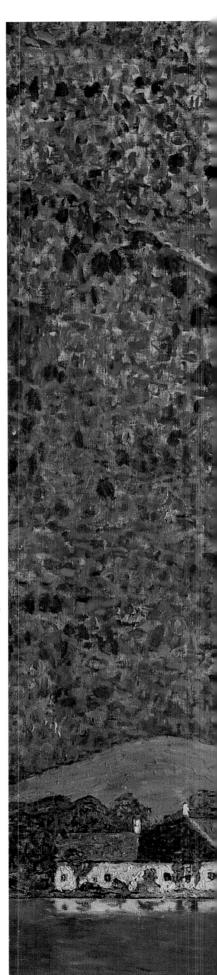

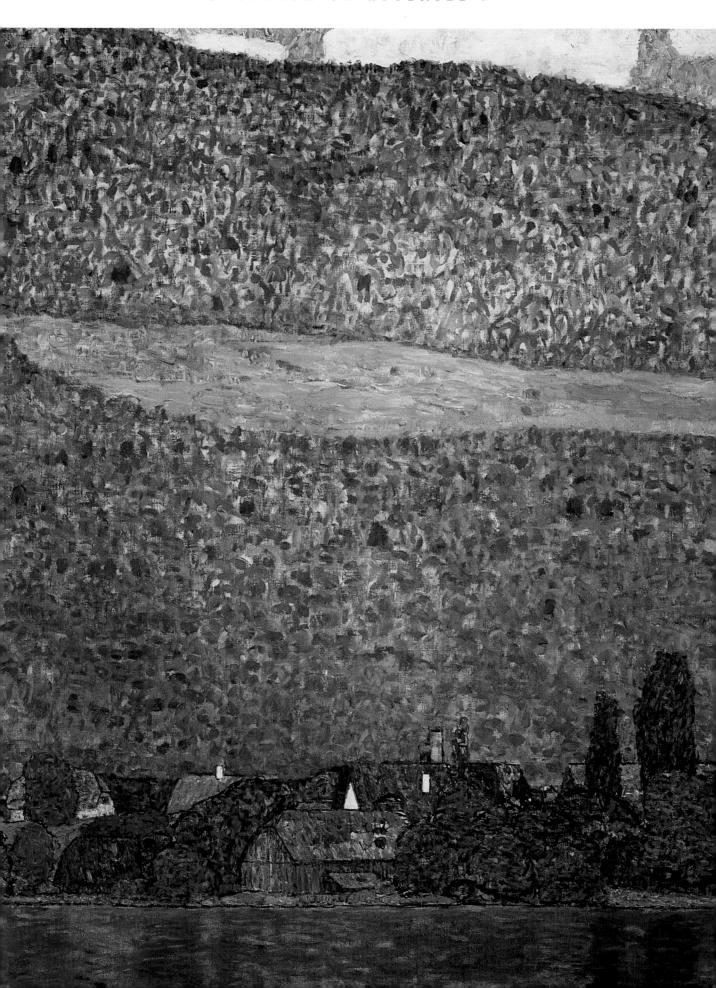

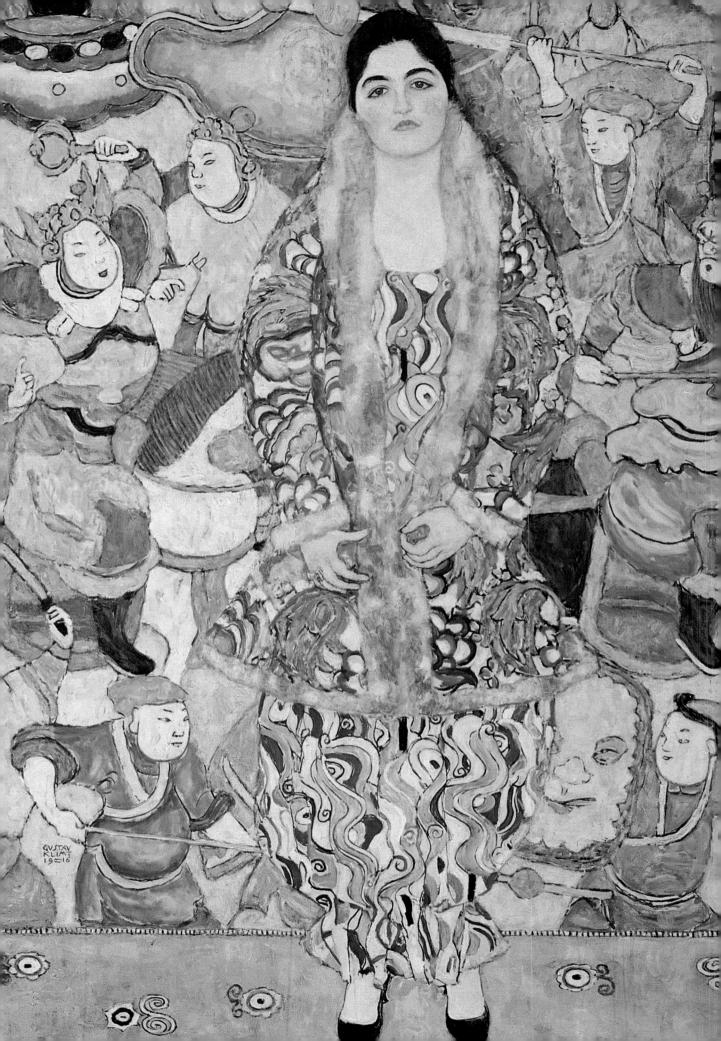

Friederike Maria Beer (1916)

Courtesy of Dr Brandstätter-Artothek

AUGHTER of a well-known Viennese night-club owner, Friederike Maria Beer was anxious to have her portrait painted by the city's famous artists. Schiele had completed an exciting colourful work and, after nagging Kokoschka unsuccessfully, she turned her attention to Klimt. The master was highly selective, being inundated with highly reputable and financially viable portrait requests. The story goes that when Beer visited Klimt's studio he eyed her up and down and demanded why she was asking for him, as she already had her portrait painted by a 'very good painter'. She quick-wittedly and cleverly answered, 'that this was true but through Klimt she would be made immortal'. He was suitably flattered and accepted the commission. Beer was right – the work became a masterpiece, representing Klimt's exciting change of direction in its originality.

Owing much to Matisse, the portrait is a colourful, busy but satisfying creation, as is the similar 1912 work of Adele Bloch-Bauer. According to critics, the fabulous Oriental scene was copied from a Korean vase in Klimt's collection and the then-outrageous jacket and trousers was a Vienna Workshop's creation with the jacket turned inside out to expose the fabulous lining, at Klimt's instruction.

APPLETREE II (1916)

Courtesy of Osterreichische Galerie Belvedere, Vienna

HIS odd, slightly oppressive work was completed during the height of the First World War. Holidaying at Attersee may seem incongruous, yet day-to-day life in Austria seemed to proceed oblivious to the momentous events of the war. Klimt produced no specifically war-orientated works and it is easy to conclude that, probably like most Viennese, he was largely unaffected by it. There is a darker theme at work here, as in several landscapes of this period, as though Klimt is anxious to extend his theme of urban escape to the portrayal of a paradoxical tranquil haven set apart from world events.

Here, the painting is not stylised by a careful placement of Pointillist dots, instead the paint is allowed to flow enthusiastically as Klimt attempts a Post-Impressionist sky, reminiscent of the work of Claude Monet (1840–1926). The tree's distinctly outlined fruit, to highlight individual objects from the mass, is another repeated post-Impressionist technique, as ventured in the flowers of *Country Garden with Crucifix* (1911–12). The work also has a Fauvist, child-like quality with its simple lines and distortion of form, giving it a greater sense of plasticity, as seen in the elementary line of trees across the back horizontal plane which completes this orchard scene.

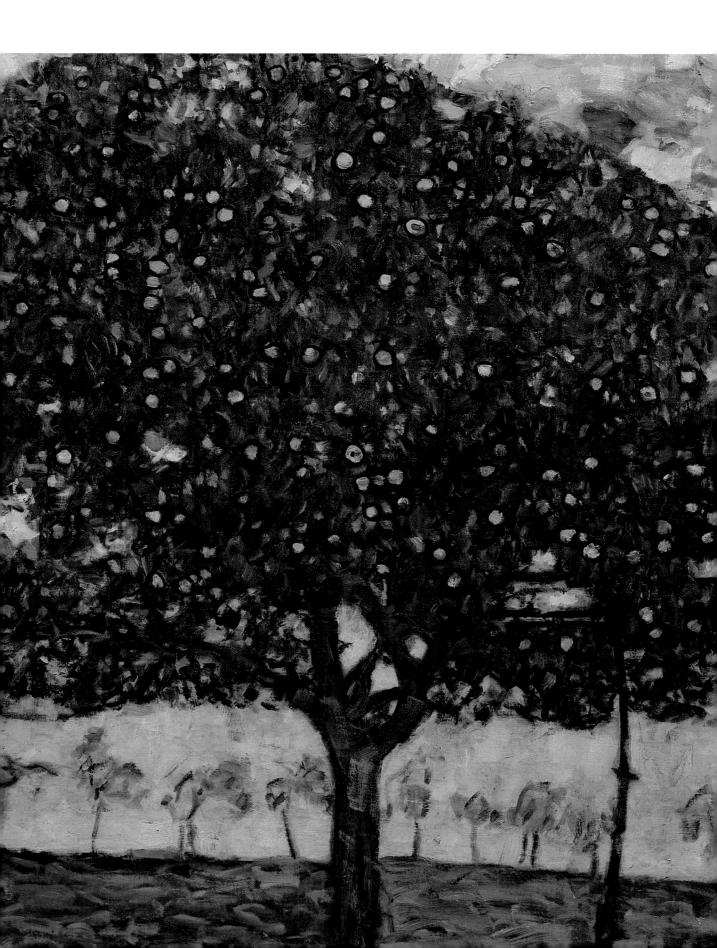

HOUSES AT UNTERACH ON ATTERSEE (1916)

Courtesy of Osterreichische Galerie Belvedere, Vienna

LIMT cruised his boat to the same spot at which Unterach on Attersee (1915) was painted, so the viewer can enjoy a tightly framed shot of the village. Once again this is a world devoid of people and separated by art. There is no evidence of habitation, such as the curtains or flowers, attempted in Villa on Attersee (1914). Instead, the work's key objective is the construction of shapes and forms within the confines of this tight frame. Schiele's more abstract, Cubist landscapes of this period arguably influenced this study of form and pattern. Its geometric exploration has much in common with Matisse's Fauvism, with its child-like simplicity, than with the violent characteristics and complexity of Schiele's Germanic Expressionism. Klimt's Pointillist style has given way to a flatter, planar structure. The solidity of line, heavy black rimming and loose, free brushstroke rhythm simply defines and enhances the superb colour blocks and their resulting schematic tensions. Consequently, the bright

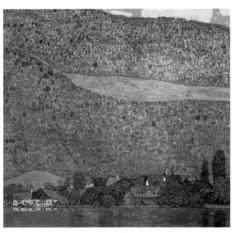

Unterach on Attersee (1915) Residenzgalerie, Salzburg. Courtesy of AKG London/Erich Lessing. (See p. 228)

orange-red house front, to the right of the composition, sets up a remarkable visual focal point, dynamically polarised by the contrasting green surrounds. This resulting energy forces the eye to travel in a zigzag motion, back and forth across the picture plane to track the colour's progression.

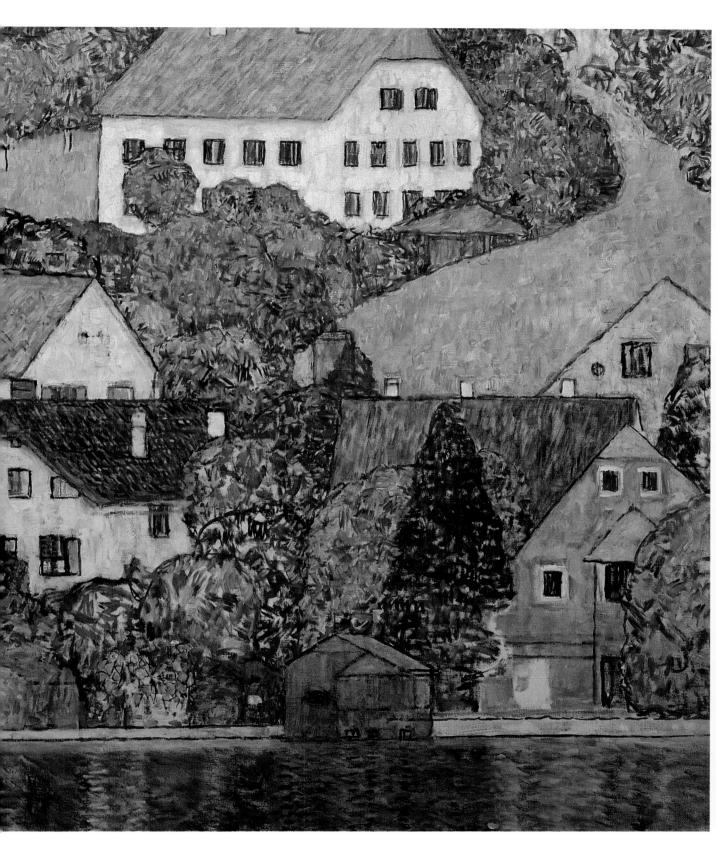

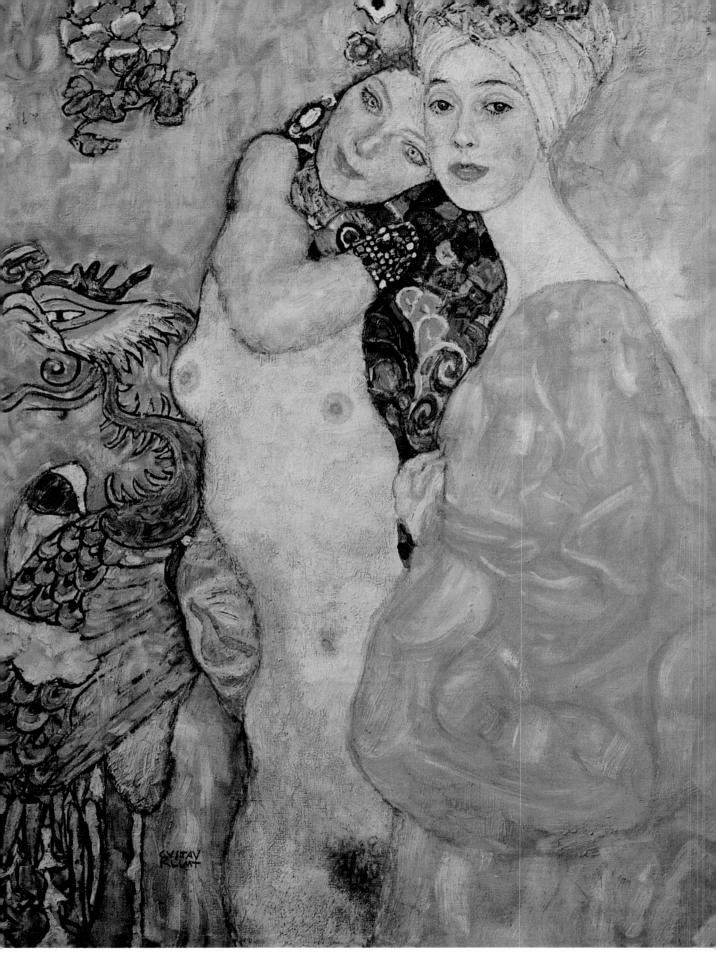

GIRLFRIENDS (1916–17)

Galerie Welz, Salzburg. Courtesy of AKG London/Erich Lessing

HE final works produced before Klimt's sudden early death in 1918 develop a loose, free line, as seen here, and pastel colouring, associated with Matisse and the Fauves. Similar to the *Friederike Maria Beer* (1916) portrait, Klimt maintains a fabulous Oriental backdrop as his decorative device instead of his older techniques of motif entrapment. The characters pose on an imaginary stage against a Klimt-designed backdrop. It is almost a return to the artist's early roots in theatre fresco work. The girl's turban, truncated at the top to catch the viewer's attention, adds another dramatic and exotic touch.

As in *Friederike Maria Beer*, the girls gaze directly at the viewer, though without any of the psychological insight which has started to become an interesting advancement in these later works. In fact, in this representation of an overtly lesbian couple Klimt seems to revisit some of his older femme fatale mythology, with a return to heavy sensual and provocative expressions. The nude's form on the left echoes images from the series of erotic drawings scattered around his studio floor and both woman look like painted Russian dolls with their

rosy round faces, rouged cheeks and heavy lidded eyes.

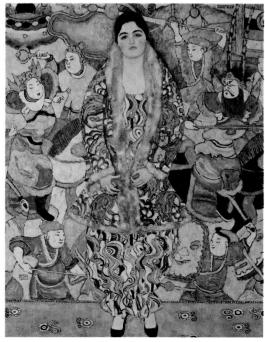

Friederike Maria Beer (1916) Courtesy of Dr Brandstätter-Artothek. (See p. 231)

THE ITALIAN GARDEN (GARDEN OF FLOWERS) (1917)

Osterreichische Galerie Belvedere, Vienna. Courtesy of AKG London/Erich Lessing

N all, Klimt painted 54 landscapes out of a total of 230 pictures. This was one of the last, from the final holiday spent with Emilie, his lifelong companion, before his sudden death just six months later at the beginning of 1918. He called out for her as he was dying.

Although the work is another development of his Post-Impressionist style, it is more concerned with transcendence than realism. It is an expression of love and harmony with the natural world, a quest that absorbed him all his working life. Klimt never saw the end of the First War World, and even here it is worlds away, never touching his methodical life-style. This was a man of deeply in-grained habits, who always lived with his mother and unmarried sisters and breakfasted at the Tivoli Café in Vienna's Schönbrunn before going to work all day in his studio without a lunch-break. Strangely, for an artist, he feared changes to his routine, even holidaying in the same place almost every year of his life. Perhaps this is not surprising from a man whose work concerns pattern and its contribution to form and order. Even in his landscapes, nature's structure is artistically reorganised and then worshipped.

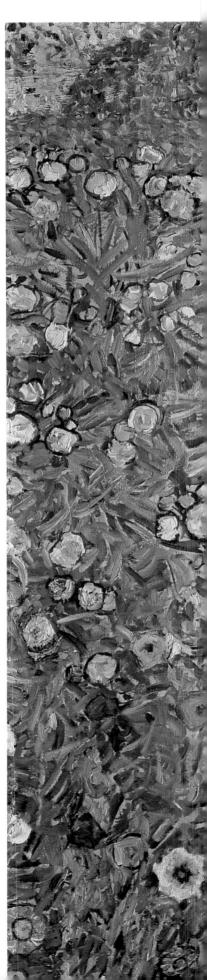

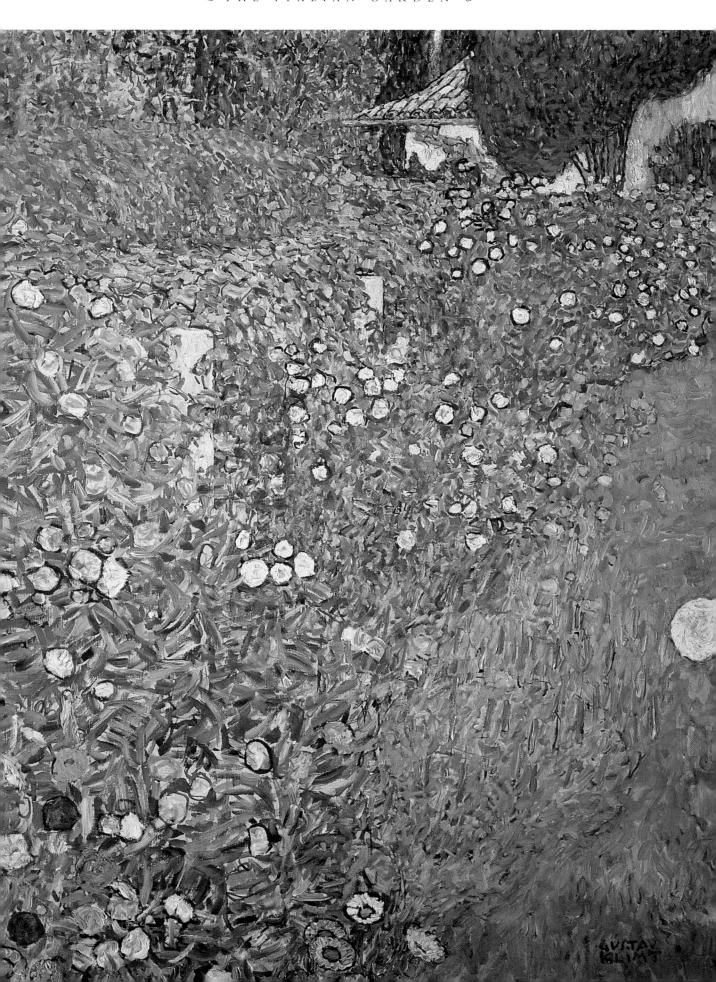

PORTRAIT OF JOHANNA STAUDE (1917–18)

Osterreichische Galerie Belvedere, Vienna. Courtesy of AKG London/Erich Lessing

HIS is one of several unfinished works found after Klimt's death on 6 February, 1918. He had suffered a devastating stroke a month earlier which paralysed his right side. Paralysis was his greatest fear and he knew he would never paint again. Without art his will to live was completely sapped. While in hospital he caught influenza during a lethal pandemic which was sweeping through Europe, killing millions, and he finally died of pneumonia.

The unfinished works are mainly portraits, such as this, but Klimt constantly battled with the medium, taking his work into new realms as he searched for fresh elements. Here, for instance, he appears to return to his traditional early 1900s style of portraiture, with the incorporation of a solid, bold monochromatic background rather than

Detail from Fable (1883) Historical Museum, Vienna. Courtesy of AKG London. (See p.21)

an ornate setting. This background is possibly unfinished and might have been waiting for further embellishment, however the strong Post-Impressionist colours are a long way from the insipid Pointillist-inspired backdrops of works like *Marie Henneberg*, (1901–02). Instead here we encounter the new liberated woman, confidently dressed in fashionable haute-couture, probably a Vienna Workshop outfit, while boldly confronting the viewer at eye-level.

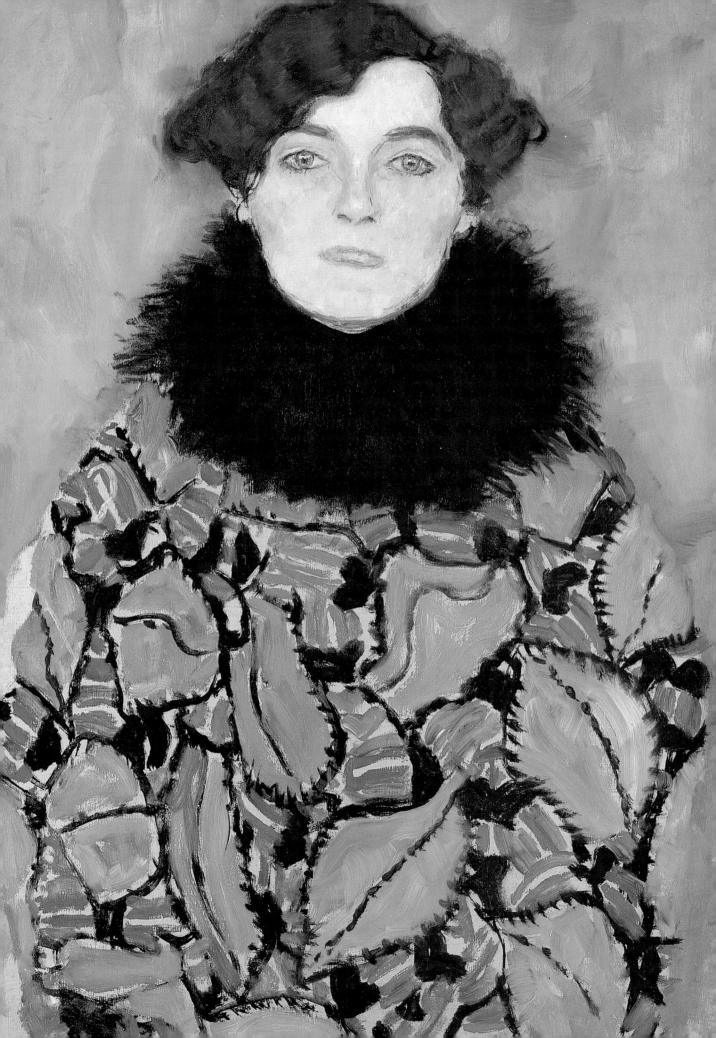

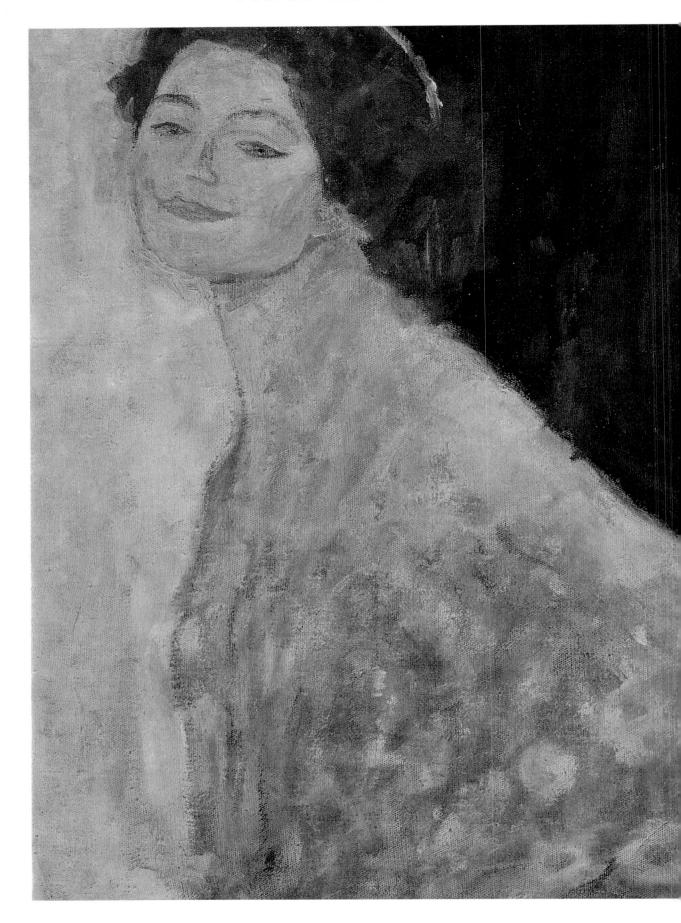

WOMAN IN WHITE (1917–18)

Courtesy of Dr Brandstätter-Artothek

S in the unfinished portrait of Johanna Staude (1917–18), here Klimt has managed to capture greater psychological depths of character with his new, energetic style. Even though this work is incomplete, the woman's stance and lovely smiling countenance convey a greater sense of fluidity and animation about the body than the heavily stylised and structured works of earlier years. The diagonal line of the arm is carefully positioned to help define the composition's geometric balance. The fine paint work, with its delicate silvery blue mottling, allows the viewer to glimpse at the promise of fleshy form underneath the semi-transparent chemise.

Although unfinished, one can savour Klimt's aesthetic intention: to suggest a glimmer of allure that is checked by a controlled artistic environment. This is the Vienna of Freud and psychology. Subsequently, issues of sexual control and release are exquisitely caught in carefully contrived oppositional tensions of form and content, such as the intimation of transparent clothes set against a solid, dark background. These aesthetic devices help accentuate aspects of sensuality or eroticism, as in *The Girls (The Virgin)* (1912–13); in which a rich, intricate pattern creates an artistic order which symbolically restrains the erotic desires of the naked girls, and presumably those of the male viewer.

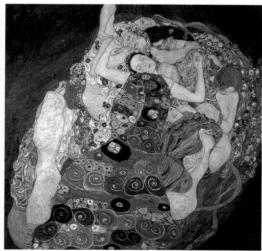

The Girls (The Virgin) (1912–13)
National Gallery, Prague. Courtesy of AKG
London/Erich Lessing. (See p. 215)

PORTRAIT OF A LADY (1917–18)

Neue Galerie der Stadt, Linz. Courtesy of AKG London

LSO from the unfinished collection, this life-size work would undoubtedly have been in the vein of Adele Bloch-Bauer II (1912), in terms of colouring and dramatised background when finished. Unlike Adele, and some of the later female figures, this woman is not standing face-on, instead her pose is slightly to the side, with a wistful expression that captures a fascinating intimation of sensual beauty. This is a study of graceful elegance and refinement, without the haughty feigned grandeur of some of Klimt's wealthy nouveau riche clientele, such as Adele. Whether the sitter was of the aristocracy, or whether the use of 'Lady' in the title was a play on words, is not clear, although Klimt was not known for artistic raillery. Some Klimt experts believe it to be a portrait of a Maria Munk, but opinion is divided. Whoever she was, Klimt has secured something original and evocative in her stance, as he searches for something that is tangible about her personality.

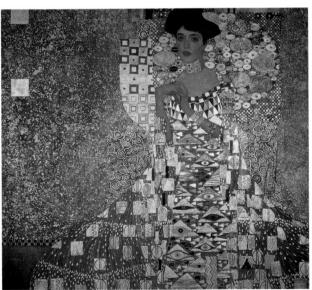

Adele Bloch-Bauer II (1907)
Osterreichische Galerie Belvedere, Vienna. Courtesy of
AKG London/Erich Lessing. (See p. 185)

It is interesting that the work in progress shows how Klimt preferred to paint in the intricate background around the drawn form of the woman and then complete the face before finishing the figure's detail. This concentration on the order and structure of his schematic patterning devices serves to establish the composition's balance.

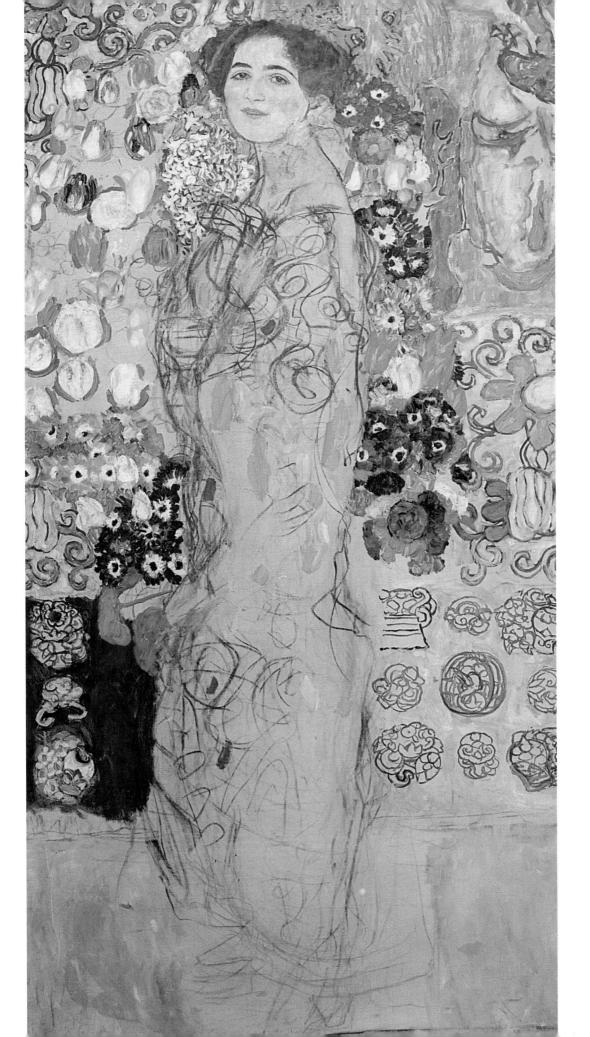

HEAD OF A WOMAN (1917-18)

Neue Galerie der Stadt, Linz. Courtesy of AKG London

T is very unfortunate that this picture was never completed because it would have demonstrated, probably more than any other in the unfinished collection, Klimt's synthesis of old and new styles. Always art's knight, he fought every day to discover

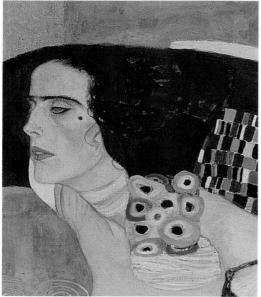

Detail from Salome (Judith II) (1907–09) Modern Art Gallery, Venice. Courtesy of AKG London. (See p. 192)

something new about his work, but this was a gradual process of change and sublimation as he was a creature of order and detail.

Now we see a work concentrating solely on a close-up of the sitter's face rather than a contrived pose against a heavily patterned background. Lessons learned from zoomed-in landscape work are being employed on portraits to discover aspects of personality, hitherto ignored. His interest in the abilities of Schiele's Expressionism to capture something notable, also provoked him into experimenting with new methods, as work leading up to his death reveals. These few lines recall similarities of technique in celebrated works of ten years earlier, such as *Salome (Judith II)* (1907–09), in which the artist's strong handling of

black and red around the face create animation. Here, Klimt is employing a bright yellow frame of hair against black to obtain the same effect, but with the promise of more vitality because of the proximity of the figure and greater simplicity of the design.

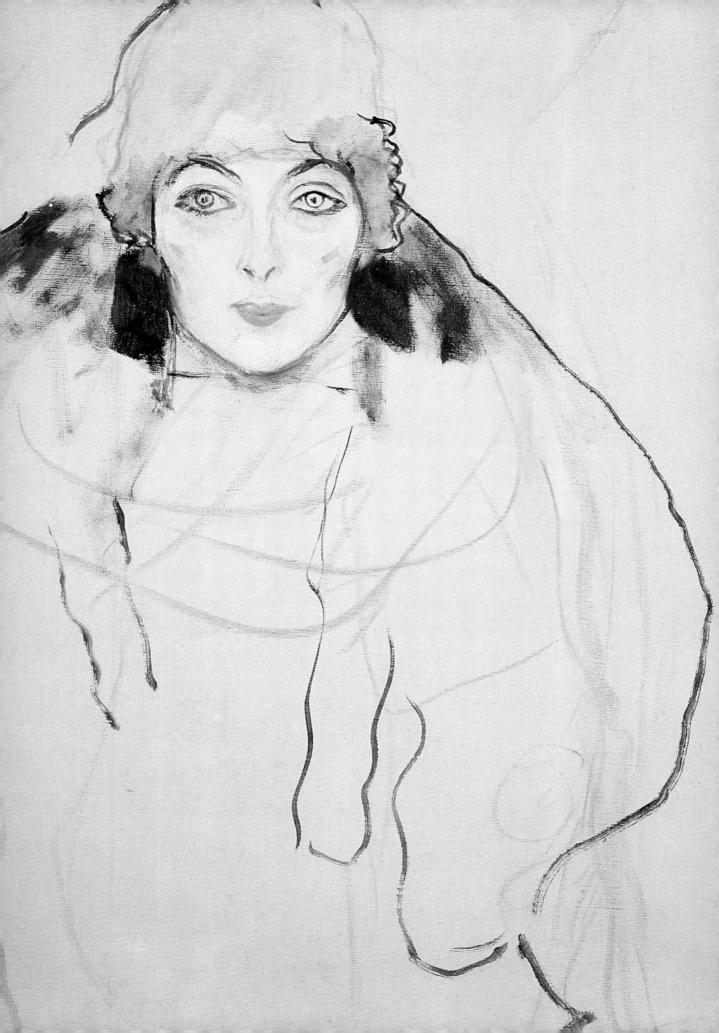

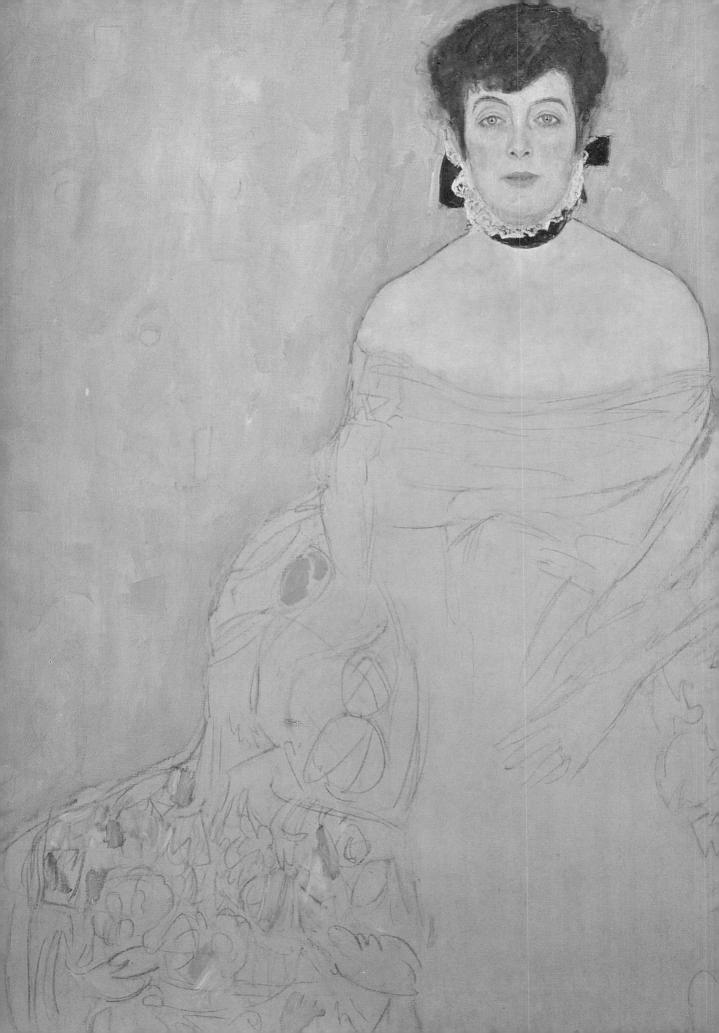

AMALIE ZUCKERKANDL (1917–18)

Courtesy of Dr Brandstätter-Artothek

HIS studio work was found by Klimt's grieving life-long friends, including Josef Hoffmann, a brilliant Secession and Vienna Workshops architect and co-collaborator with Klimt in projects such as the Stoclet Palais, and *Kunstschau* exhibition hall. He could not accept Klimt's early death at 55, anguishing, 'the world is out of joint'.

The unfinished portrait is arguably of an influential cousin of the journalist and invaluable pro-Klimt critic and friend, Berta Zuckerkandl. Amalie possibly helped Klimt and Hoffmann win the Stoclet commission through her important European connections and, thanks to some of Berta's memoirs and articles, we know a great deal about the time in which Klimt lived and worked. Always outspokenly in favour of their pioneering style, she plotted with other journalist friends how to counter the popular press's often-libellous attacks on Klimt's work, such as the University painting scandal.

Klimt sadly confided to Berta in later years that the younger artists simply, 'don't understand me any more – they are going somewhere else. This is what happens to an artist, but it's a bit early for it to happen to me ... youth always wants to tear down whatever exists'. He was wrong. Klimt was approaching a major transformation, and would probably have continued to create inimitable works out of contemporary developments, as did Pablo Picasso, had he lived longer.

THE BRIDE (1917–18)

Private Collection. Courtesy of AKG London/Erich Lessing

HOTOS of final scenes from Klimt's studio show this huge canvas, 160 cm x 190 cm (64 in x 76 in), still in progress on the easel. Although it marks a return to allegory, where he started his career 30 years before, this strange, highly symbolic piece reveals linear and colour adaptations from Expressionism, which he was beginning to plunder freely in order to develop a new aesthetic.

Aspects of *The Bride* recall *Death and Life* (1908–11), as Klimt conjures up another vision from his 'column of life' symbolism that eventually spanned his whole career. The key woman's head is set in the centre, and the same doll-like face.

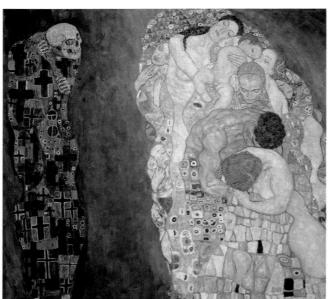

Death and Life (1908–11) Leopold Collection, Vienna. Courtesy of AKG London/Erich Lessing. (See p. 204)

with its innocently closed eyes, appeared regularly over the previous ten vears: as chief emblem of motherhood in Death and Life, as the virgin in the The Girls (The Virgin) (1912-13) painting, and here, as symbolic bride. In this respect the unfinished work appears little altered. Critics place it at the end of a long line of some perplexing, symbolic, sexual drama. However, the intimated blue robe equates her, on another level, with Renaissance

Madonna figures and, considering the other unfinished work, *Adam and Eve* (1917–18), Klimt was contemplating his definitive study of the subject he loved best: the essence of woman.

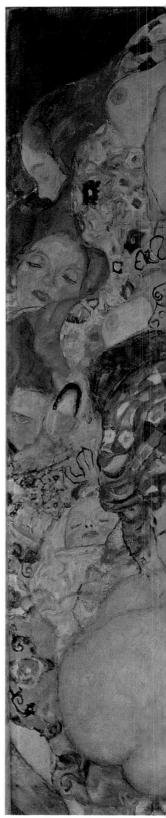

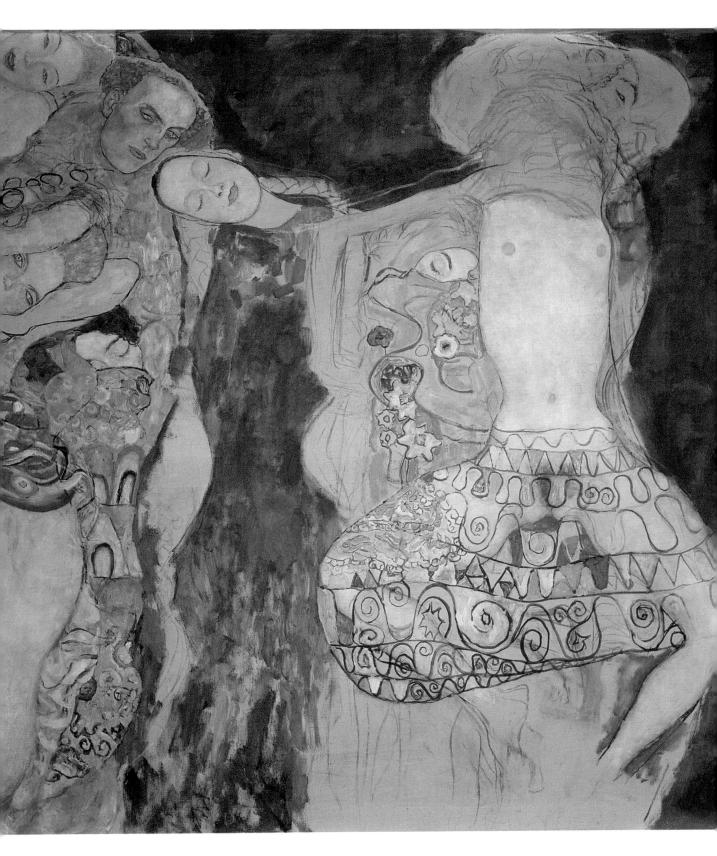

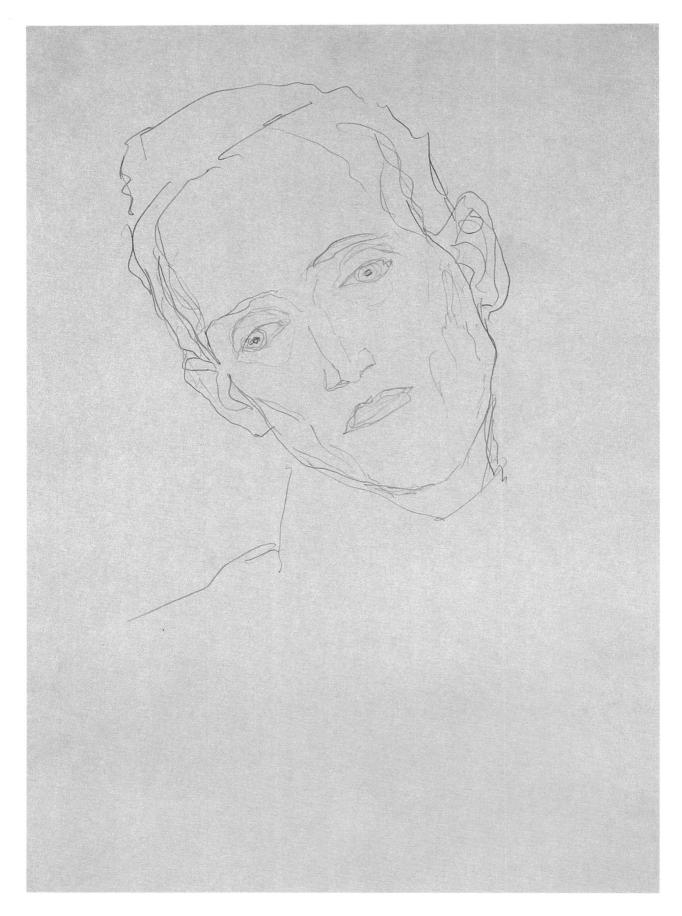

HEAD OF A MAN (1917-18)

Courtesy of Historical Museum, Vienna

LIMT rarely drew or painted men, so this is an unusual find and is probably a study for *Adam and Eve* (1917–18). The similarities of facial characteristics, bone structure and expression convincingly tie the two works together, although the man has closed eyes in the final painting.

There is an amazing similarity between the drawing's face and pictures of Expressionist artist Egon Schiele, Klimt's admirer and collaborator. In a few lines, Klimt has caught an expression often seen in Schiele's disturbing self-portraits. Did Schiele pose for the final *Adam and Eve* painting? More interestingly, did Schiele's young wife,

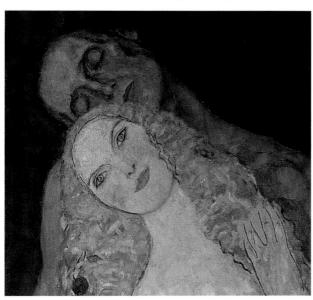

Detail from Adam and Eve (1917–18)Osterreichische Galerie Belvedere, Vienna. Courtesy of AKG London/Erich Lessing. (See p. 254)

Edith, who had long blond tresses, though a thinner face than this, model for Eve?

Schiele, devastated by Klimt's death, drew his face in the morgue. This shocking death-mask records how Klimt's ample beard was shorn and the proud, bullish face pathetically sunken. Tragically, by October 1918, Edith was also dead from influenza, and he died in December. In one year Austria lost two of its greatest artists as well as countless war casualties.

ADAM AND EVE (1917–18)

Osterreichische Galerie Belvedere, Vienna. Courtesy of AKG London/Erich Lessing

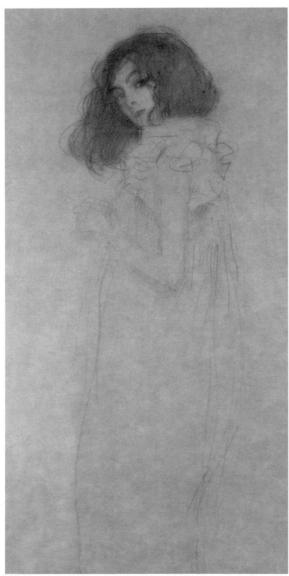

Portrait of a Young Woman (1896–97) Private Collection. Courtesy of The Bridgeman Art Library. (See p. 59)

HIS large panel, with its full-frontal female nude and half-obscured man standing behind her, is a wonderful and important shift in the Klimt oeuvre. Found alongside the unfinished allegory, The Bride (1917–18), Klimt was perhaps contemplating creating his most definitive study of the subject he loved best: woman. This is a new chapter in the thematic 'Kiss' series which Klimt had constructed during a rich and revolutionary career into a lasting highly symbolic language, uniquely his own. Finally, in this last painting, we see a man with his eyes shut in a moment of ecstasy and fulfilment, rather than the woman's. She is looking out lovingly, rather than seductively, at the viewer. This is no femme fatale. This is a new, independent woman to whom the man now succumbs, a shift in Klimt's symbolic emphasis.

By the last few years of the artist's life, a new artistic world was beckoning. Cubism and abstraction were fundamentally changing aesthetic perceptions and Klimt's once-radical work, having con-

tributed to these developments, was being influenced in return. His death was a tragic loss at this point in the fight. A philosopher and poet, he saw himself as art's knight but to his friends he was always 'könig', the king. Sadly, now, the king was dead.

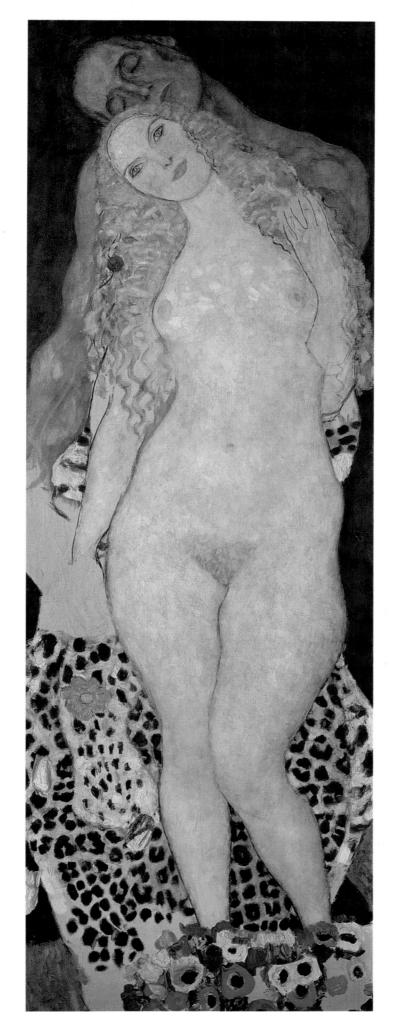

AUTHOR BIOGRAPHIES AND ACKNOWLEDGEMENTS

Laura Payne is a Klimt afficionado and UK-based writer, journalist and broadcaster, who has followed the arts movement for many years. She took time out from an international media career to pursue an MA in Literature and the Visual Arts, and now her current area of research is British and European early modernism, in which she is working on a new critical analysis and aesthetic theory.

Dr Julia Kelly was educated at Oxford and the Courtauld Institute of Art. She specialises in twentieth-century art, in particular Surrealism and the inter-war period. Her PhD thesis was in the art writings of Michel Leiris. She has published works on Picasso and Francis Bacon.

While every endeavour has been made to ensure the accuracy of the reproduction of the images in this book, we would be grateful to receive any comments or suggestions for inclusion in future reprints.

With thanks to AKG and The Bridgeman Art Library for assistance with sourcing the pictures for this series of books. With thanks to Josephine Cutts and Karen Villabona.

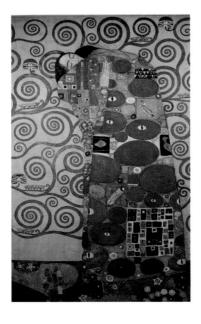